SPACEBORNE

to Peggy

DONALD R. PETTIT
FOREWORD BY ALAN BEAN

D. Pettit

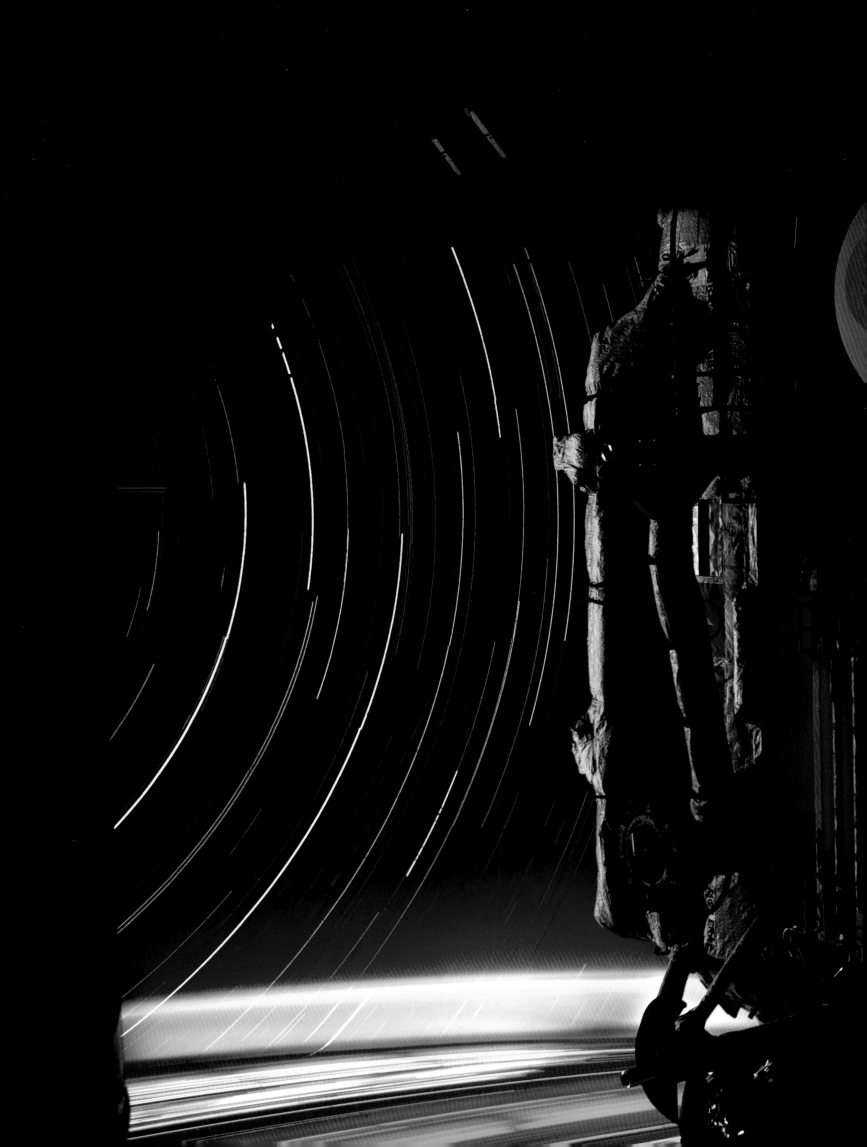

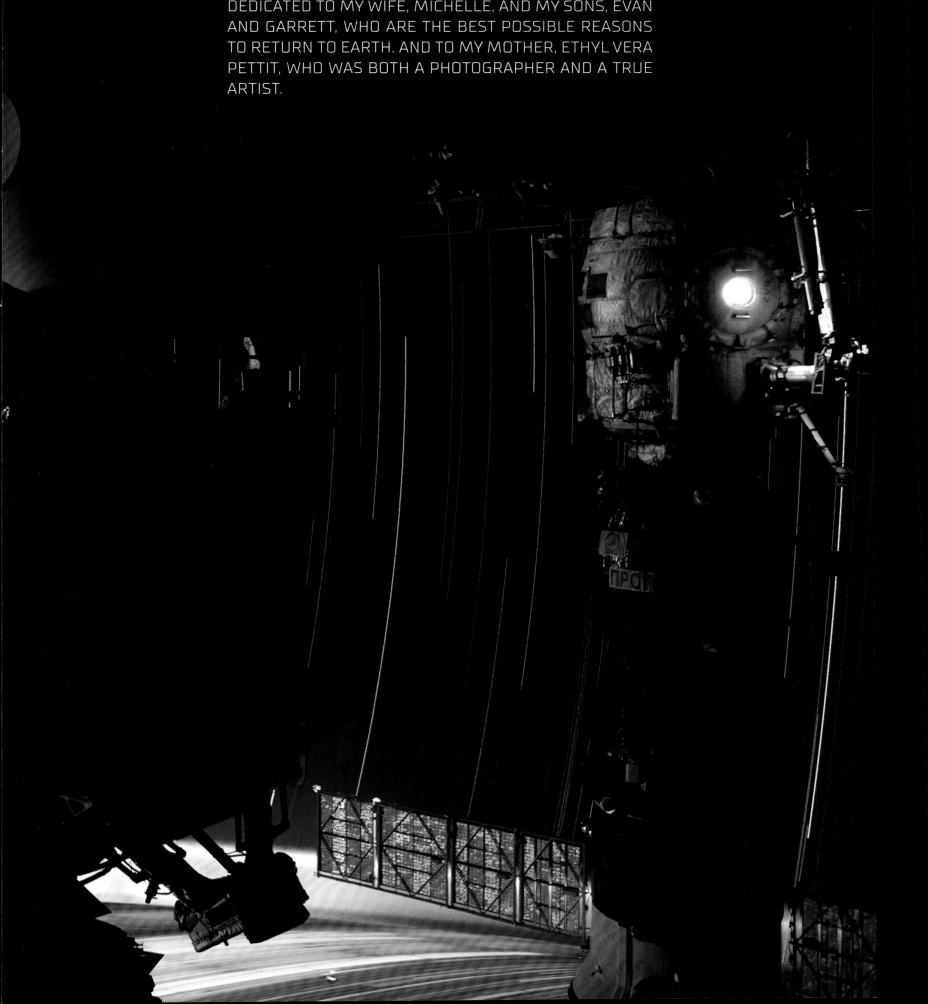

DEDICATED TO MY WIFE, MICHELLE, AND MY SONS, EVAN
AND GARRETT, WHO ARE THE BEST POSSIBLE REASONS
TO RETURN TO EARTH. AND TO MY MOTHER, ETHYL VERA
PETTIT, WHO WAS BOTH A PHOTOGRAPHER AND A TRUE
ARTIST.

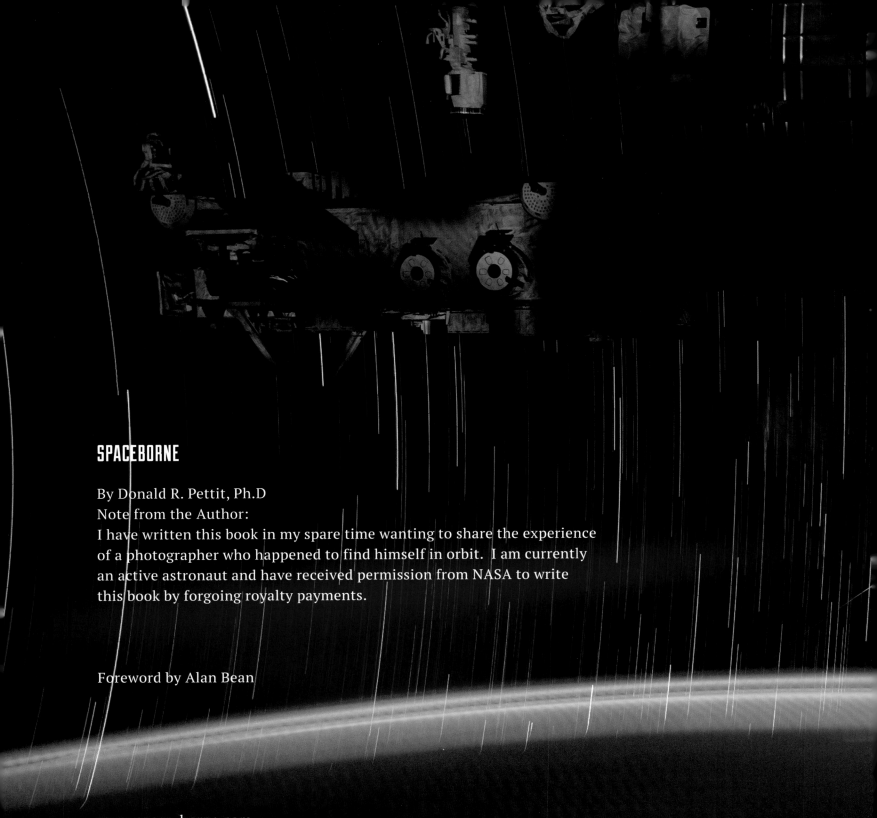

SPACEBORNE

By Donald R. Pettit, Ph.D
Note from the Author:
I have written this book in my spare time wanting to share the experience
of a photographer who happened to find himself in orbit. I am currently
an active astronaut and have received permission from NASA to write
this book by forgoing royalty payments.

Foreword by Alan Bean

www.space-borne.com

Photographs contained in this book are by Donald Pettit/NASA or the crew of Expedition
30 where the specifics of who took what photograph are lost in the NASA achieving process
except for what I remember below:
Photographs on pages 12-13 and 19 are by Dan Burbank.
Photograph on page 16-17 and 116 by Andre Kuipers.
Photographs on pages 127, 129, and 131 by Anatoli Ivanishin.
Photograph on page 10-11 by crew of STS-119.
Map on page 172 by Nathan Bergey.

PUBLISHED BY

PRESS SYNDICATION GROUP
t: 646.325.3221
2850 N. Pulaski Road, #9
Chicago, Illinois 60641
www.psgwire.com
sales@psgwire.com

RIGHTS & LICENSING CONTACT
N. Warren Winter
warren@psgwire.com
t: 646.325.3221

EDITOR & PUBLISHER : N. Warren Winter
TEXT EDITOR : Lynne Warren

$59.95
First Edition, 2016
ISBN 978-0-9960587-6-6
Library of Congress PCN : 2016940476

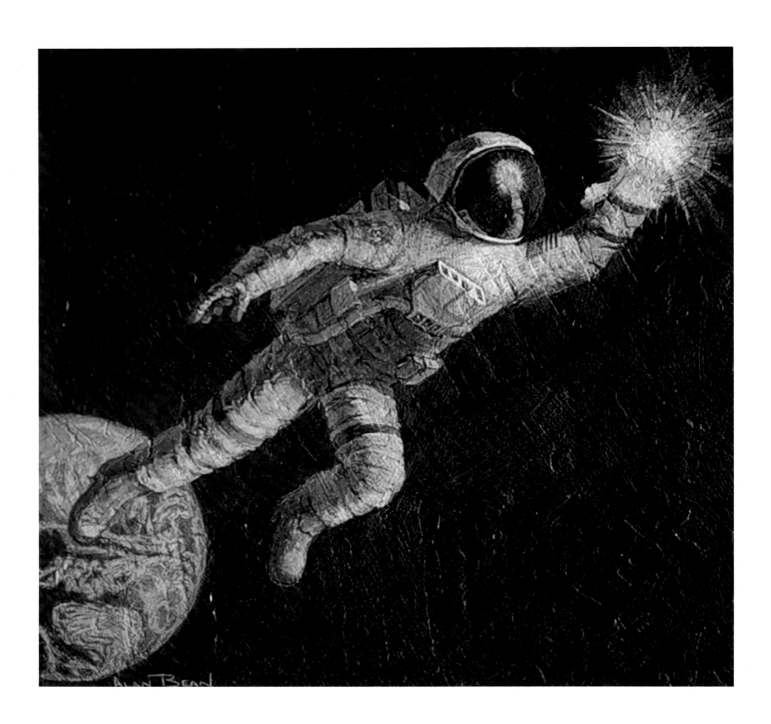

I am an artist who used to be an astronaut. My eighteen years with NASA were a lot of hard work, and of course, every once in a while I got to fly in space.

Nothing is more beautiful than planet Earth from space. Nothing. From the Moon, Earth resembles a shiny Christmas tree ornament hanging in a vast black sky. Its bright blue and white is a stark contrast to the matte grey of the Moon's surface, where I stood as a crew member of Apollo 12. It was hard to believe that everybody I had ever known and loved—indeed all of humanity—was there on that little blue marble.

For a long time I didn't think of myself as an artist. Art was a hobby I took up during test pilot school just because I liked it. But as we blandly documented astounding events with our cameras, I began to think that humankind's greatest achievement could be recorded another way. Maybe I could tell stories with paint and brush; stories that otherwise would be lost forever. I needed to use my art—felt it was my duty to use my art—to share these experiences with future generations.

This painting is a portrait of everyone who has flown or will fly in space. I call this explorer the Star Sailor. This universal astronaut is an emissary for all of us, soaring away from planet Earth and traveling as far as it is humanly possible to go. The Star Sailor stands for everyone whose spirit is dedicated to exploration. Our only limits are those we place upon ourselves: It is up to each of us to keep reaching for our own stars and to understand that they are not light years away, but as close to us as our planet, our homes, and our families.

Don Pettit is also an astronaut who tells stories through art. He creates images with cameras in a way that no one else has. As artists, storytellers, and explorers, Don and I are kindred spirits.

Alan Bean is widely known for artwork that explores the experience of space travel, and documents his own journeys in space as well as those of his fellow Apollo astronauts. In November 1969, aboard Apollo 12, Bean became the fourth person to walk on the Moon. He made his final flight into space on the Skylab 3 mission in 1973. Since retiring from NASA in 1981, he has pursued his passion for painting full time.

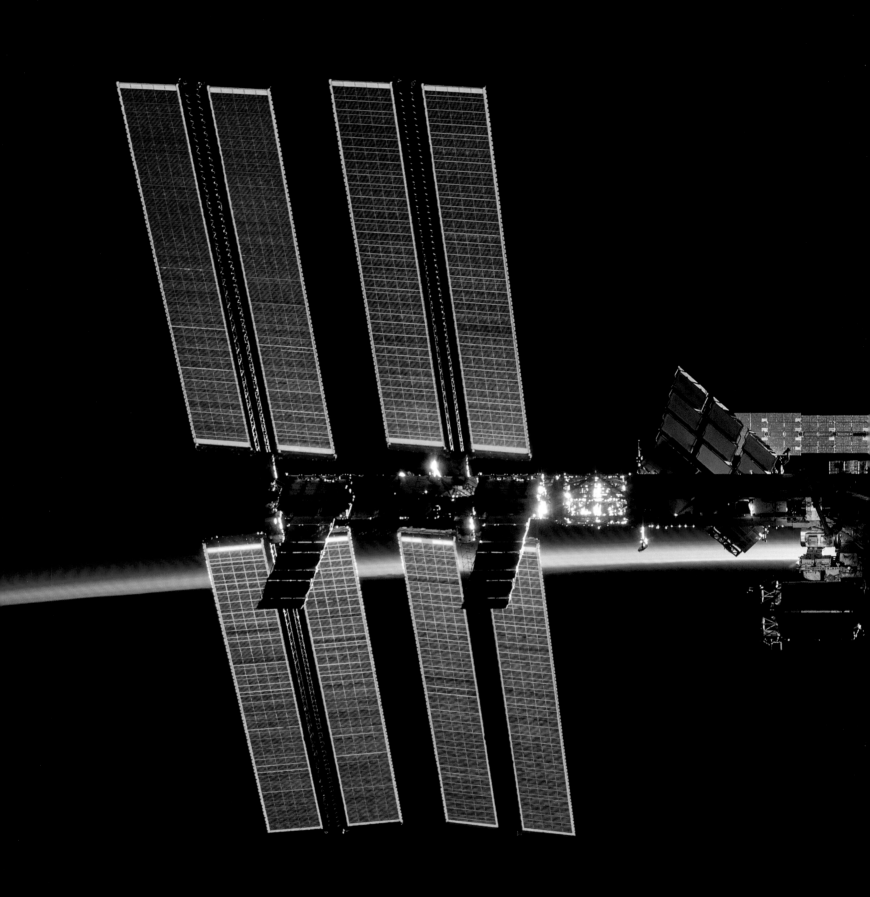

My Home, the International Space Station, as photographed from STS 119, Space Shuttle Discovery. Photo by crew of STS-119.

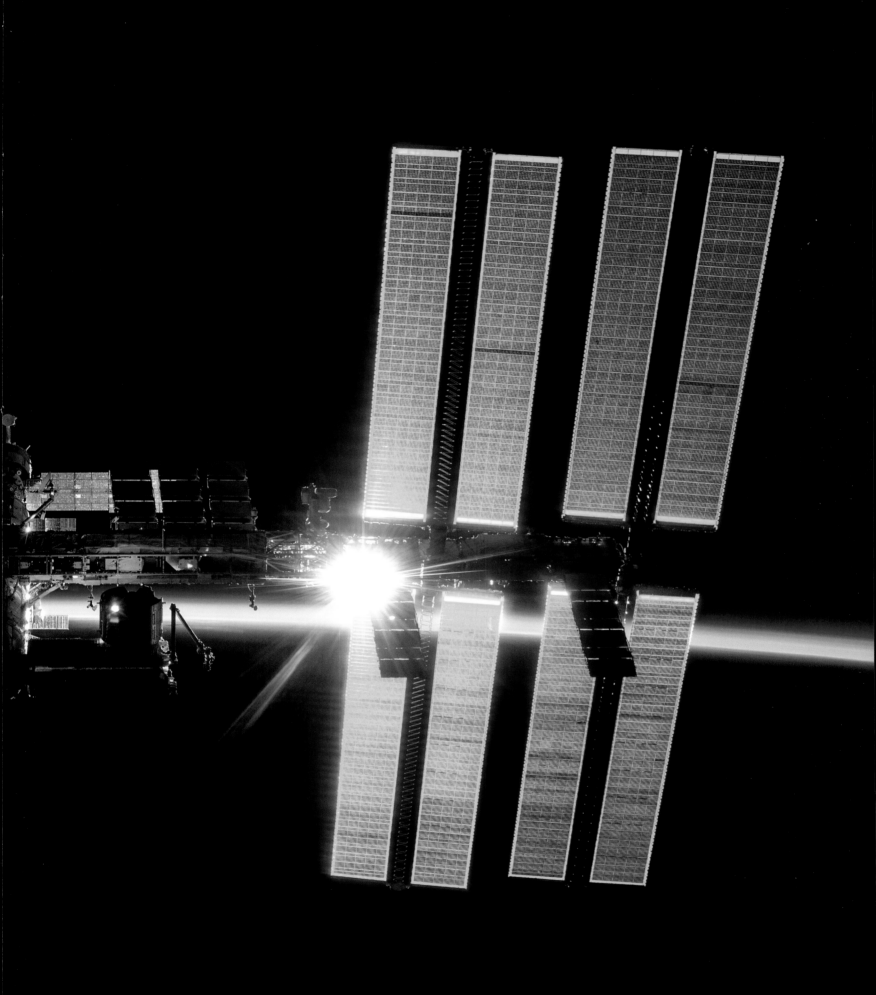

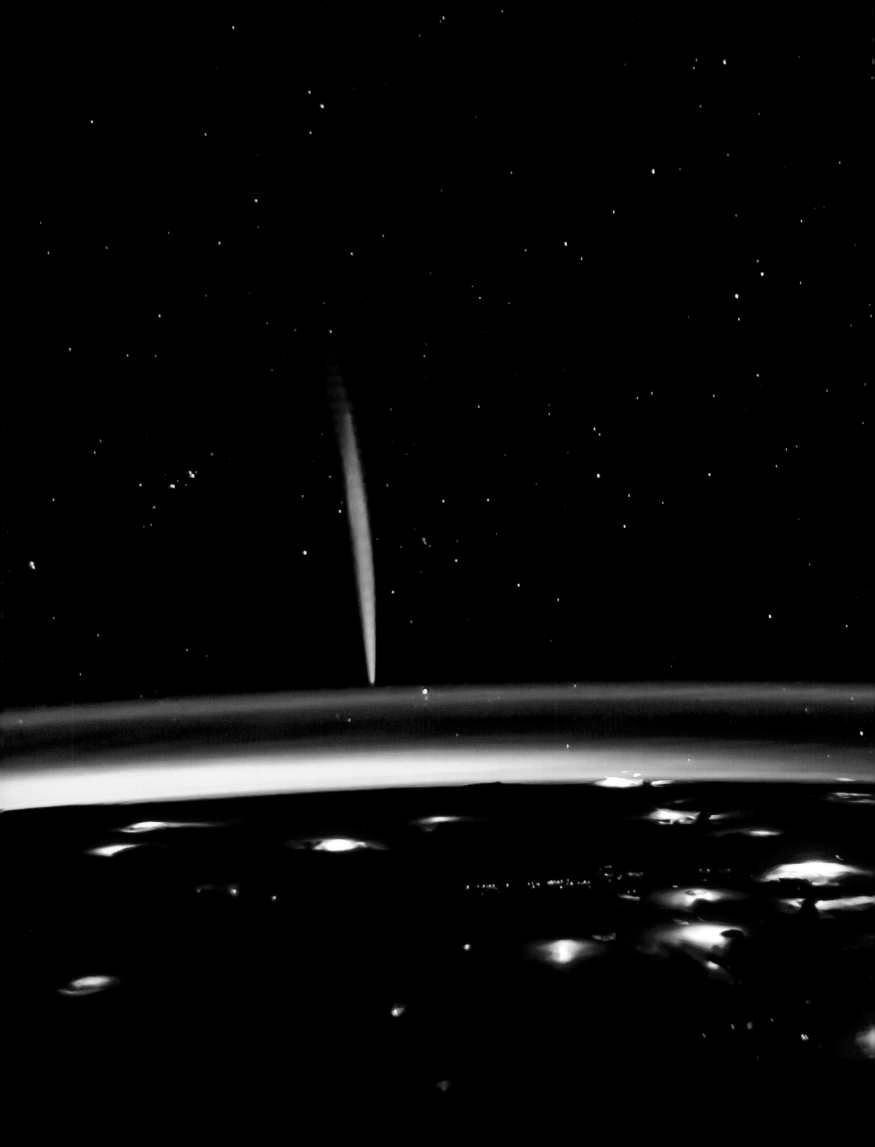

SPACE IS MY MISTRESS

BY DONALD R. PETTIT

Space is my mistress, and she beckons my return
 since our departure I think of you
 and yearn to fly across the heavens arm in arm
I marvel at your figure
 defined by the edges of continents
You gaze at me with turquoise eyes
 perhaps mistaken for ocean atolls
You tease me to fall into your bosom
 sculptured by tectonic rifts
 only to move away as if playing some tantalizing game
Time and time we turn together
 through day and night and day
 repeating encounters every 90 minutes
 with a freshness as if we have never seen our faces before
We stroll outside together
 enveloped by naked cosmos
 filled with the desire to be one
 so close
 you sense my every breath
 which masks your stare through visor haze
We dance on the swirls of cloud tops
 while skirting the islands of blue
 you know my heart beats fast for you
Oh, space is my mistress
 and when our orbits coincide
 we will once again make streaks of aurora across the sky

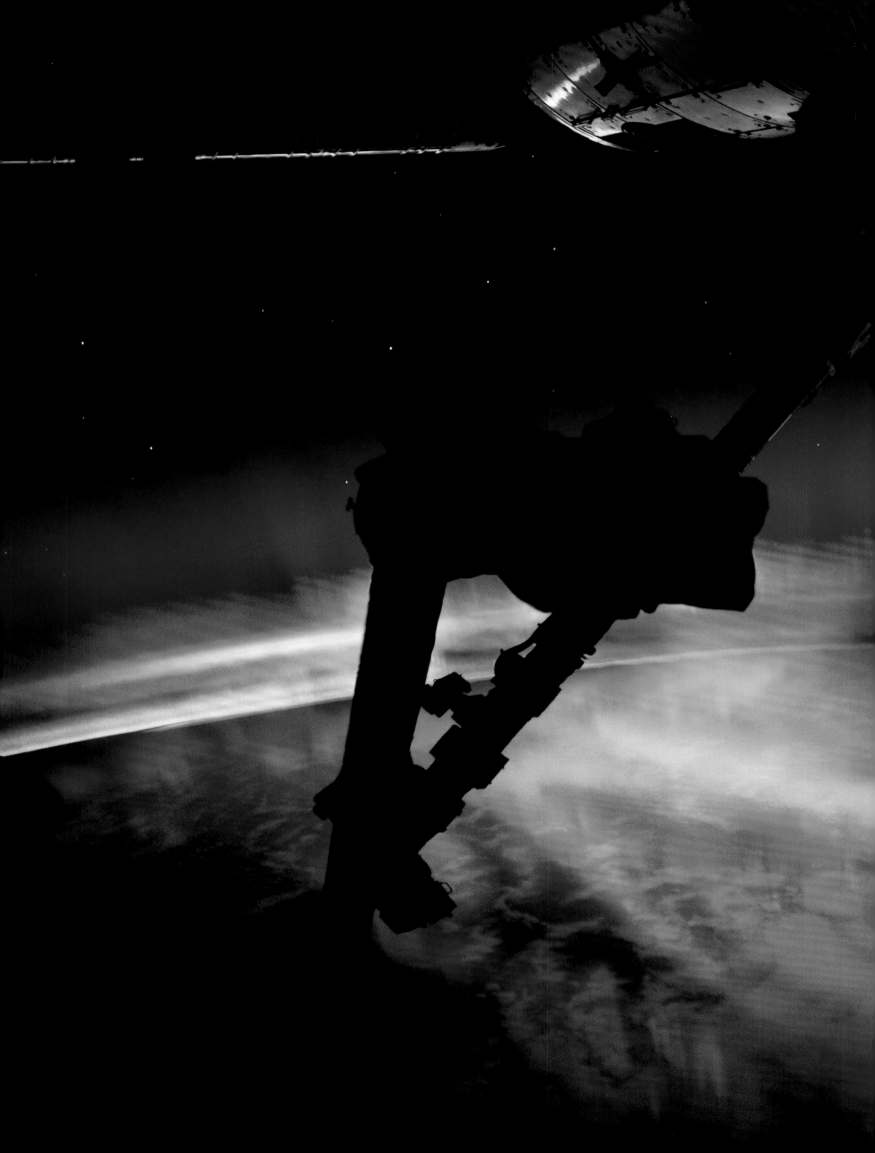

To travel in space is to be awestruck, over and over and over. Against those feelings of wonder, however, pushes the imperative of basic human survival in space. The inside of a spacecraft is like a hospital operating room, crowded with high-tech mechanisms—sheaves of cables and pulsating hoses, whirring pumps, and blinking electronics—all functioning to maintain life. And like surgeons immersed in their task, astronauts have little time to dwell on their feelings until after the mission has been completed. But somewhere in the tangle of machinery that makes spaceflight possible, awe and wonder survive, and with them the impulse to transform emotion and experience into art. The making of art is, I believe, an inevitable consequence of being human, and it happens wherever humans choose to live—even in space.

Spaceborne is a collection of photographs that had its genesis at this powerful intersection of science, technology, and art. The collection spans three NASA missions, which all together account for my living for more than a year in orbit around planet Earth. These were extraordinary human experiences, in every possible sense. I hope I have done them justice.

I rendered these images to give the most realistic possible impression of the scenes and experiences I remember. My approach is to avoid garish over-saturated colors and grainy over-sharpened detail. Some of my photographs capture nighttime phenomena so faint as to be at the edge of human perception; but when these phenomena are recorded by sensitive cameras using time exposures, the results are vivid images that show us more than we can see with our eyes alone. I am an avid amateur astronomer, so naturally turned to the astronomer's techniques of using time exposures and post-processing to combine several exposures into an image that shows detail and motion that cannot be captured in a single frame. Some scenes

(both daytime and nighttime) span a brightness range far beyond what a single exposure can record. In those conditions I took several photographs with a wide variation in exposure, then combined the best parts of each to make one image that depicts the whole range in brightness.

My crewmates and I took about 600,000 photographs over three missions. NASA's archiving process does not retain information about who made which photograph; the agency prefers to credit images simply as "photo courtesy of NASA." I took most of the photographs in this volume, particularly those in my specialty nighttime photography. My crewmates Dan Burbank, Andre Kuipers, and Anatoli Ivanishin took many photographs, some of which are used here, especially at times when I was getting some much-needed sleep. Sometimes Dan or Andre would be heading to bed when I was just waking up; thus as a crew we were able to capture many scenes that would have escaped a single photographer. If I am able to match a particular photograph with one of my crewmates, I will point this out in the credits.

Living and working in space means being surrounded by technology. Every breath depends on it. So it's only natural for space travel stories to obsess about the amazing machines that make the experience possible. Living weightless for months on end in a thin-walled aluminum can is indeed very odd. (And how do you go to the bathroom? Everybody asks.) But this book is not about how to survive in space. It's about what it has meant to one human being's heart and soul, to see and think and feel and dream on the threshold of the Universe. Only about 550 other people have ever traveled into space. My goal is to share my experience of being in space with those who have not yet had the opportunity to live there. My hope is that these collected visions and memories will inspire many of my seven billion planet-mates to venture out there themselves.

DAYTIME

From space I have been able to capture wide-angle oblique views of natural structures on Earth that stretch across half a continent, and telephoto views that showcase fine details. Light is the heart of these photographs. Low-angle sunlight casts long shadows, and gives depth. Noontime sun creates sun glint, intense lighting that causes surface water to act like a mirror directly reflecting the sun's rays into the lens. Sun glint reveals ocean surface patterns that are invisible under any other lighting condition. Daytime views from space are joyful, offering a wonderful display of saturated color.

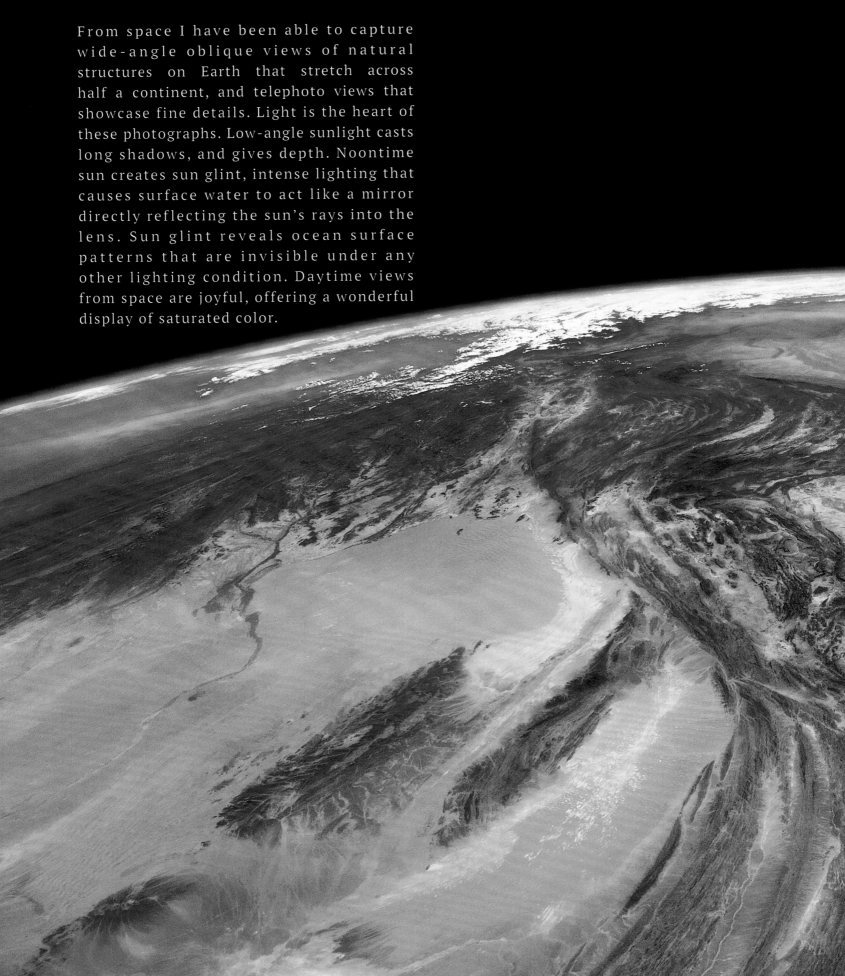

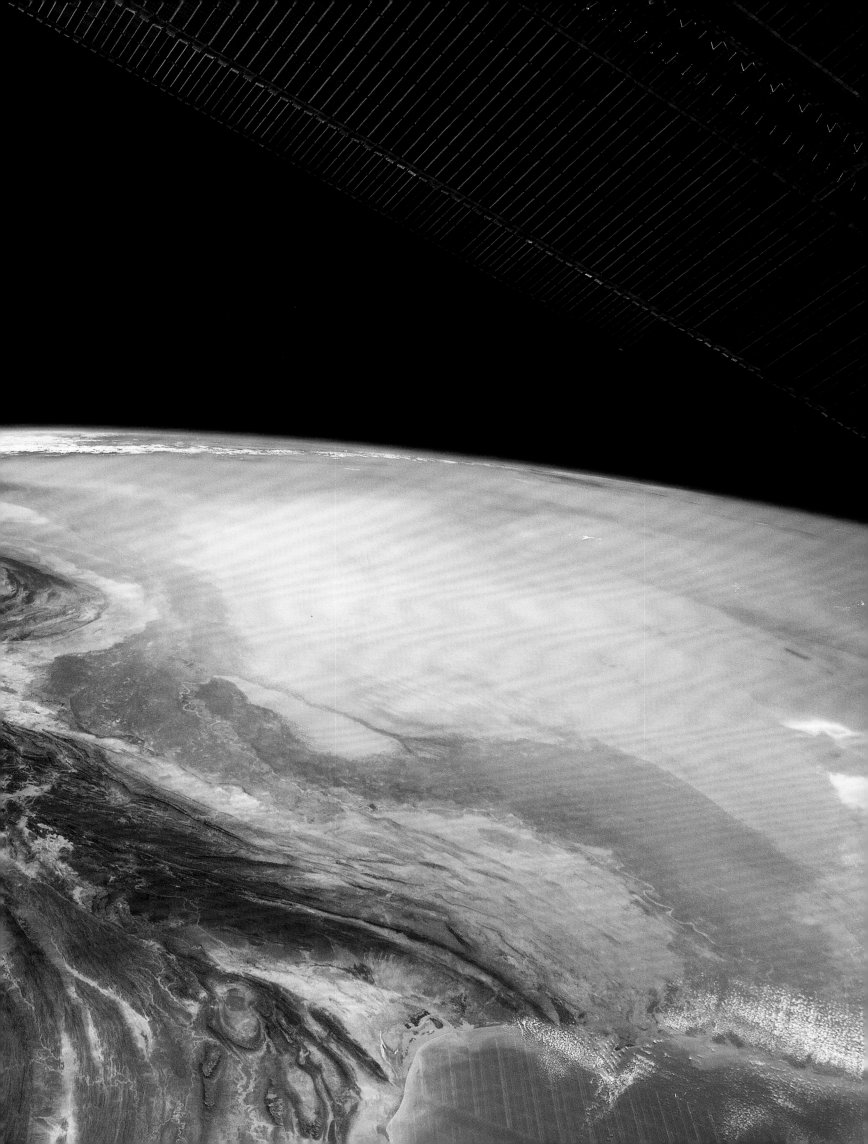

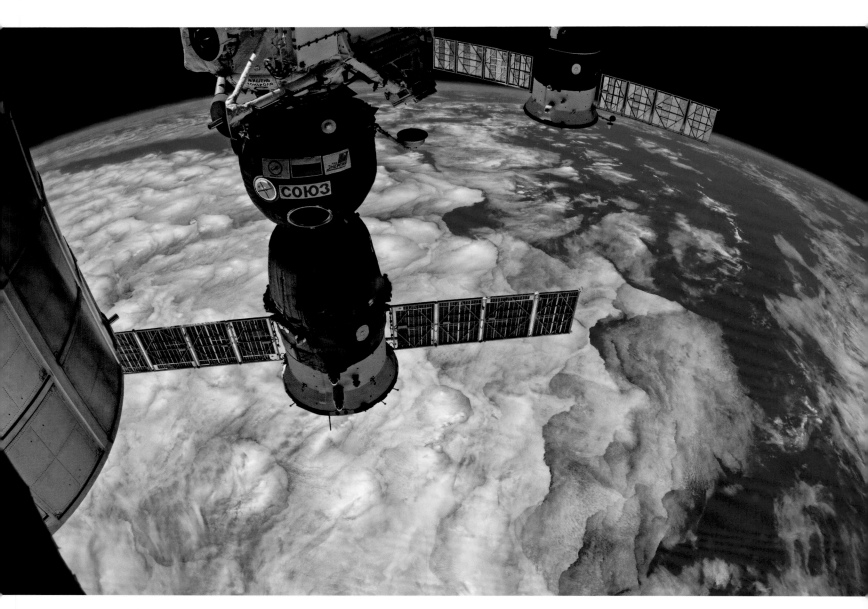

(Previous spread) *Northern Pakistan.*

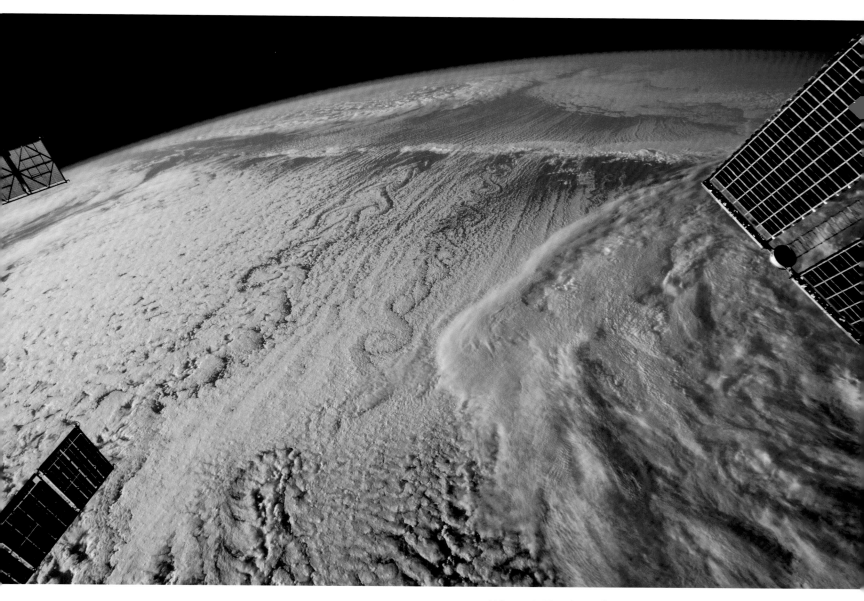

(Above) Vortices, known to scientists as Von Karman streets, are most often seen in engineering laboratories' wave tanks, or off the tips of airplane wings. Here they appear on the length scale of half a continent, generated from winds over the Aleutian Islands off the coast of Alaska.

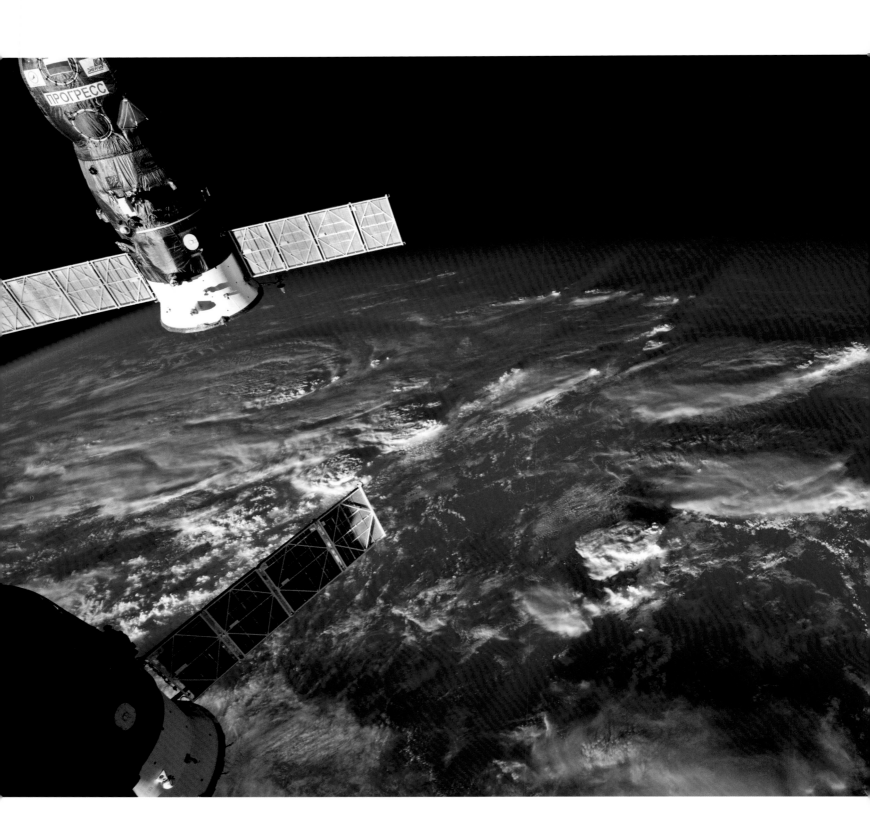

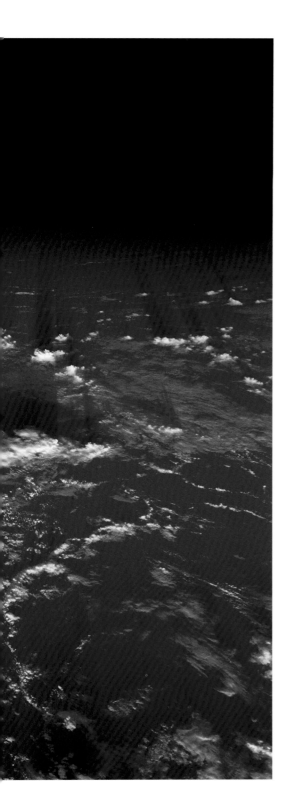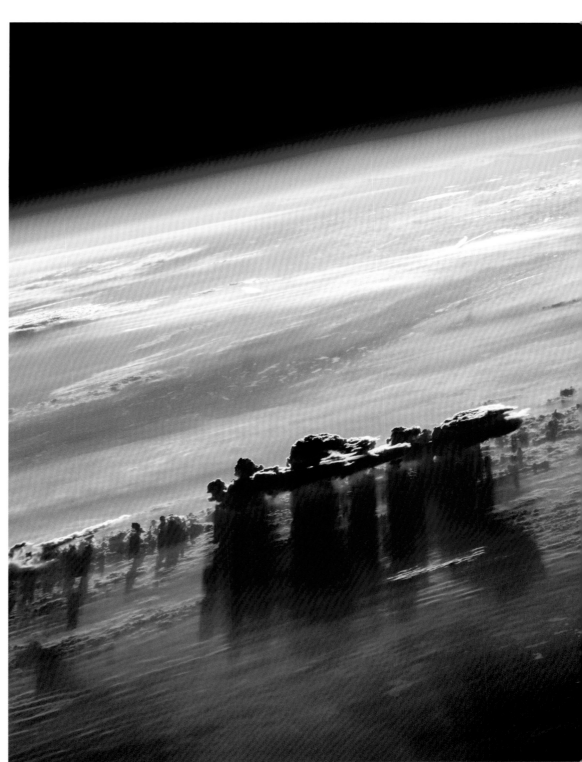

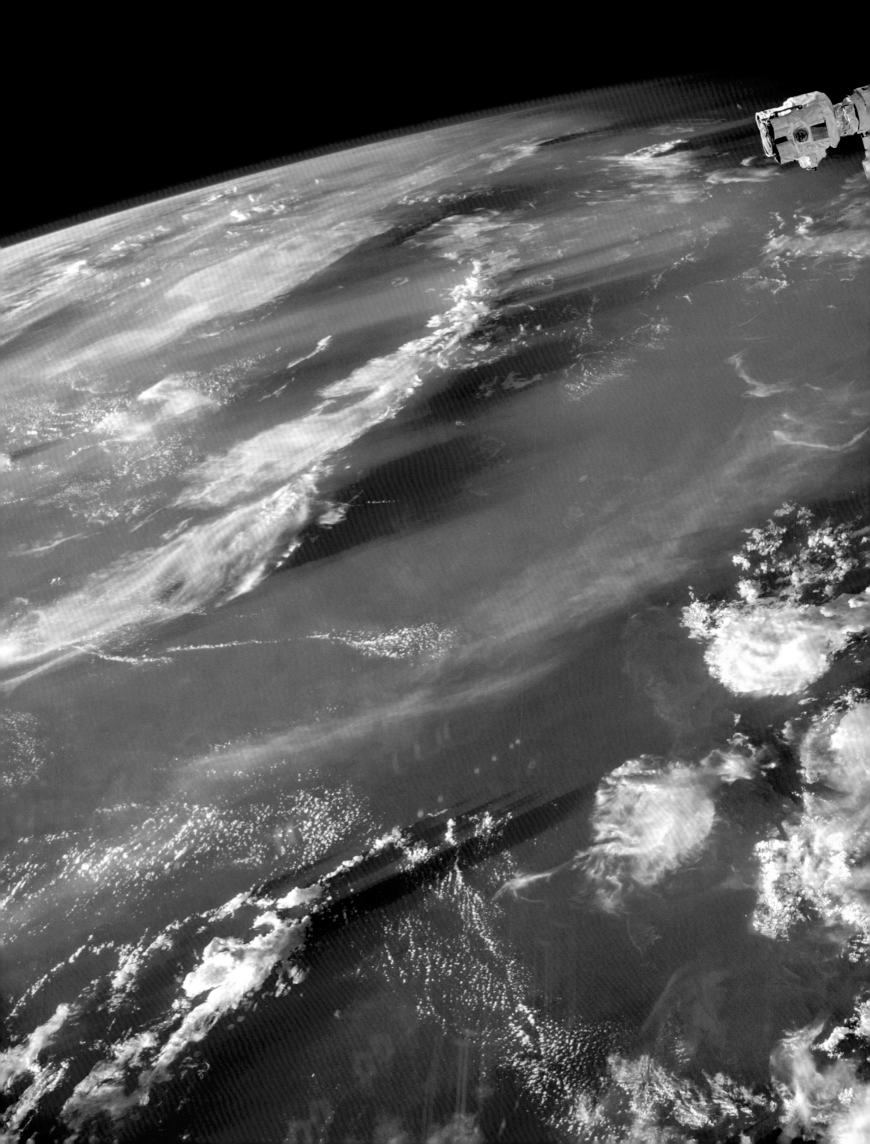

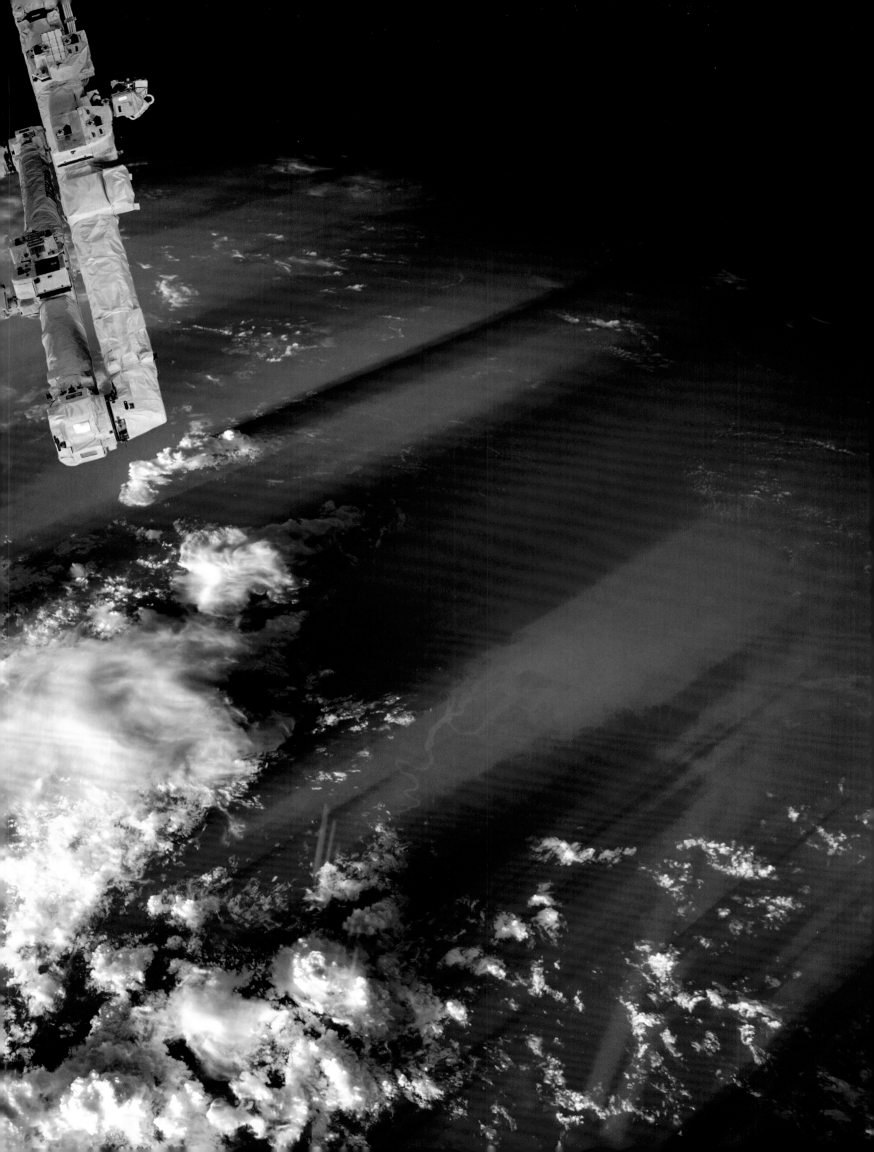

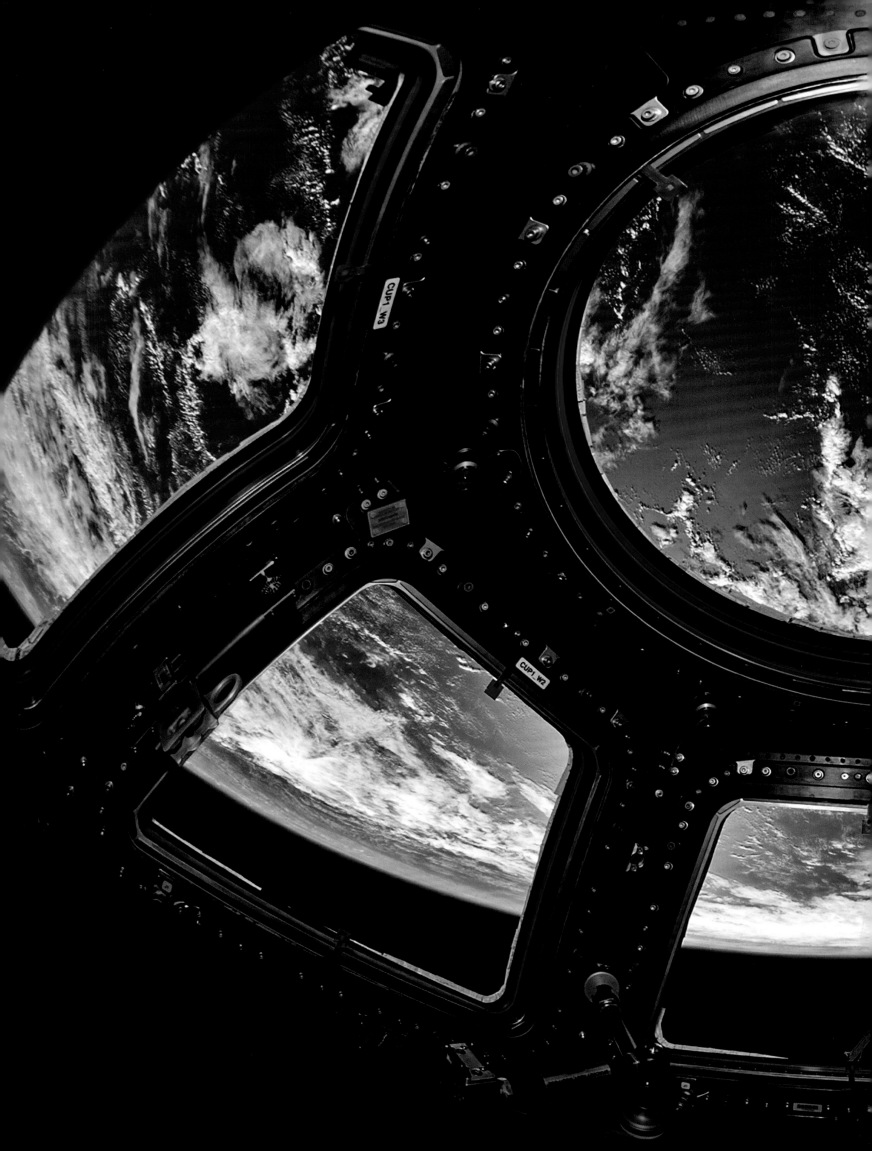

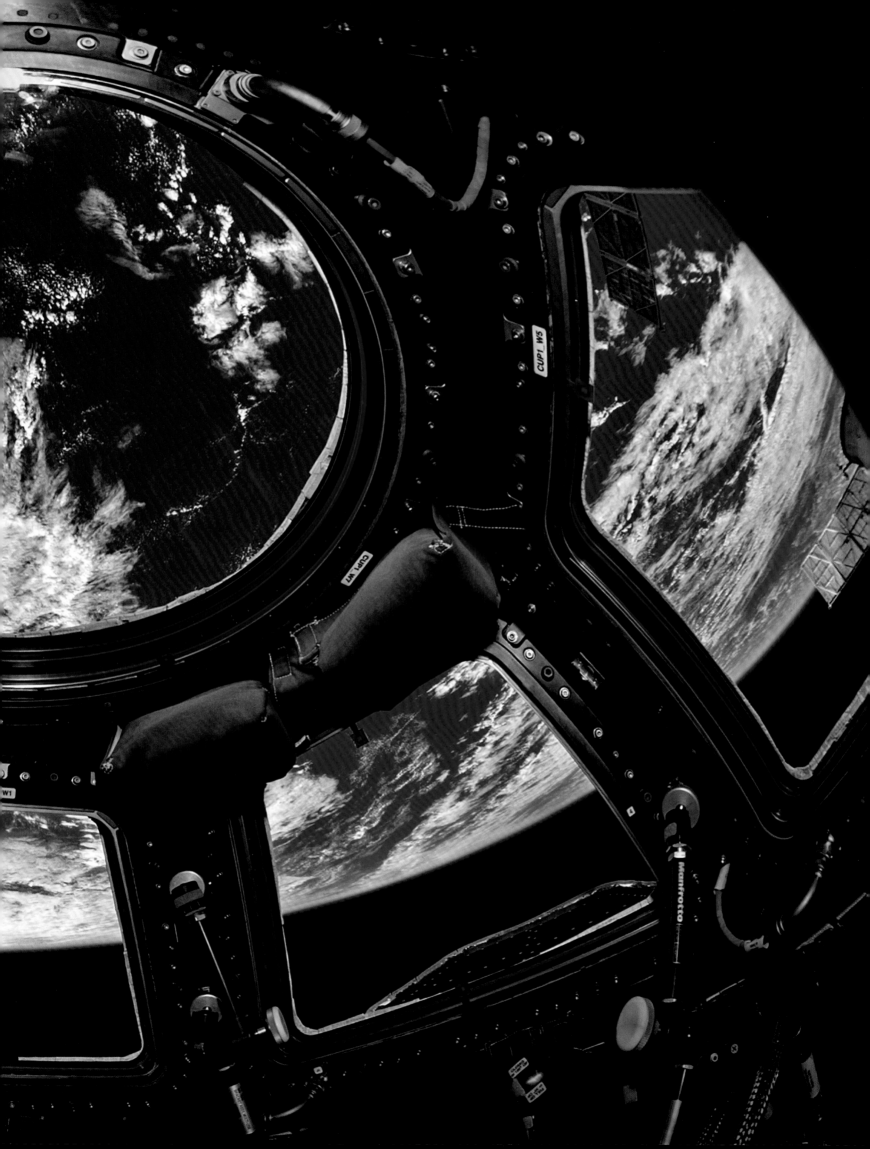

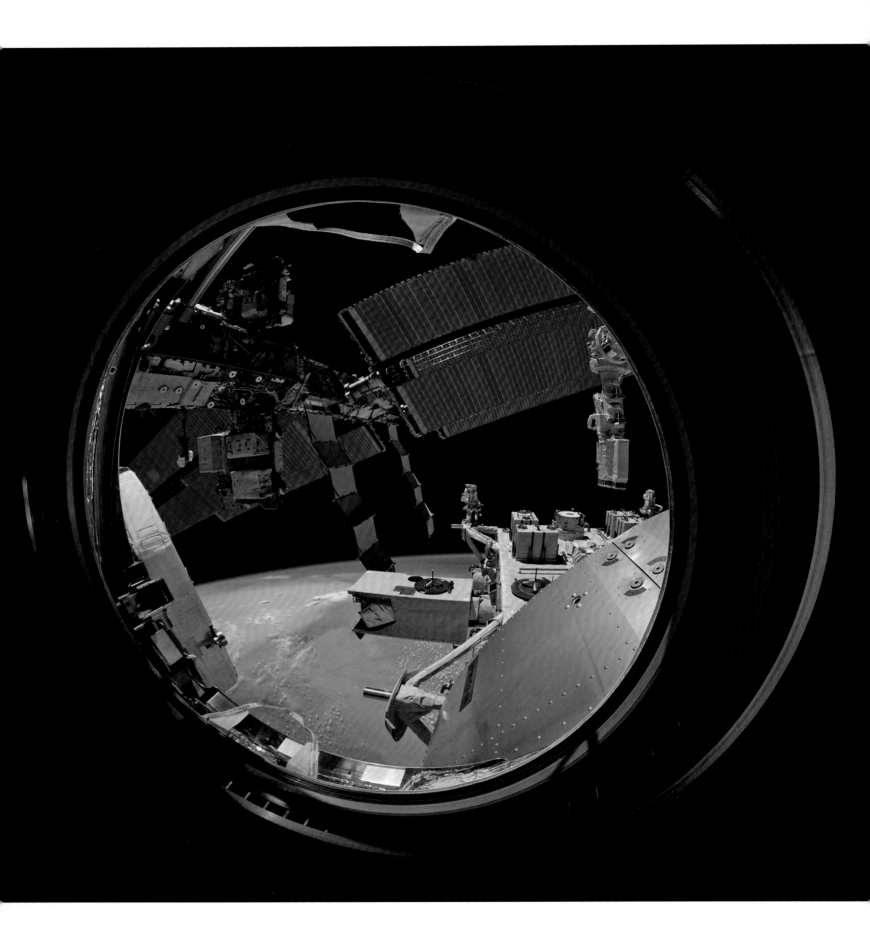

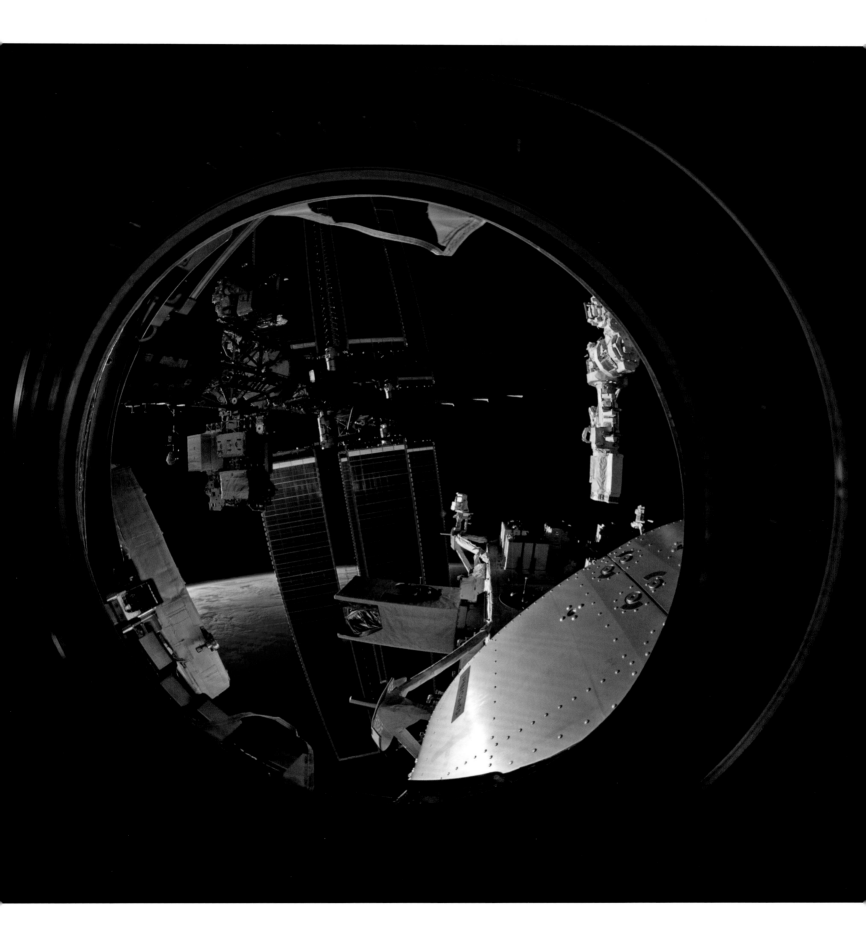

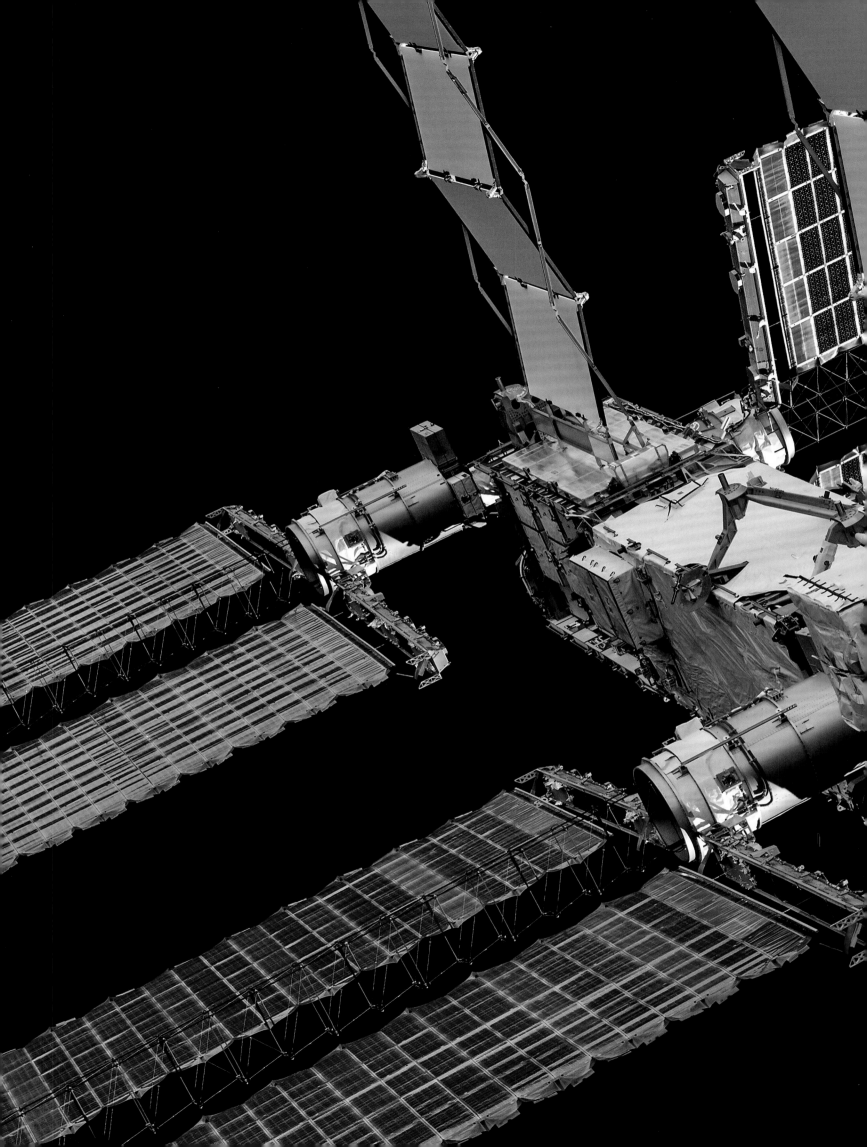

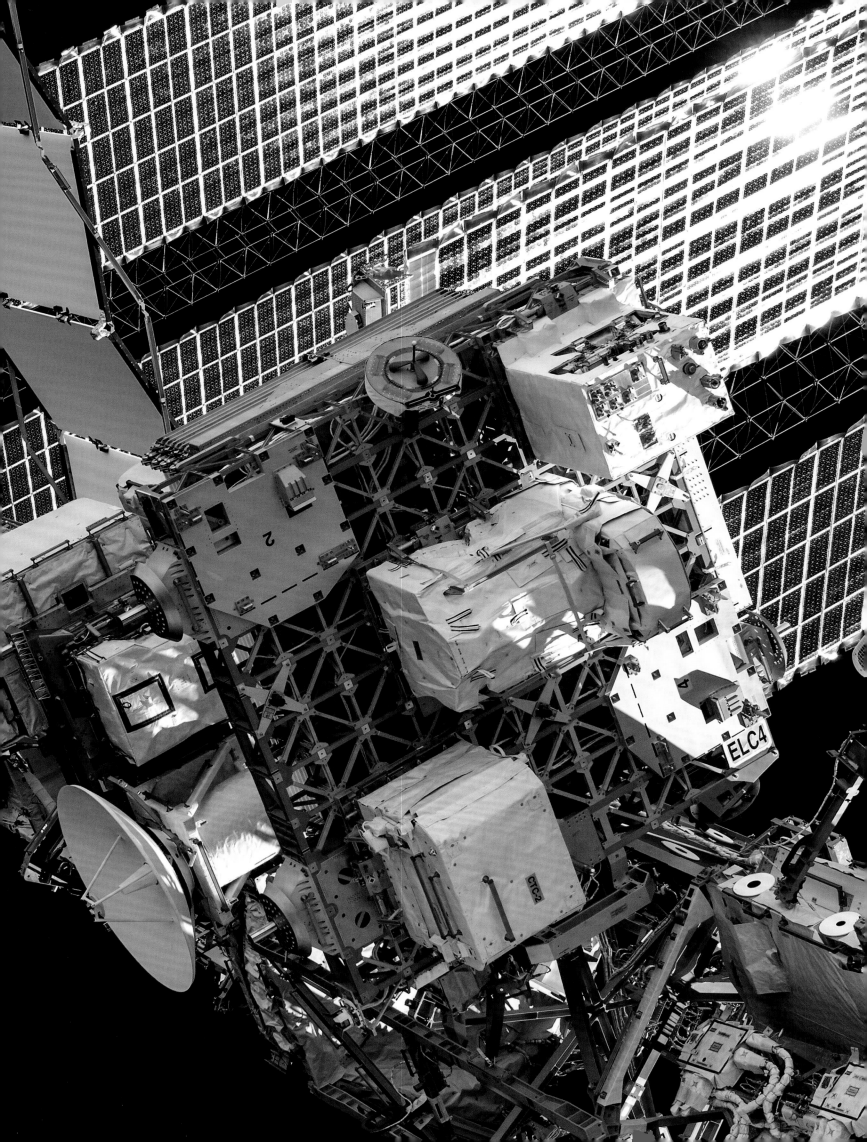

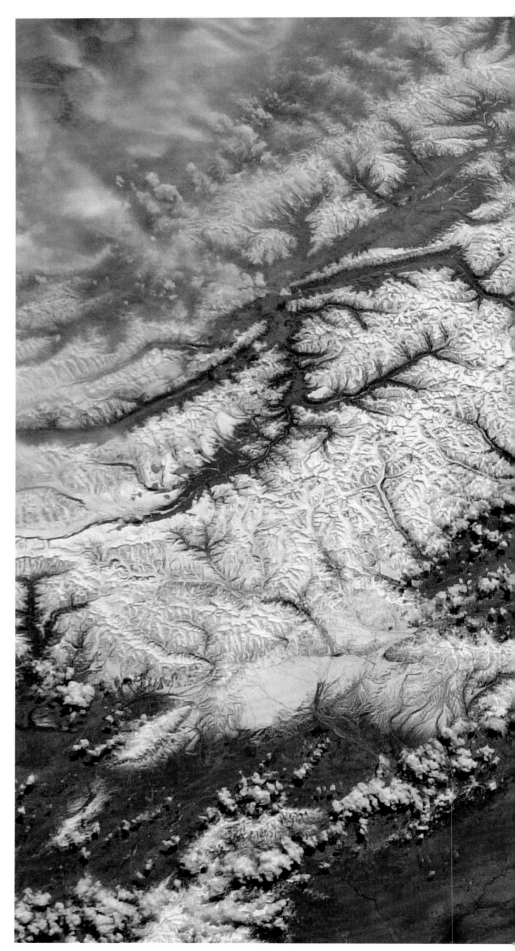

Kyrgyzstan. Wedged into a central Asian mountain range, the Tien Shan, Lake Issyk Kul is 113 miles long. Seen from orbit, it appears as a giant eye, looking at us looking at it. In winter the snow-covered mountains surrounding it become an old man's bushy eyebrows. The lake's waters are salty enough that they rarely freeze over, and reflect winter light in such a way as to make a pupil that seems to track us as we orbit overhead.

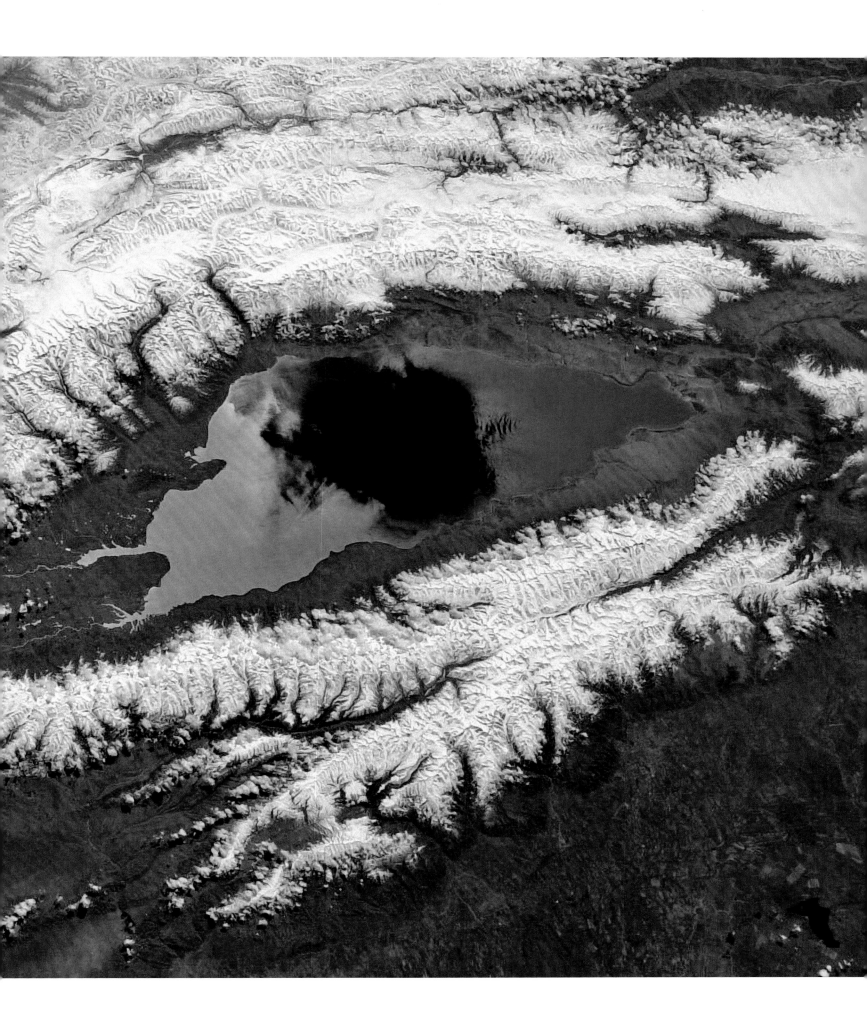

Total annular solar eclipse on May 20, 2012, off the eastern coast of Kamchatka. Centuries ago astronomers accurately described the geometry of the Sun-Moon shadow projected on Earth, but only now do humans have the chance to observe this phenomena from on high. I have had the good fortune to observe two total solar eclipses from space, a vantage point that allows the shadow details of penumbra-umbra to be seen in relation to our planet. Perhaps one of these years I'll be in the right place at the right time to see a total solar eclipse from Earth.

BLACK & WHITE

We are accustomed to seeing intensely colored
photographs from space, scenes that present
themselves as saturated treats for the eyes. Such
brilliant images are central to any orbital photo essay.
But if you strip away the colors, leaving only tones
of black and white, the eyes discover new pleasures.
Deprived of color, the mind searches for other details
where new perspectives come into focus..

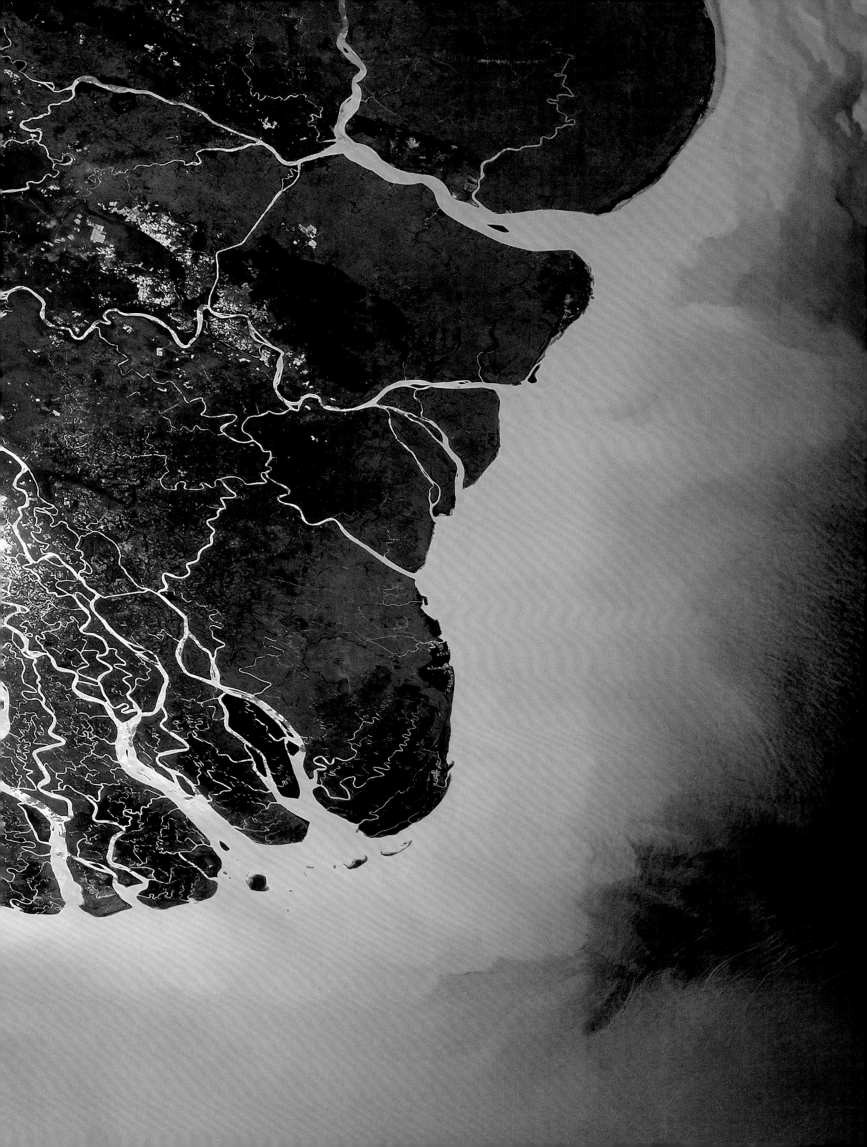

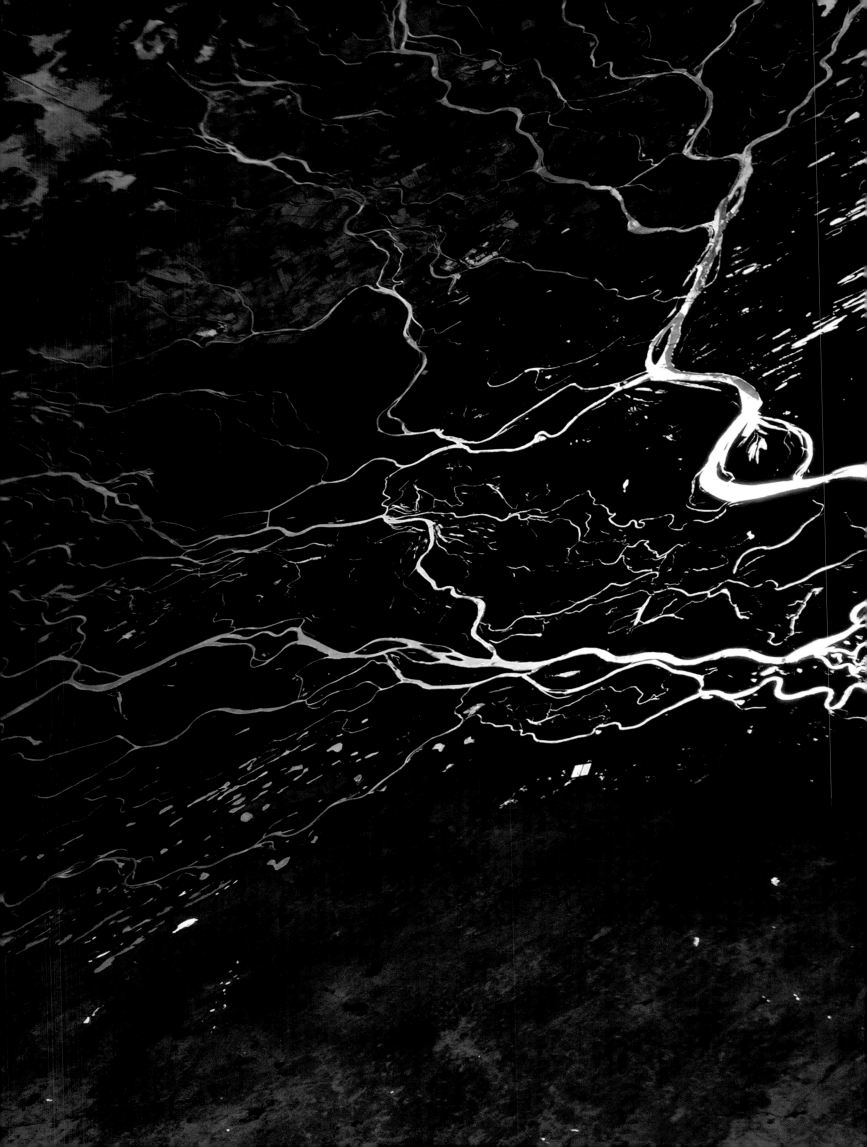

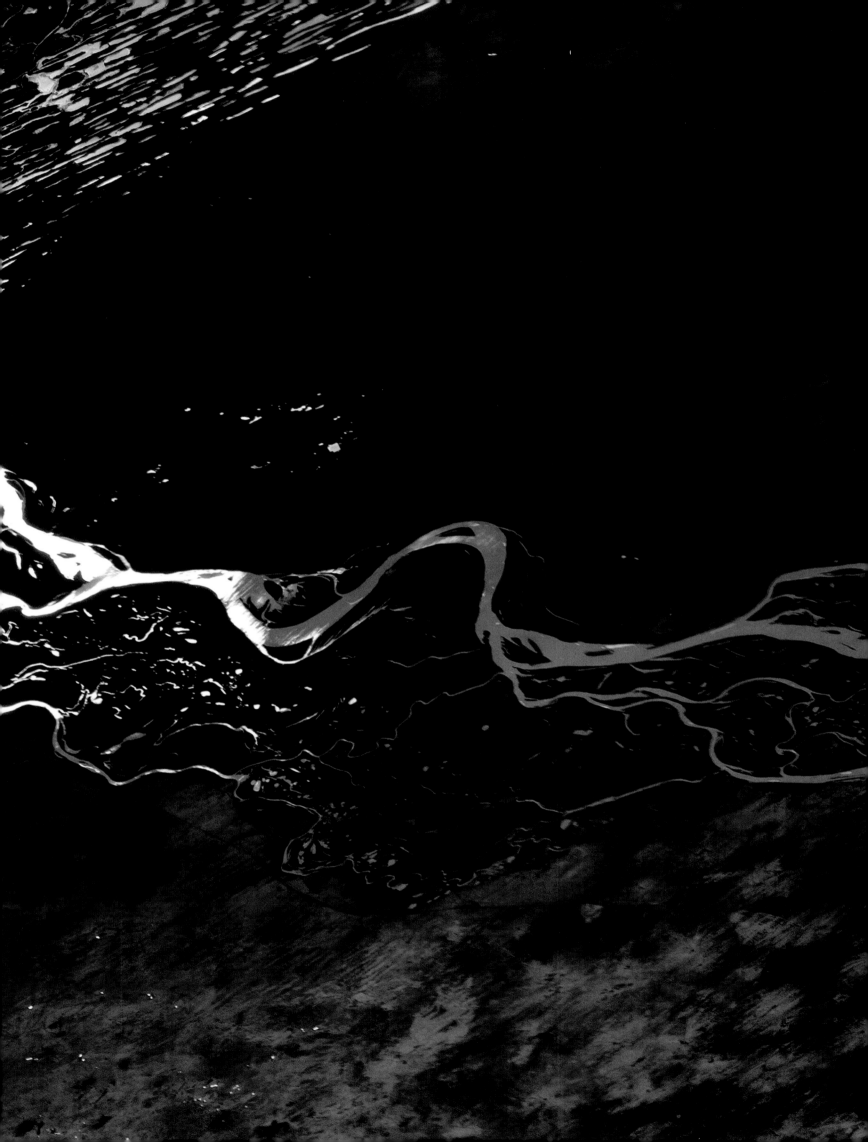

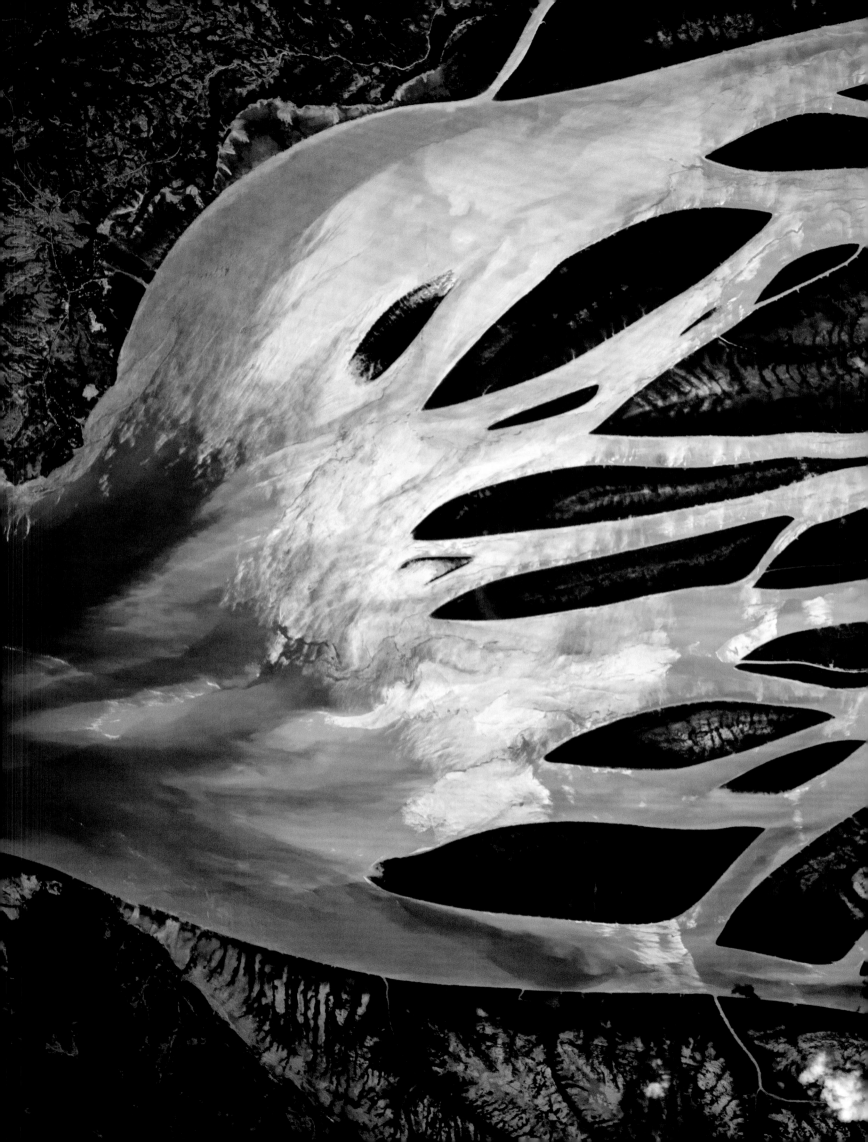

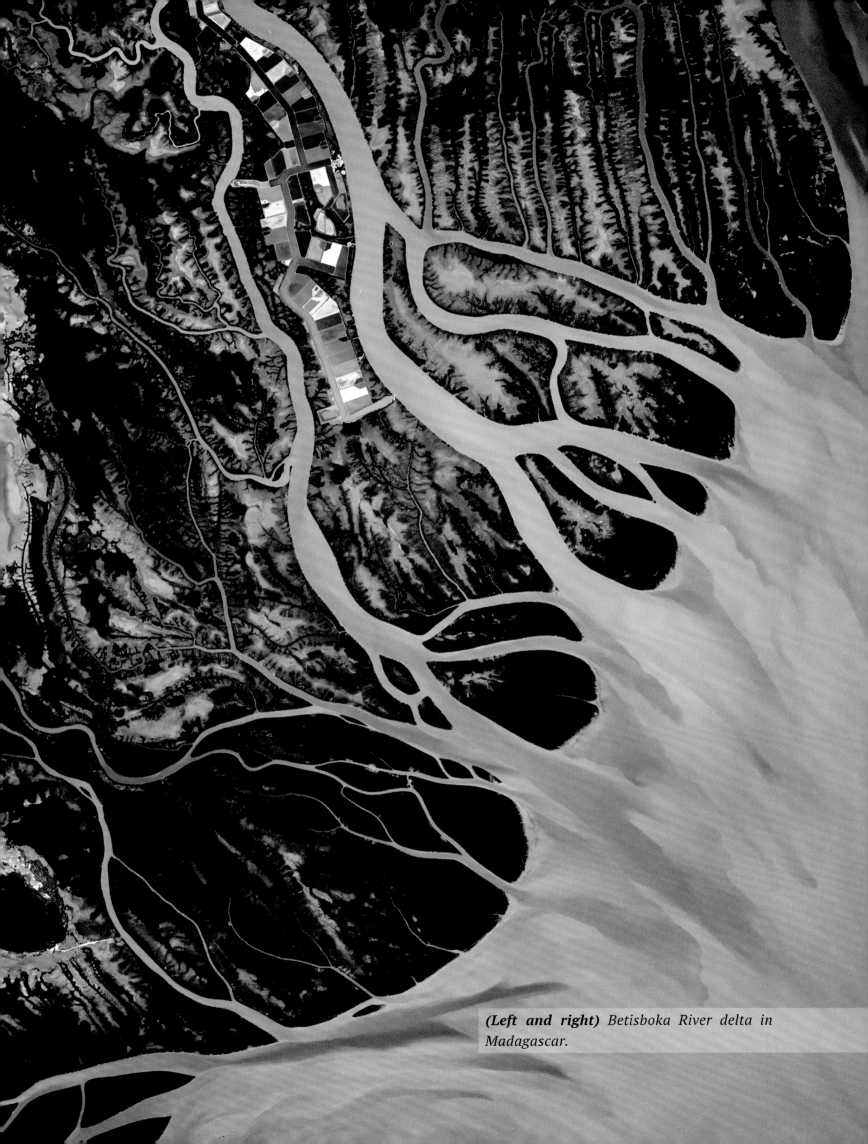

(Left and right) Betisboka River delta in Madagascar.

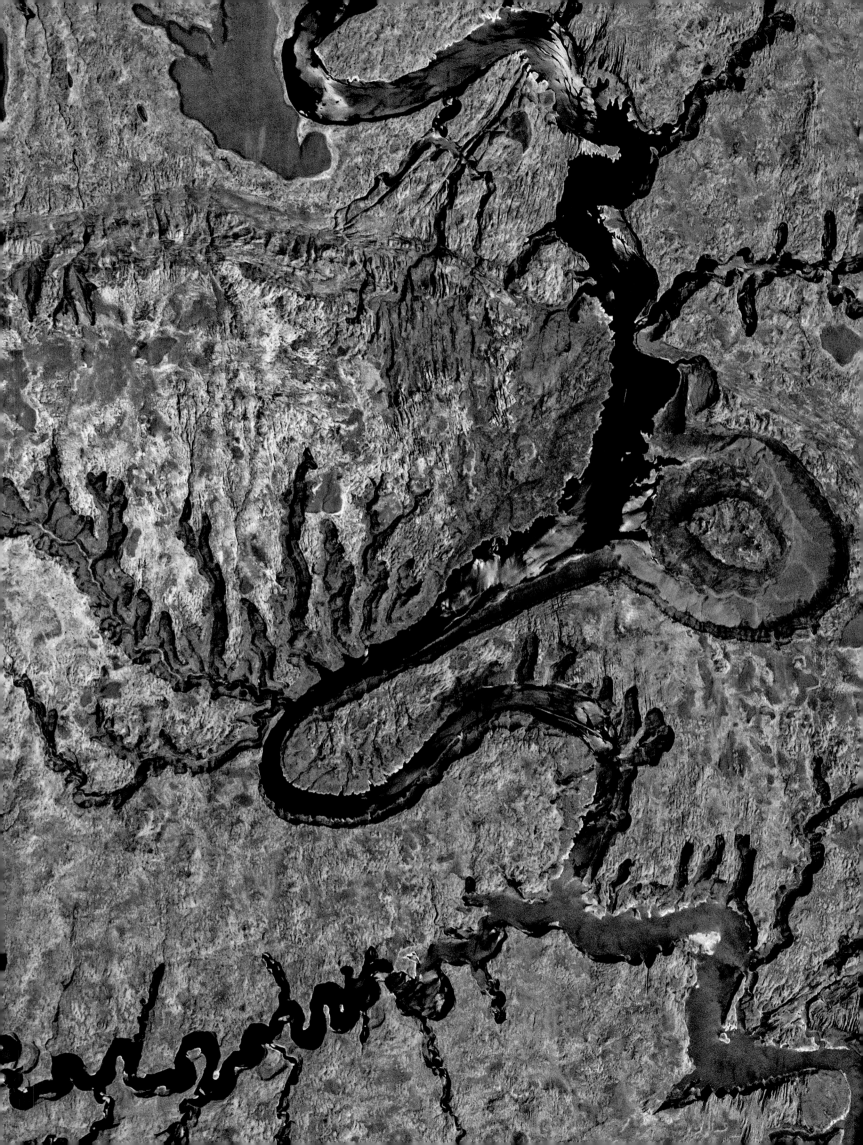

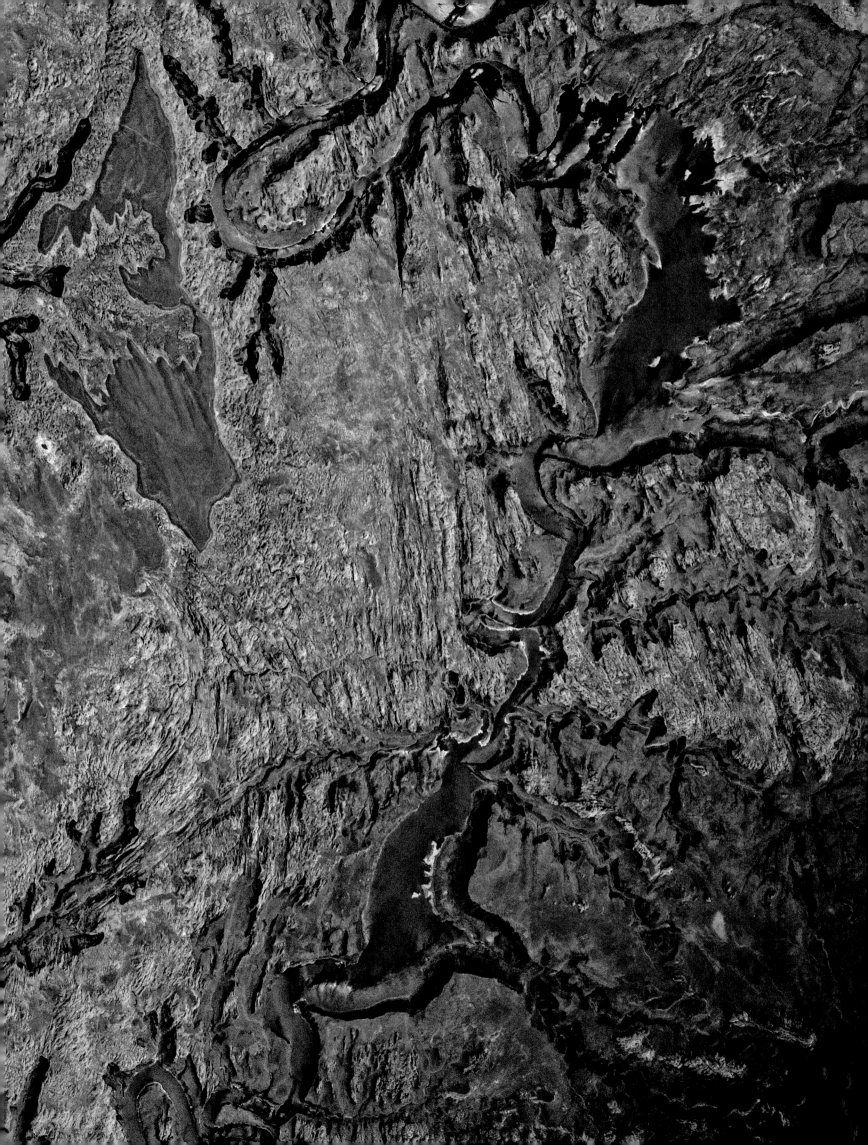

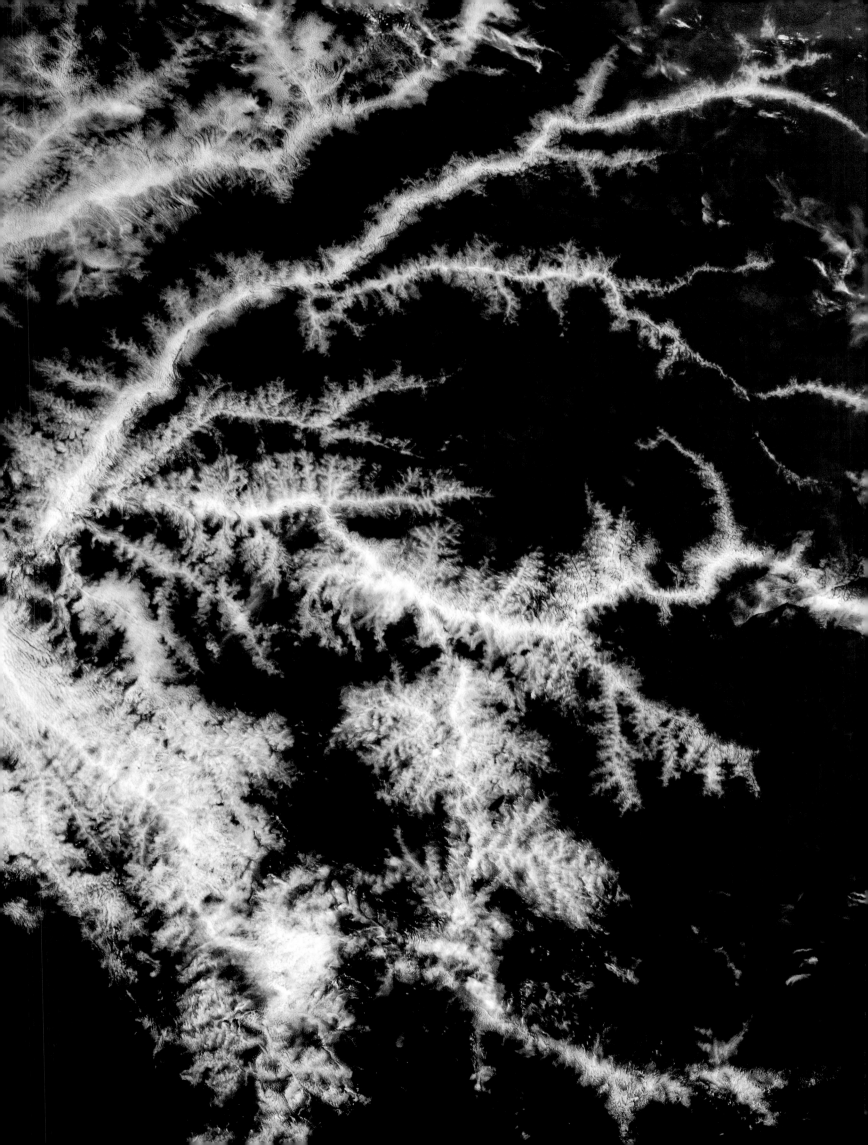

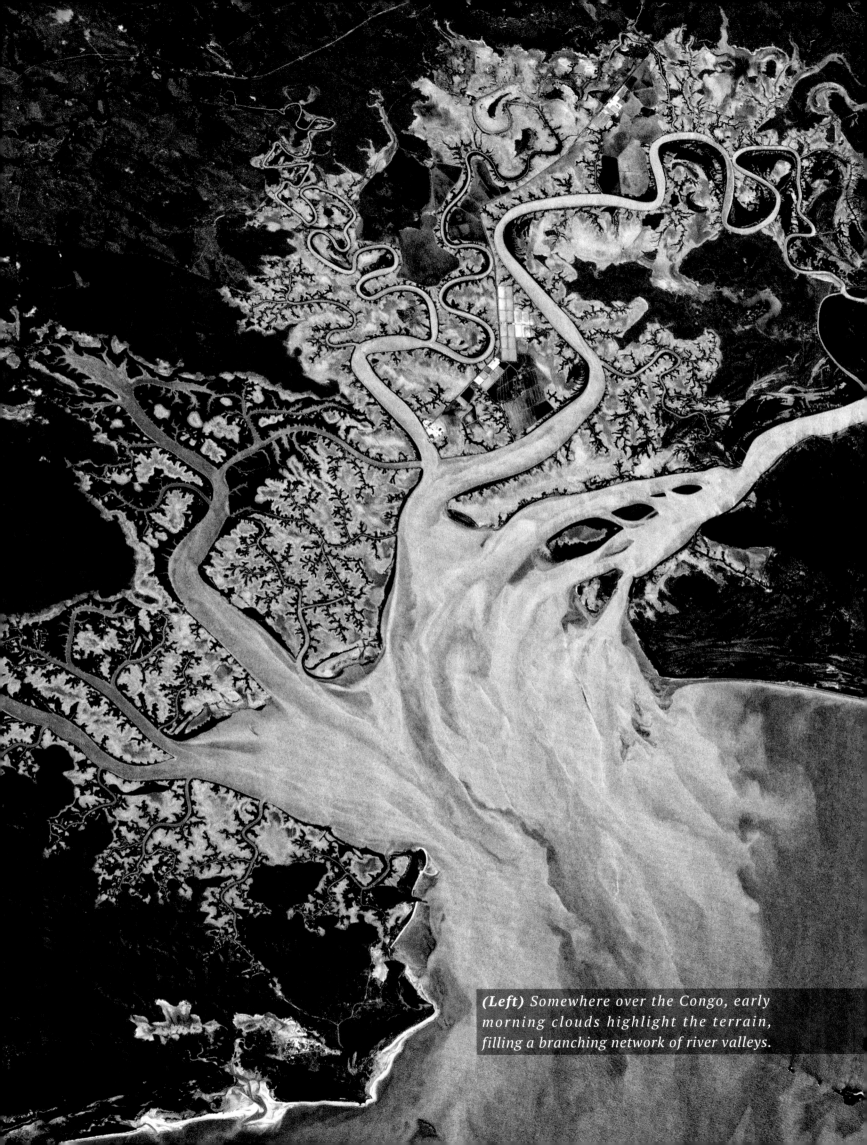

(Left) *Somewhere over the Congo, early morning clouds highlight the terrain, filling a branching network of river valleys.*

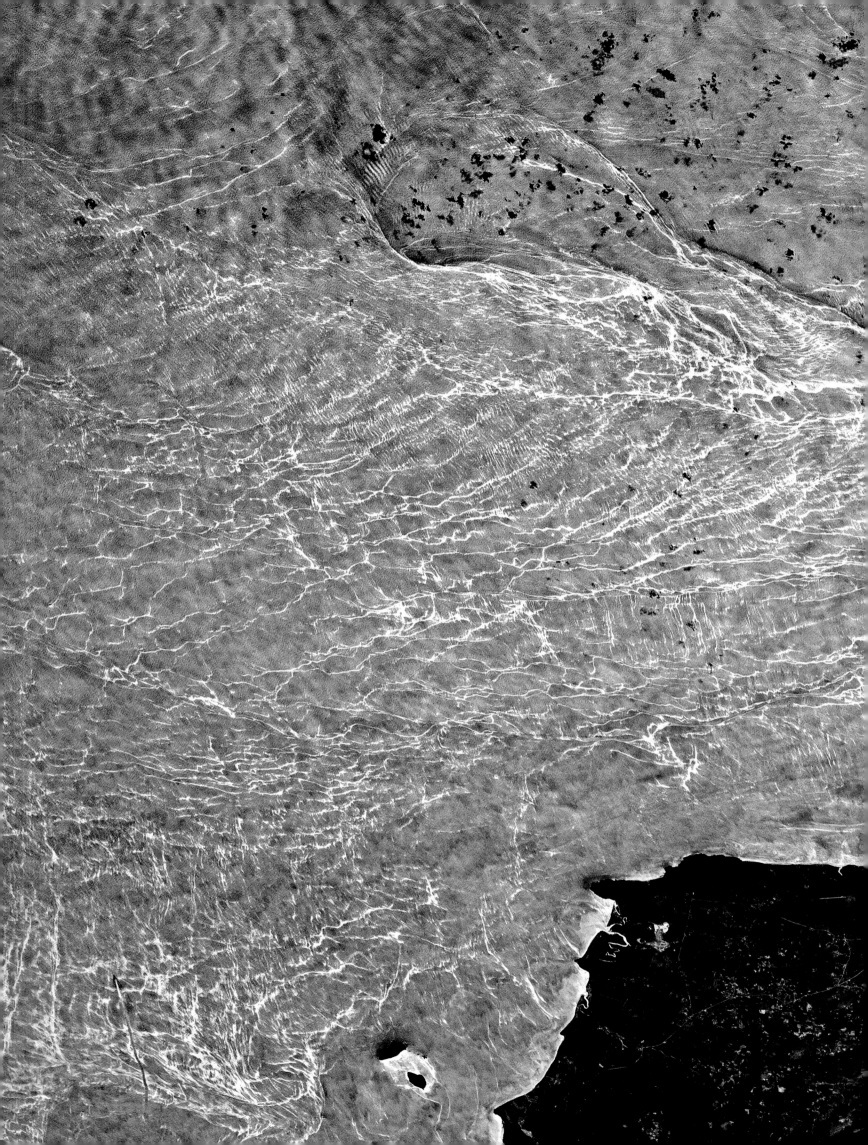

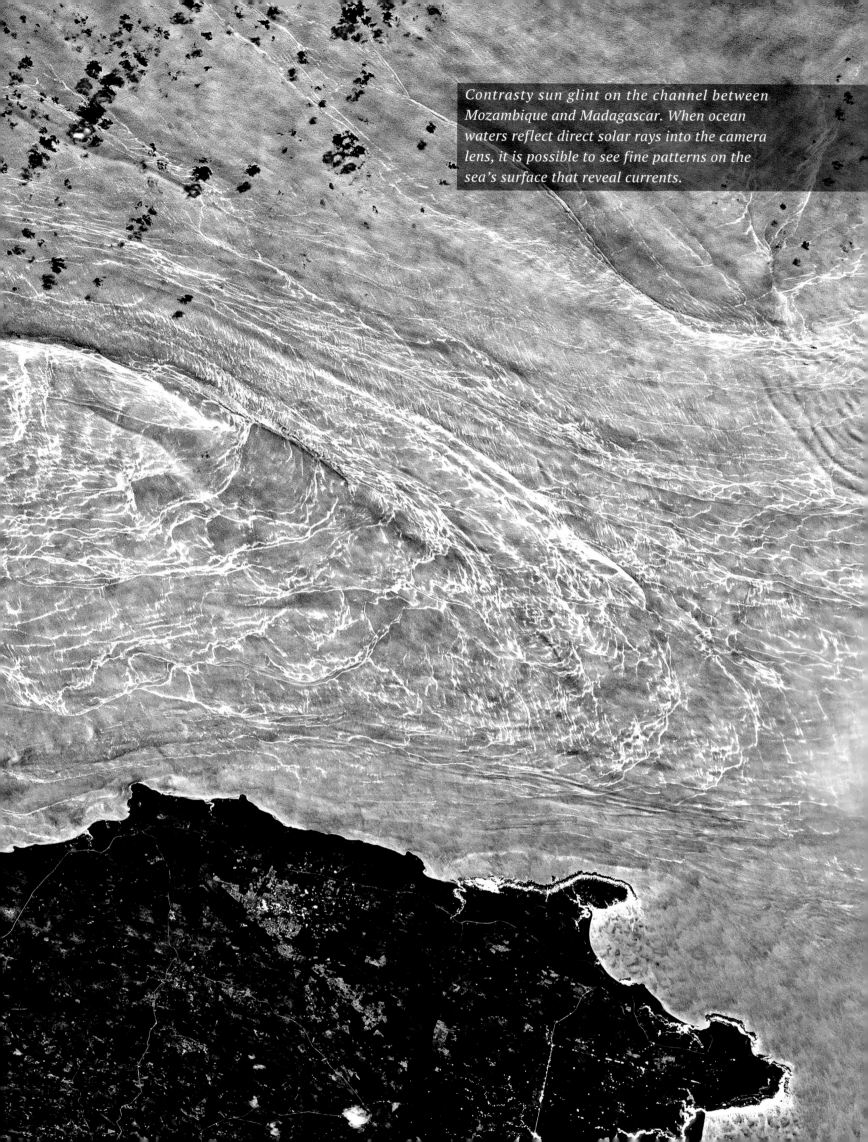

Contrasty sun glint on the channel between Mozambique and Madagascar. When ocean waters reflect direct solar rays into the camera lens, it is possible to see fine patterns on the sea's surface that reveal currents.

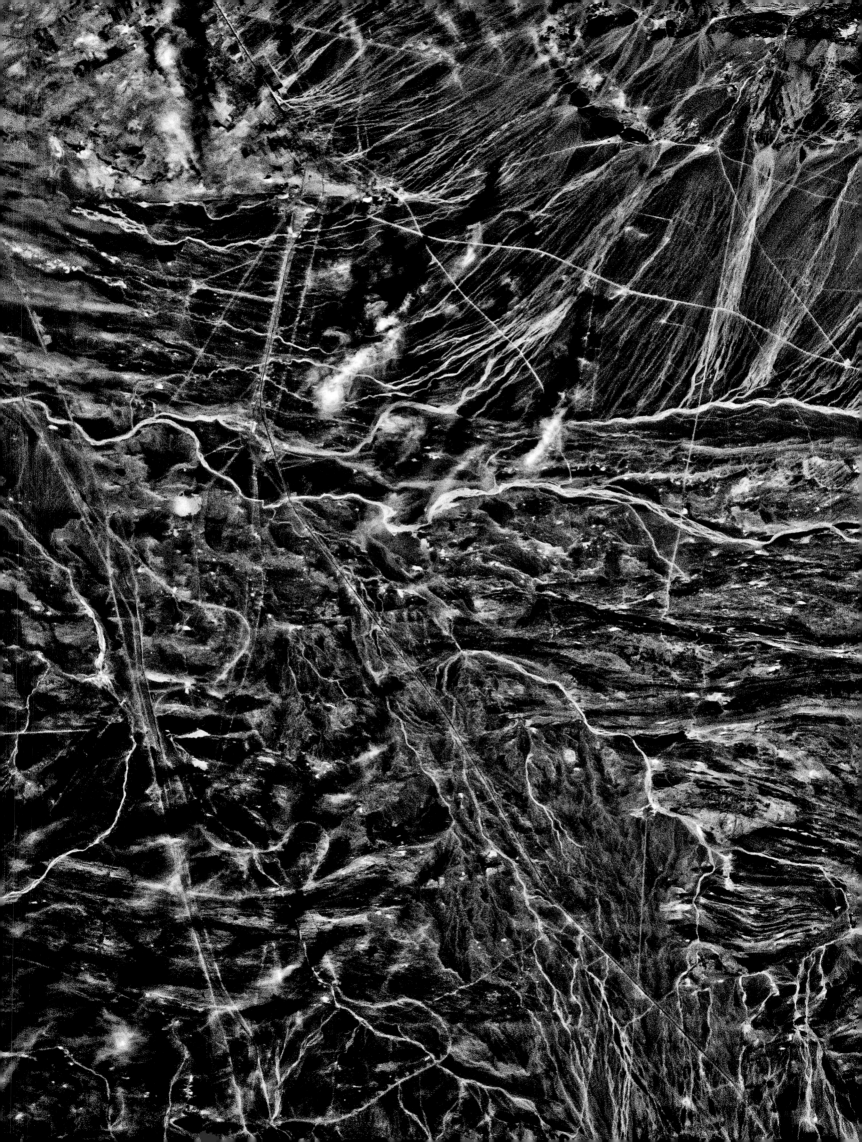

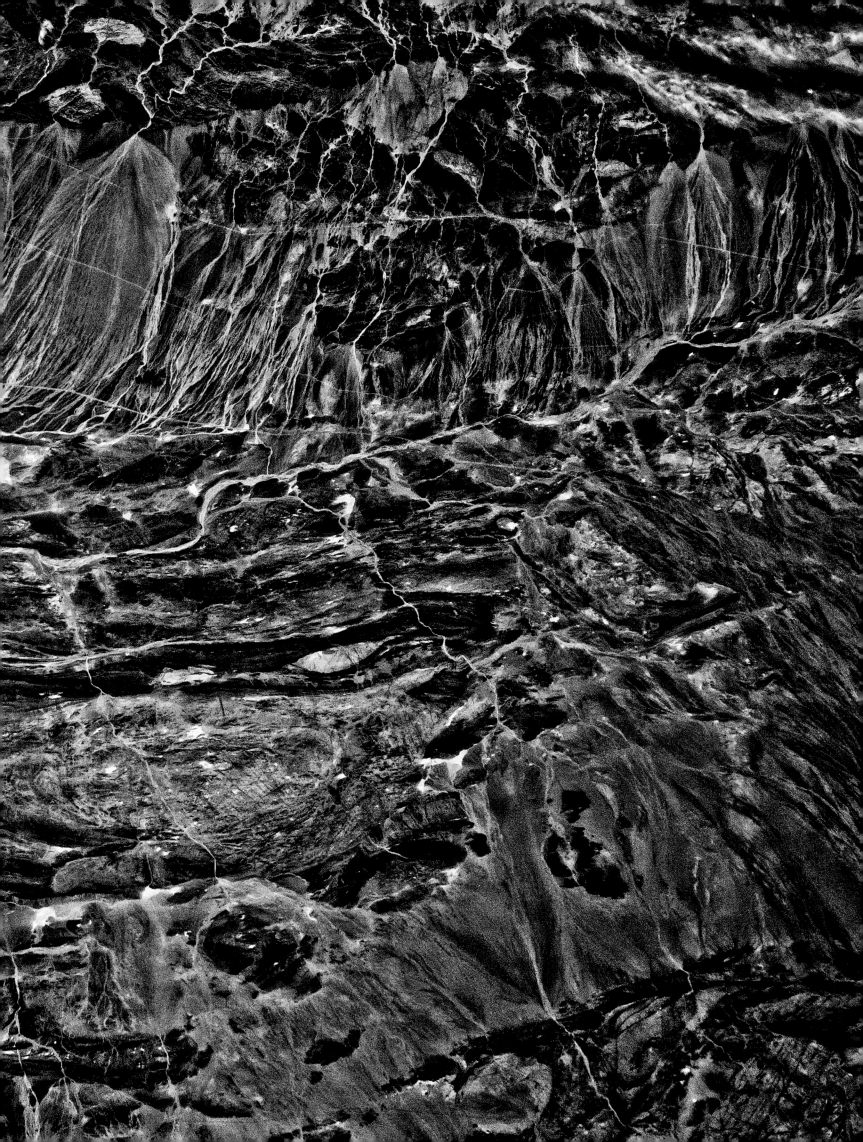

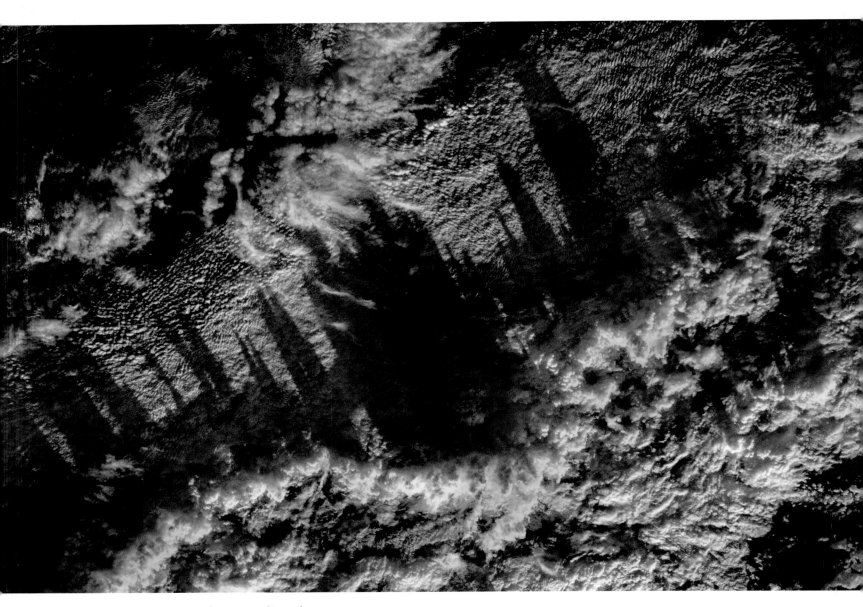

(Previous spread) Mongolian desert.

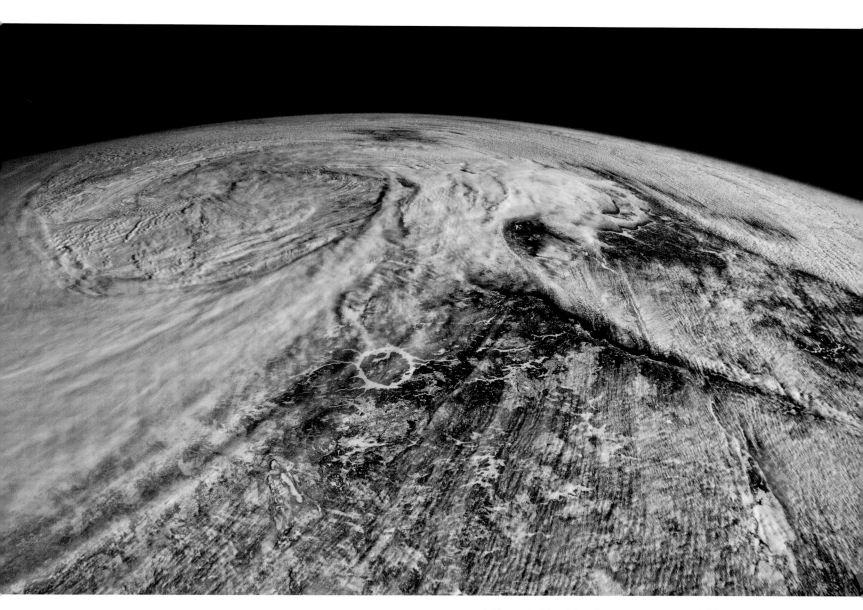

(**Above**) *The Manicouagan asteroid impact crater, approximately 40 miles across, near the mouth of the St. Laurence River, Quebec, Canada.*

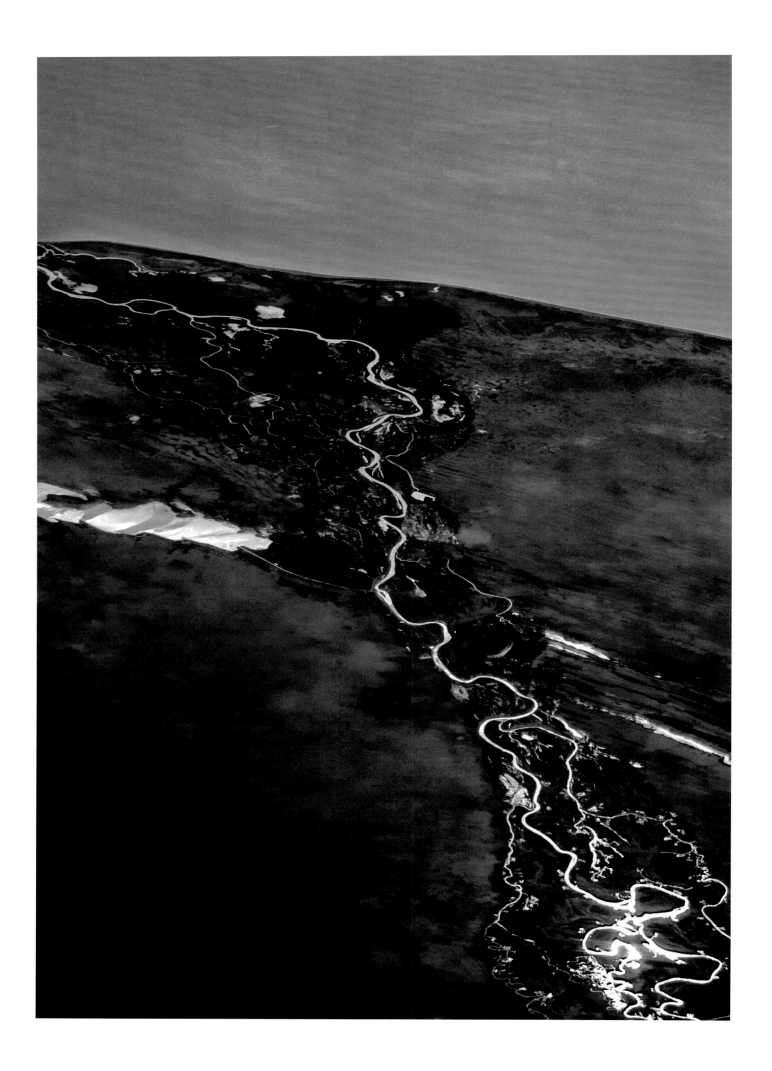

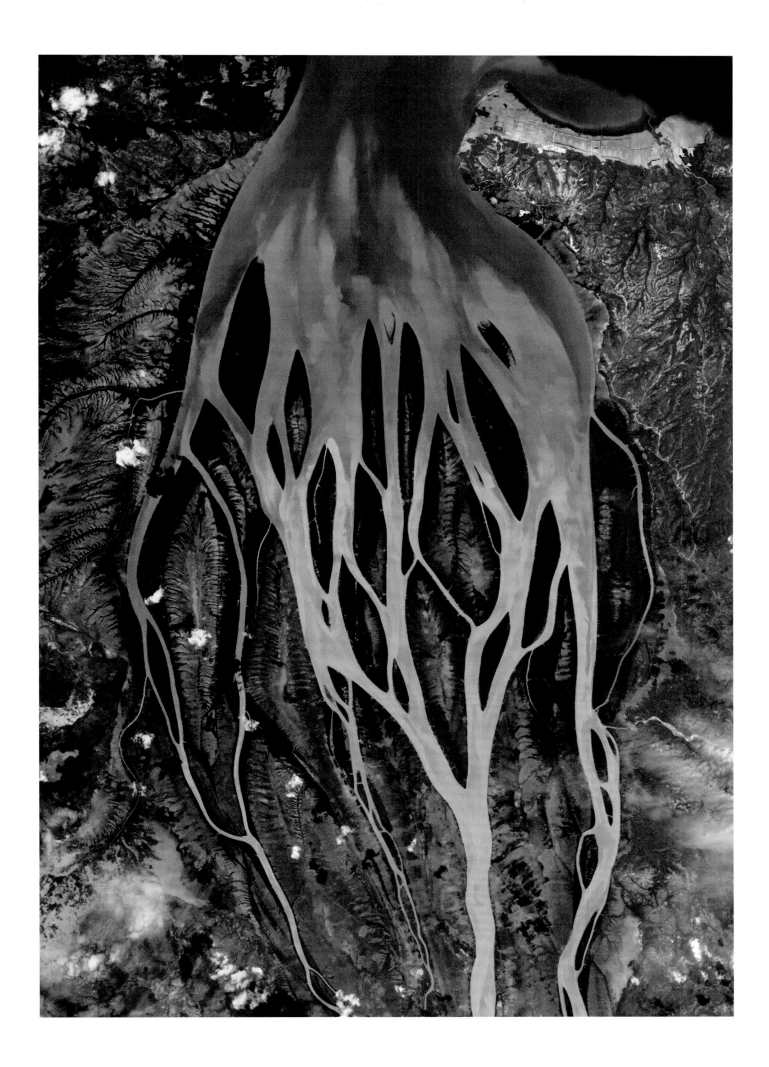

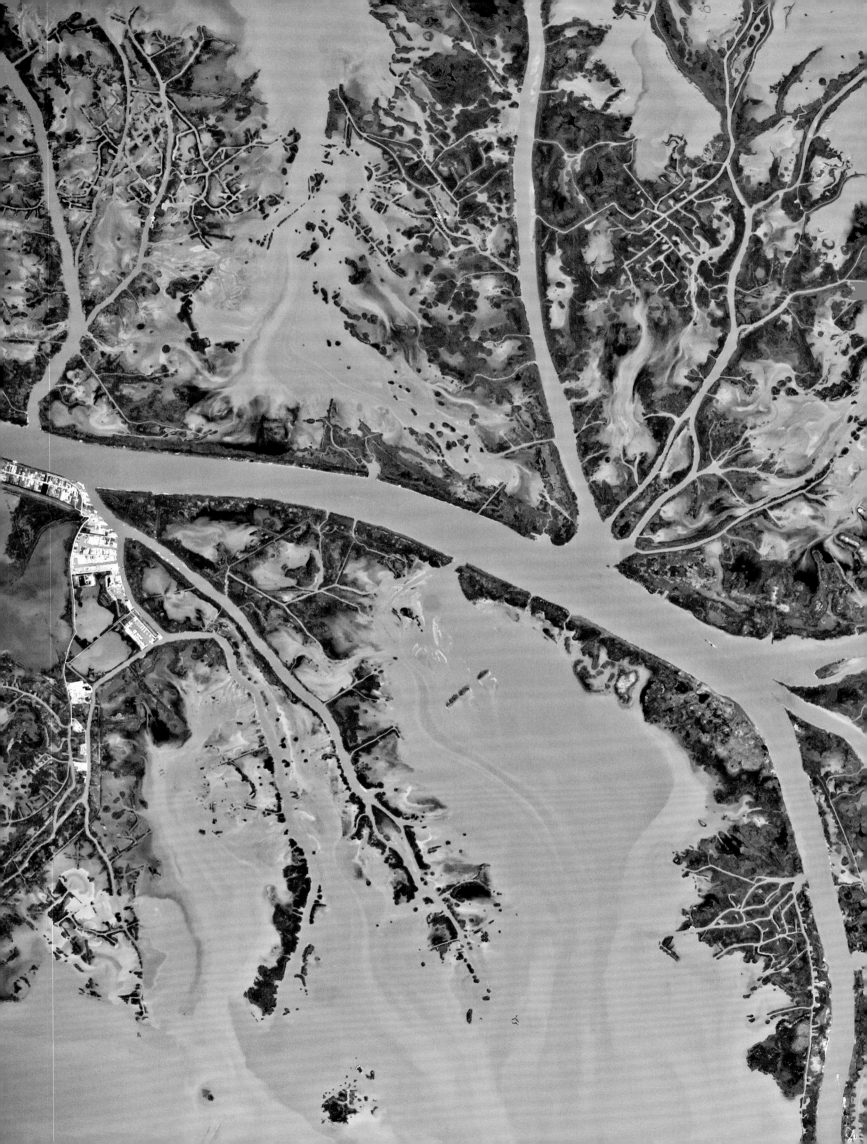

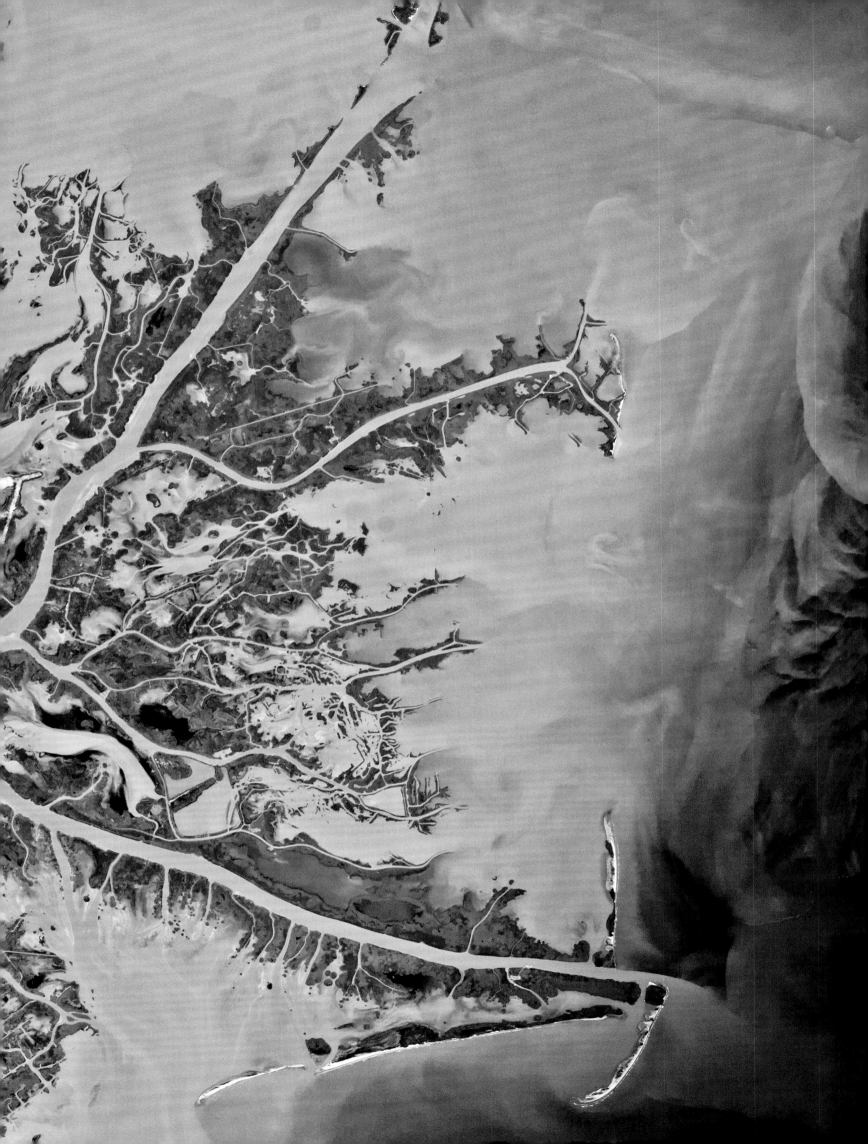

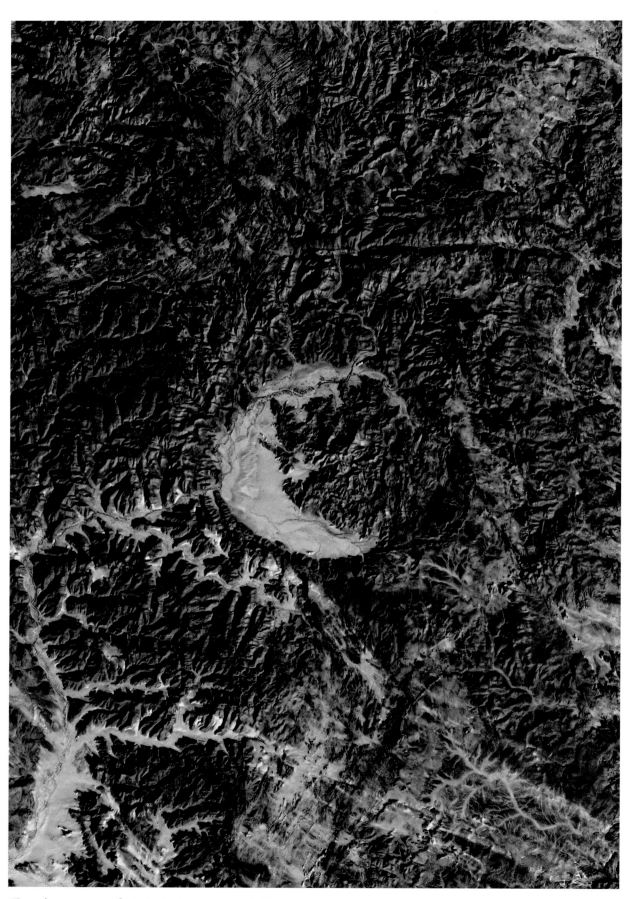

(Previous spread) Mississippi River delta.

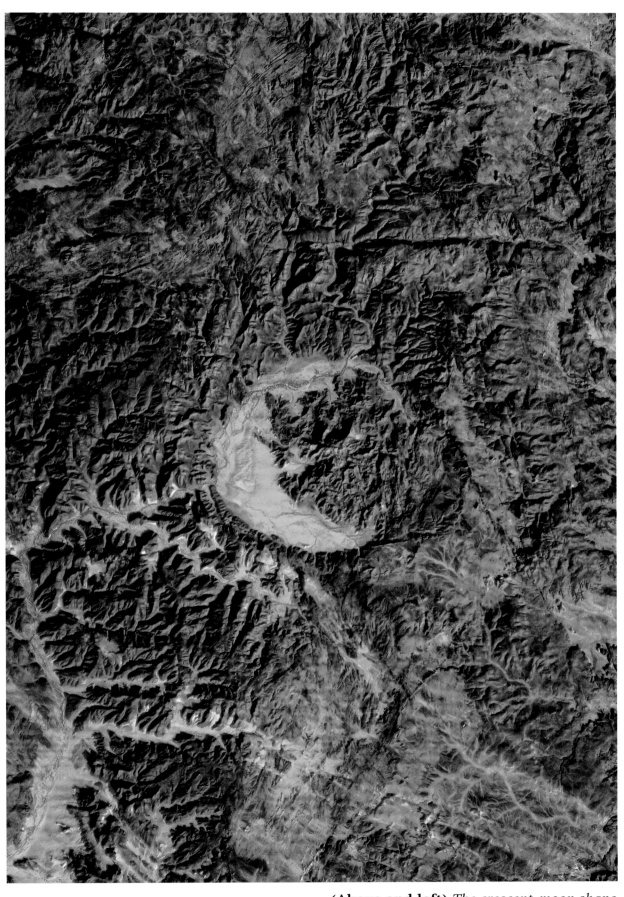

(Above and left) *The crescent-moon shape of the Gweni Fada asteroid impact crater, in the central African desert of Chad; black and white (L); infrared (R).*

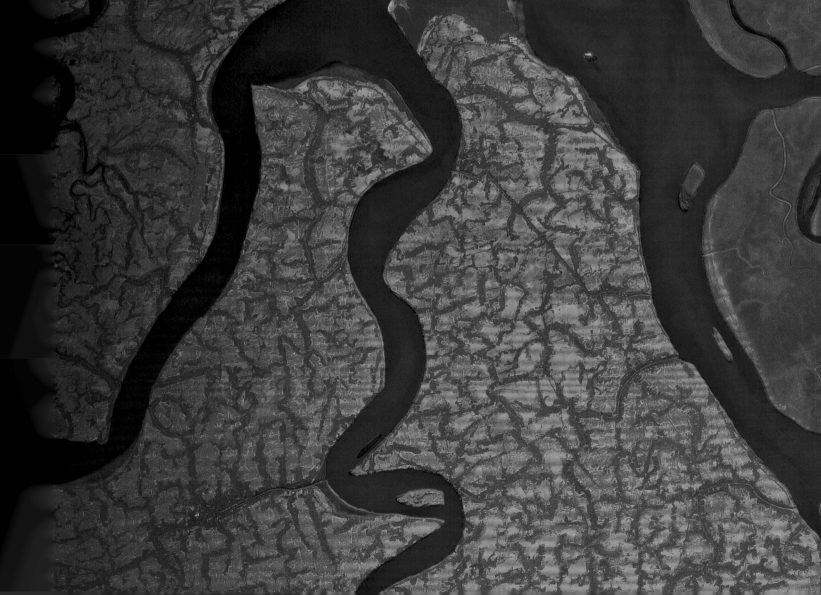

INFRARED

Human eyes can only see a limited slice of the full electromagnetic spectrum. Just beyond what we see as deep red at one end of our "visible spectrum" is infrared radiation, wavelengths that are rich with information about our environment, but escape our detection. Clever scientists have figured out how to record images in infrared with special film. With no idea what the various infrared wavelengths should "look" like, colors that we can see were assigned to span the invisible range. Scientists refer to the radiation portraits thus captured as "false color" images. When nature is photographed with color infrared film, the results look like a painting collaboration by Van Gogh and Matisse. Color infrared photography vividly portrays plant communities, geologic structures, oceanic turbulence, coral reefs, and more. The vivid colors splashed across land- and sea-scapes offer scientific insights that had previously escaped our view.

The history of spaceborne photography has been colored, too, by tragedy. On February 1, 2003, I was on the International Space Station as a member of the Expedition 6 crew. That was the day the Space Shuttle Columbia, STS-107 burned up during its return to Earth. All seven astronauts aboard perished. U.S. space shuttles remained grounded for more than two years while the accident was investigated and NASA engineers fixed the problem. The Expedition 6 mission was extended to nearly six months, and we returned to Earth on our Russian Soyuz spacecraft. The Soyuz also

suffered a minor malfunction during entry, causing us to ballistically return. Basically we became a person-packed meteorite, and missed our intended landing site by 300 miles.

Though my crewmates and I survived our rocky return, the mission extension was fatal for our photographs. Images on film are ruined by cosmic rays after a few months. Expedition 6 was the last mission to use film; all missions thereafter have relied on digital cameras, images from which can be downlinked as radio waves. With the passing of film, astronauts' ability to make color infrared photographs of Earth ended too. Or so it seemed.

For Expedition 30 in 2011, I asked that we fly with a special digital infrared camera, so astronauts could once again record the Earth with color infrared imagery. Dan Burbank, space station commander, mounted a normal camera together with the infrared camera so that visible and infrared images could be captured simultaneously. I took tens of thousands of paired photographs during our mission. In these infrared photographs, lush green plant life appears as bright orange-red. Generally, where there is water there are plants, and these areas are red. Rocky crags and other barren geologic structures appear as dark green to blue-grey. Turbulent oceanic currents become visible as whitish veils, and coral reefs glow a tie-dyed yellow-green. Clouds, snow, ice, and desert sand look much the same in both visible-light and infrared views.

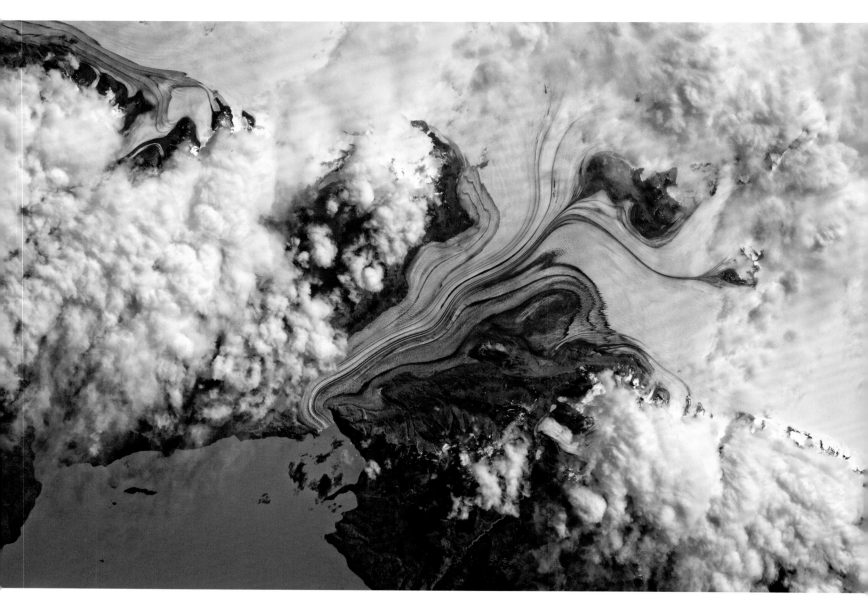

(Previous spread) Ganges River delta in
infrared, showing vibrant mangrove forests
in day-glow magenta and the encroachment
of farming in lighter red.

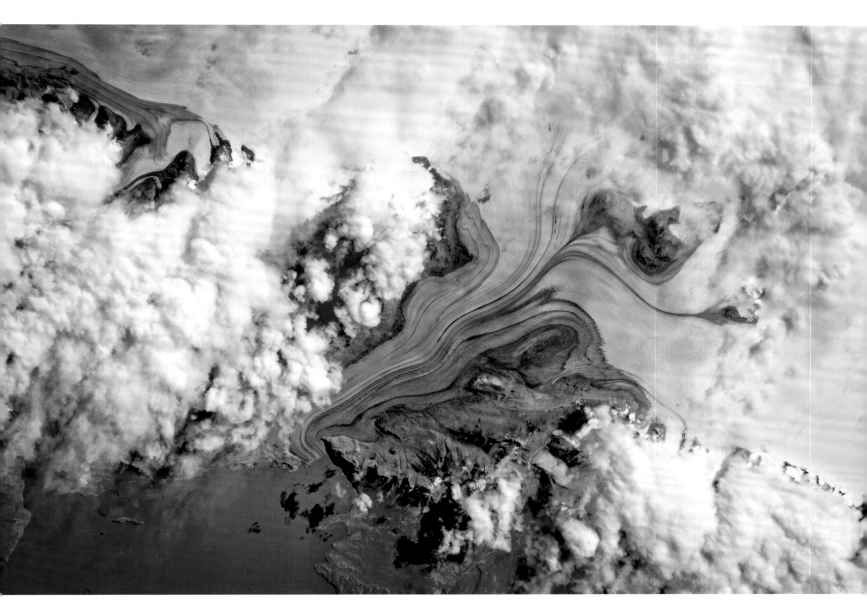

(Left and above) Patagonia glaciers;
normal color (L), infrared (R).

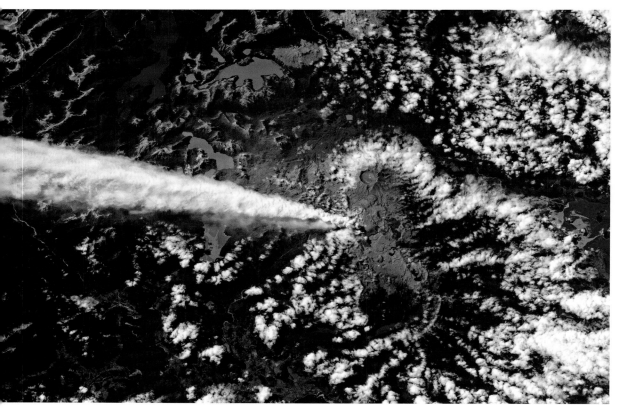

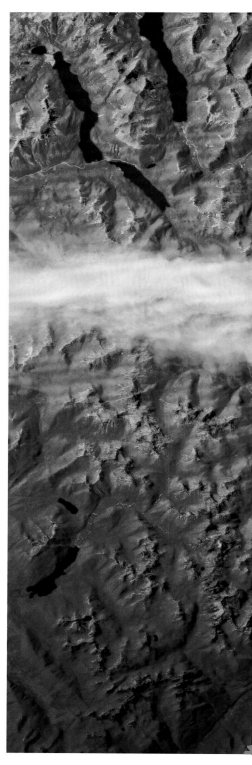

An erupting volcano in Patagonia in normal color (L), and infrared (R).

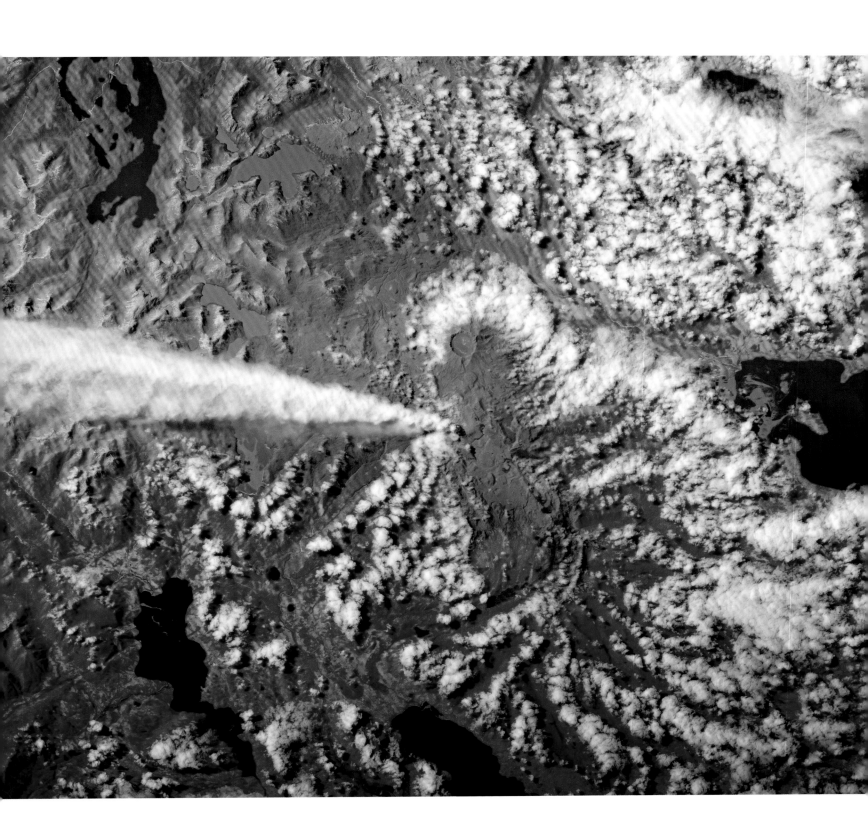

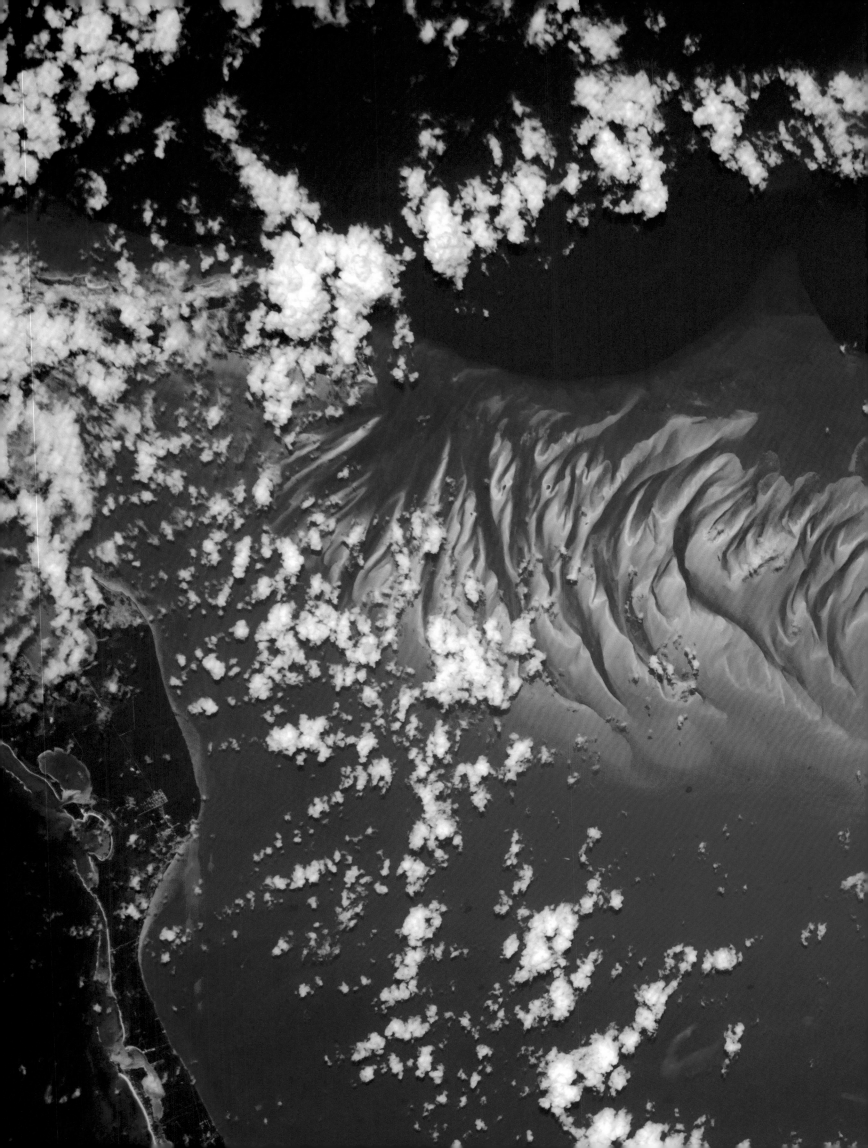

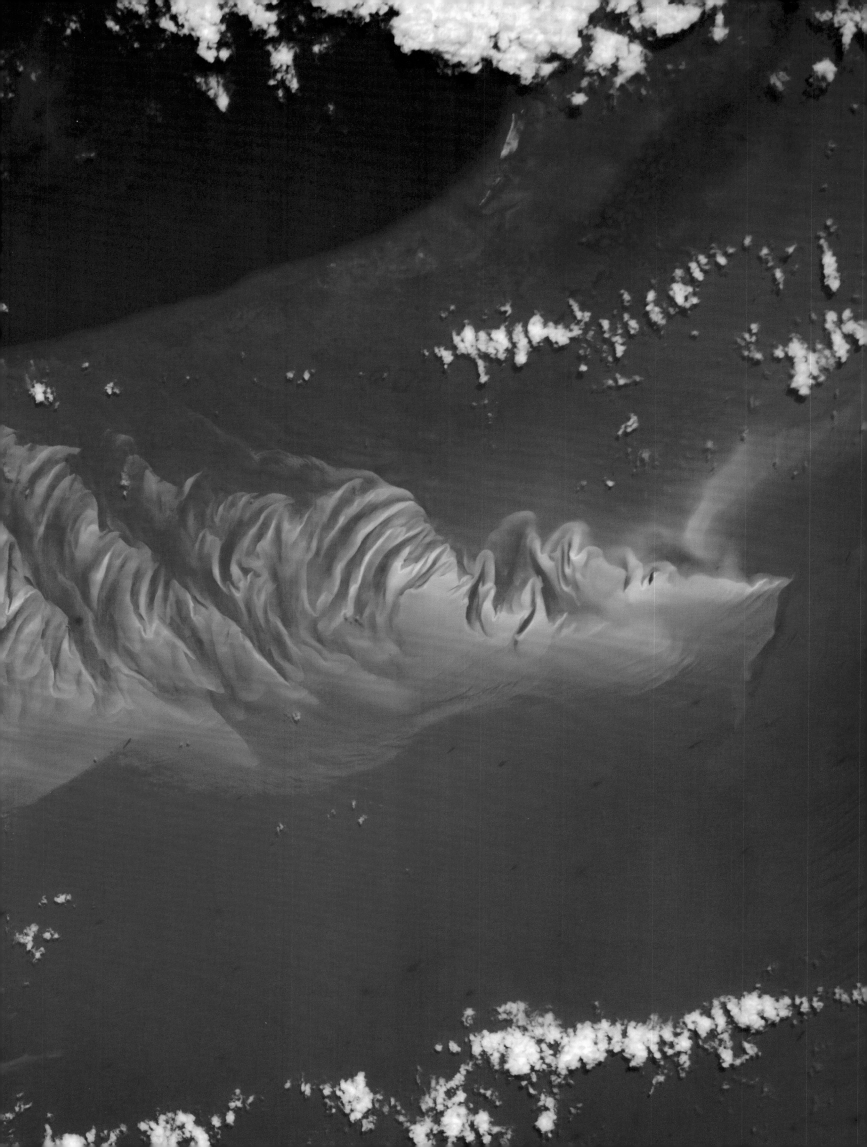

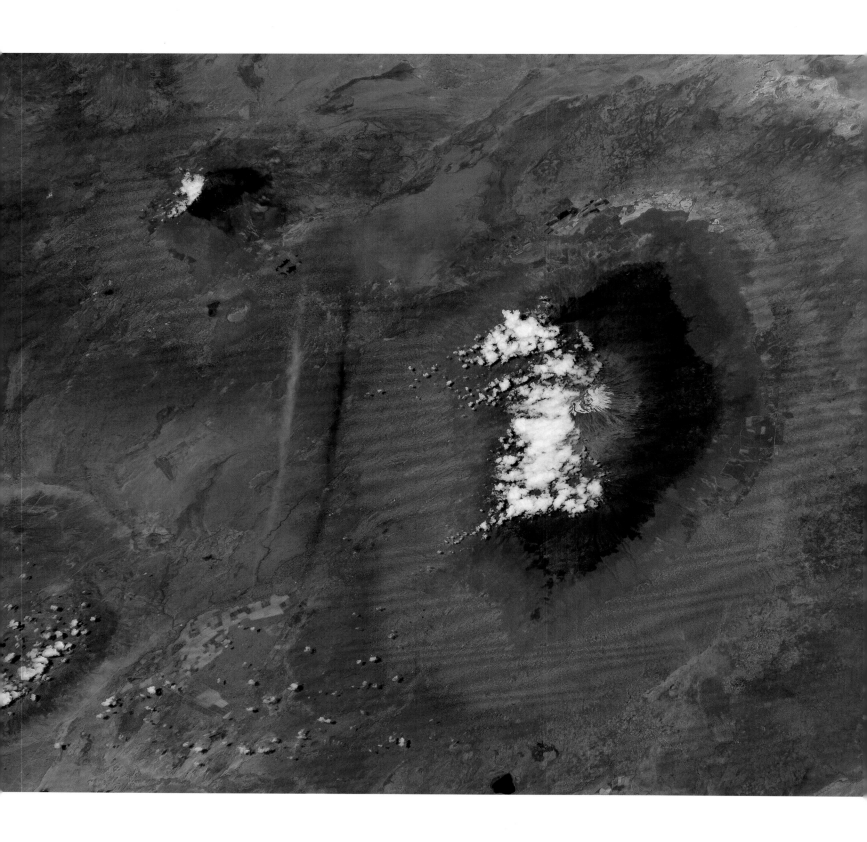

(Previous spread) Bahamas, underwater coral sand dunes in normal color.
(Left and below) Mount Kilimanjaro in Tanzania with stark color bands showing the altitude limits of different plant communities.

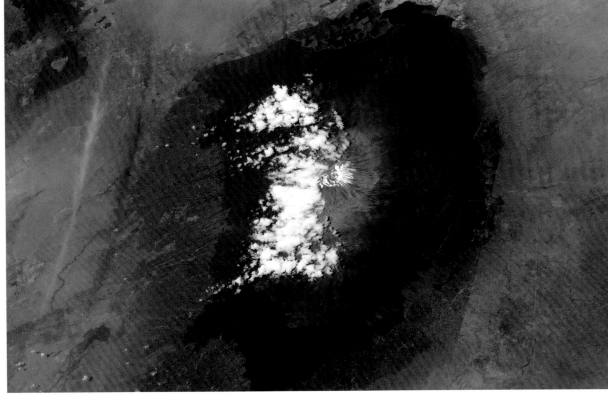

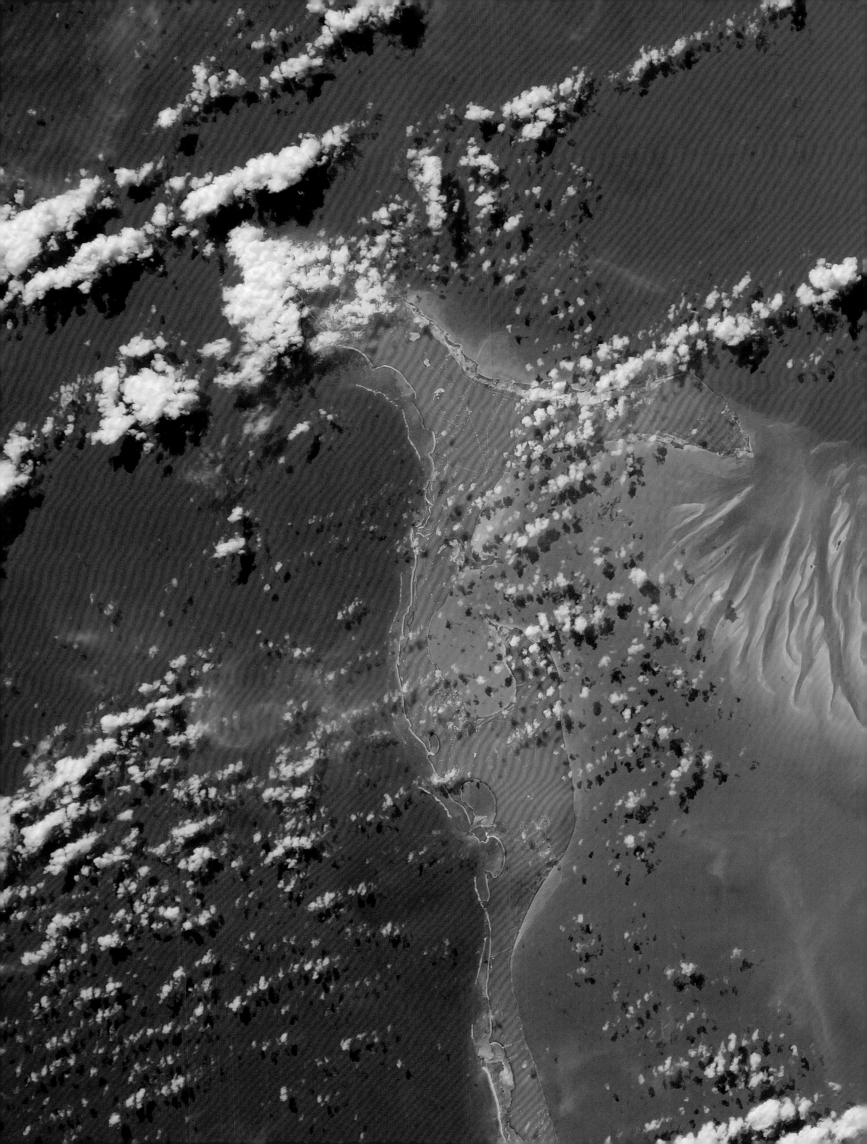

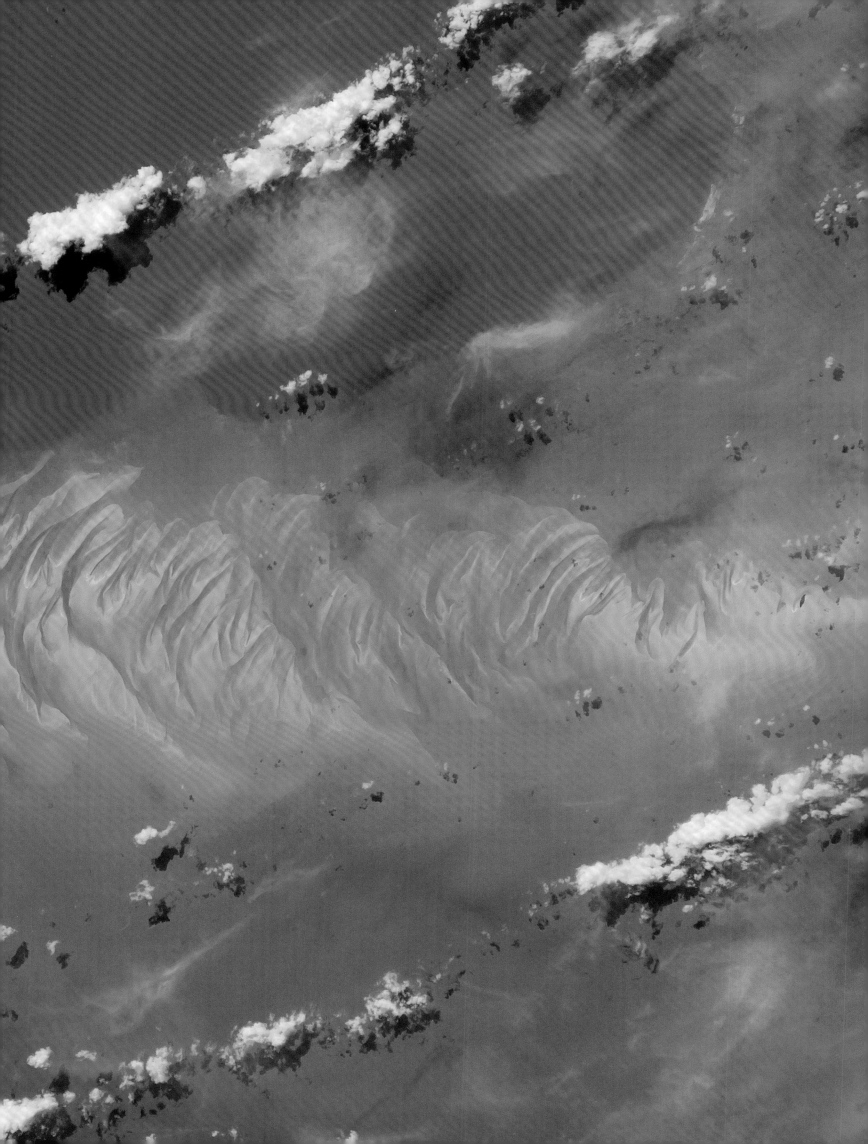

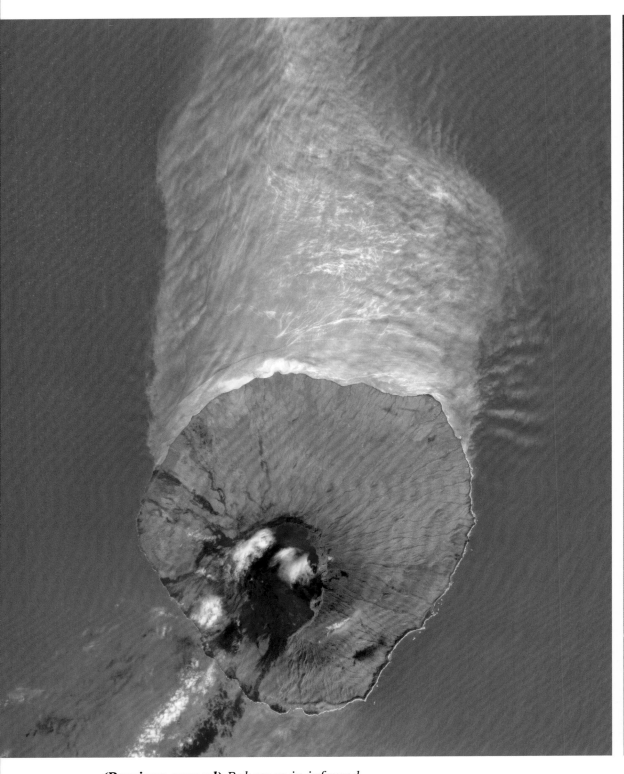

(Previous spread) Bahamas in infrared.

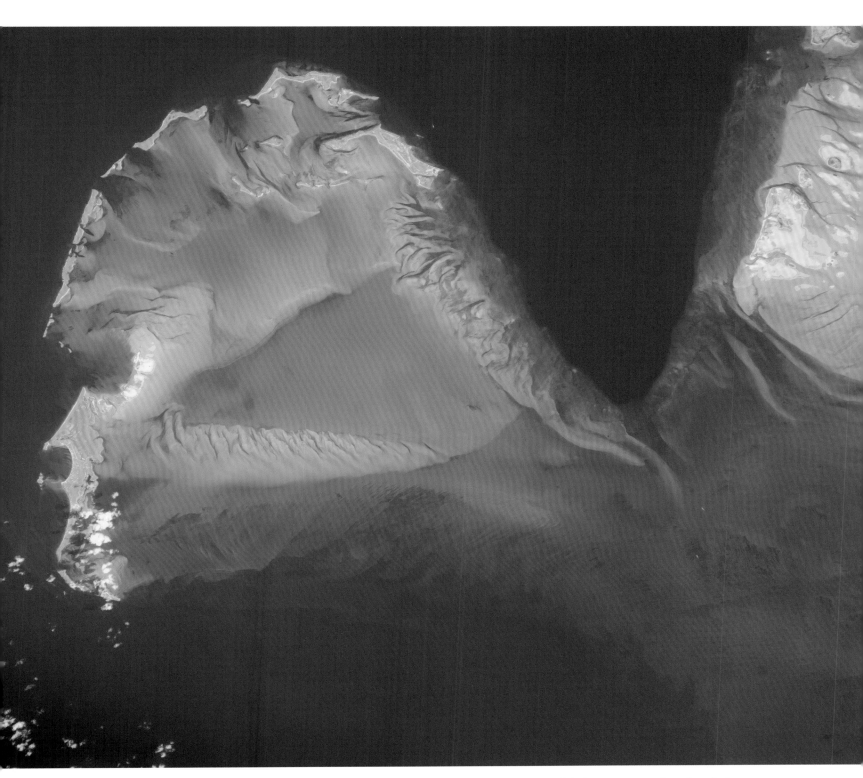

(Above and left) Cape Verde Islands in
infrared (L), Bahamas in infrared (R).

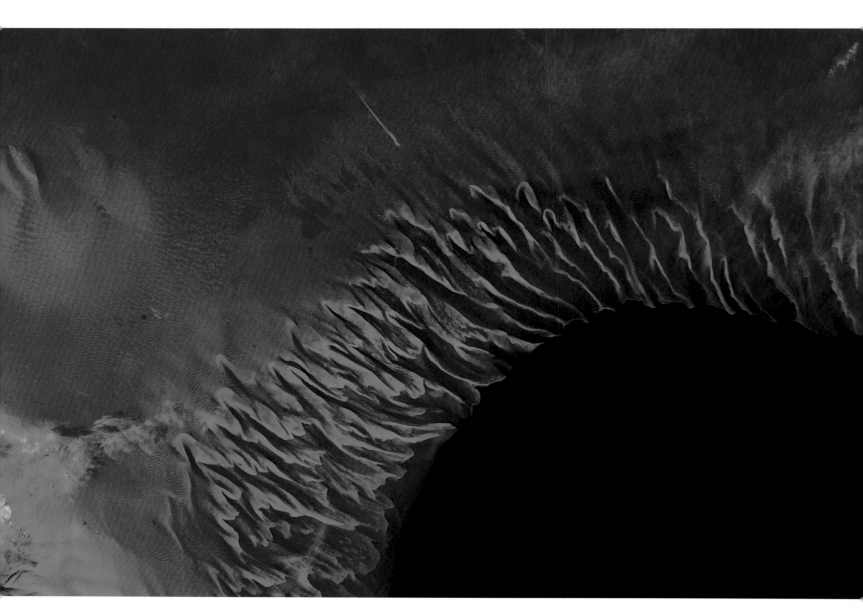

*Submerged coral sand dunes in the Bahamas,
infrared (L) and normal color (R).*

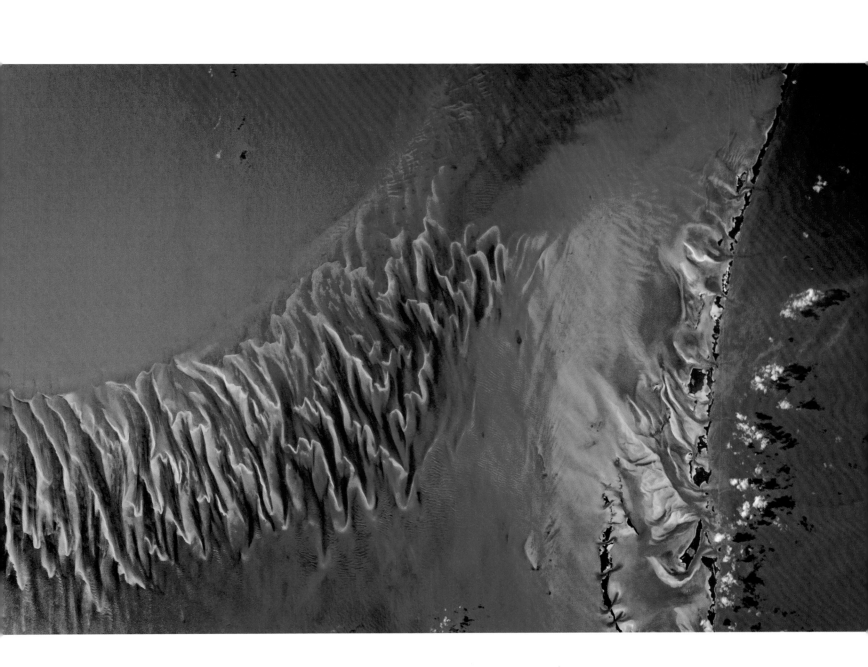

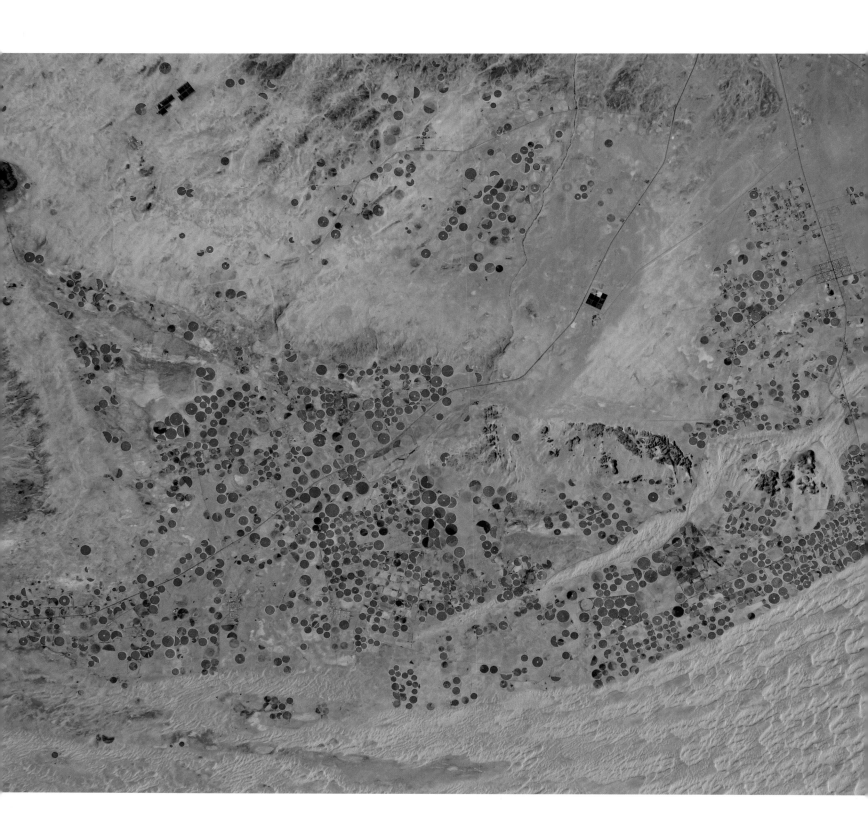

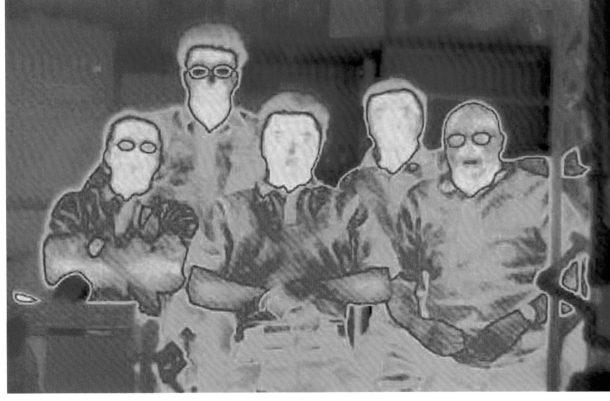

(Left) Salton Sea area in California dominated by circles of irrigated agricultural land surrounded by desert.
(Below) Expedition 31 crew portrait.

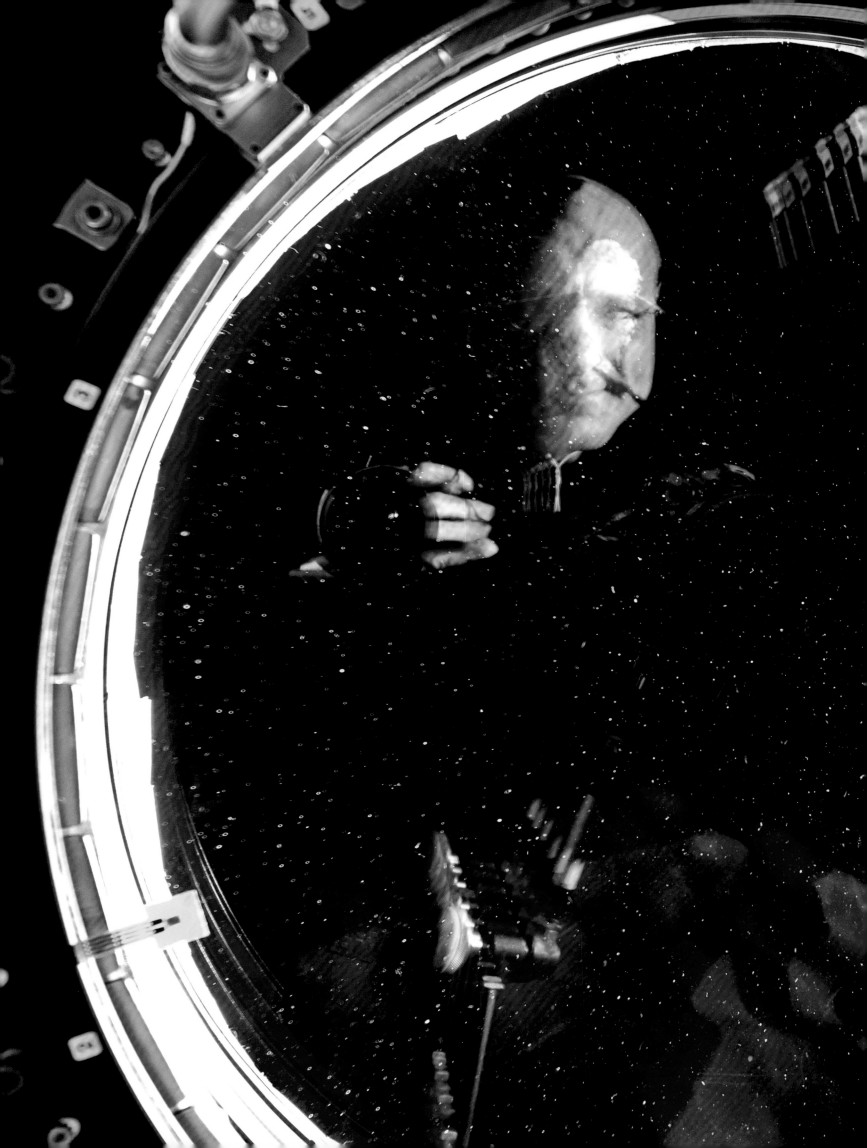

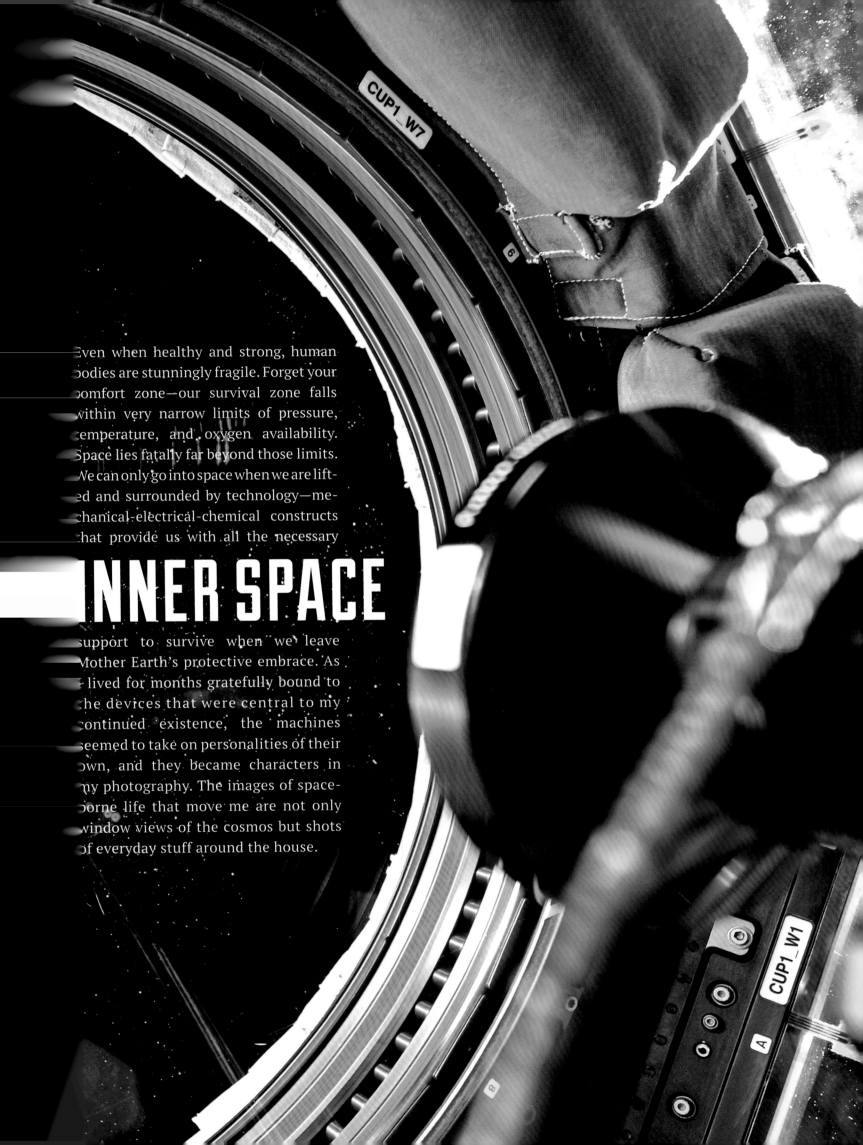

Even when healthy and strong, human bodies are stunningly fragile. Forget your comfort zone—our survival zone falls within very narrow limits of pressure, temperature, and oxygen availability. Space lies fatally far beyond those limits. We can only go into space when we are lifted and surrounded by technology—mechanical-electrical-chemical constructs that provide us with all the necessary

INNER SPACE

support to survive when we leave Mother Earth's protective embrace. As I lived for months gratefully bound to the devices that were central to my continued existence, the machines seemed to take on personalities of their own, and they became characters in my photography. The images of space-borne life that move me are not only window views of the cosmos but shots of everyday stuff around the house.

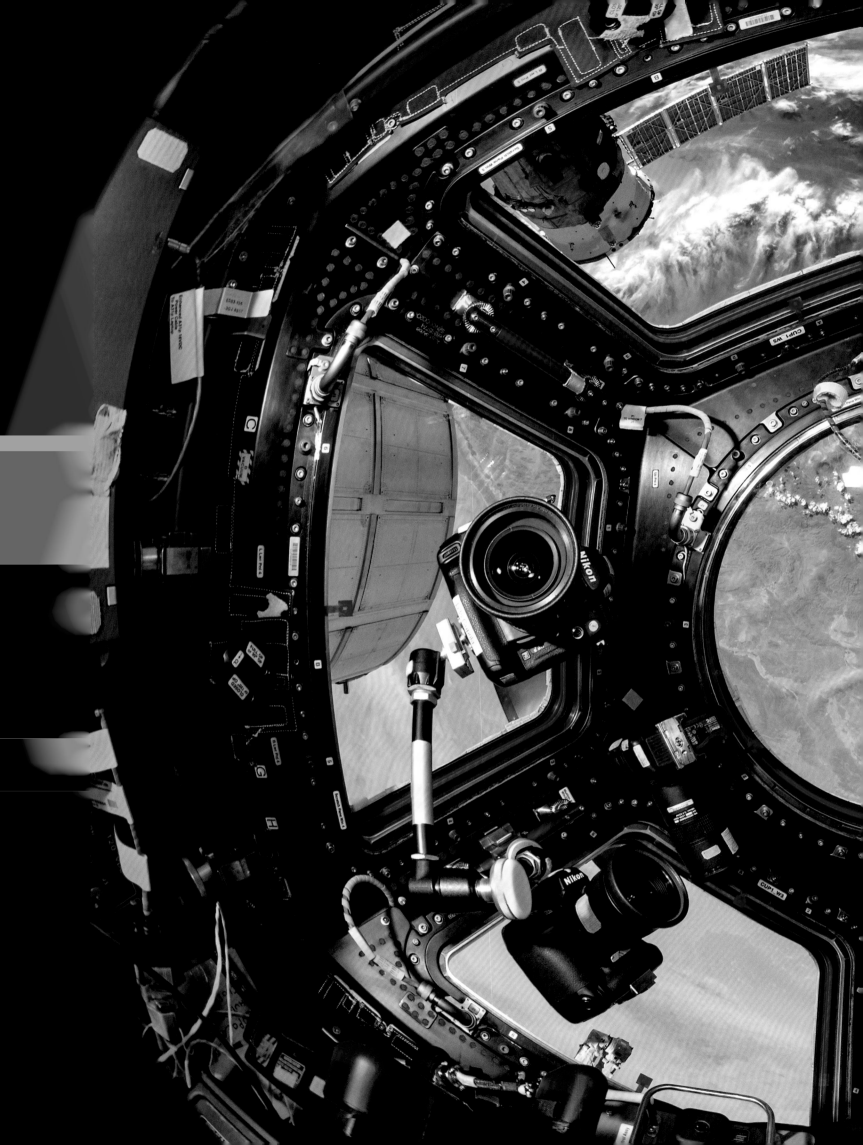

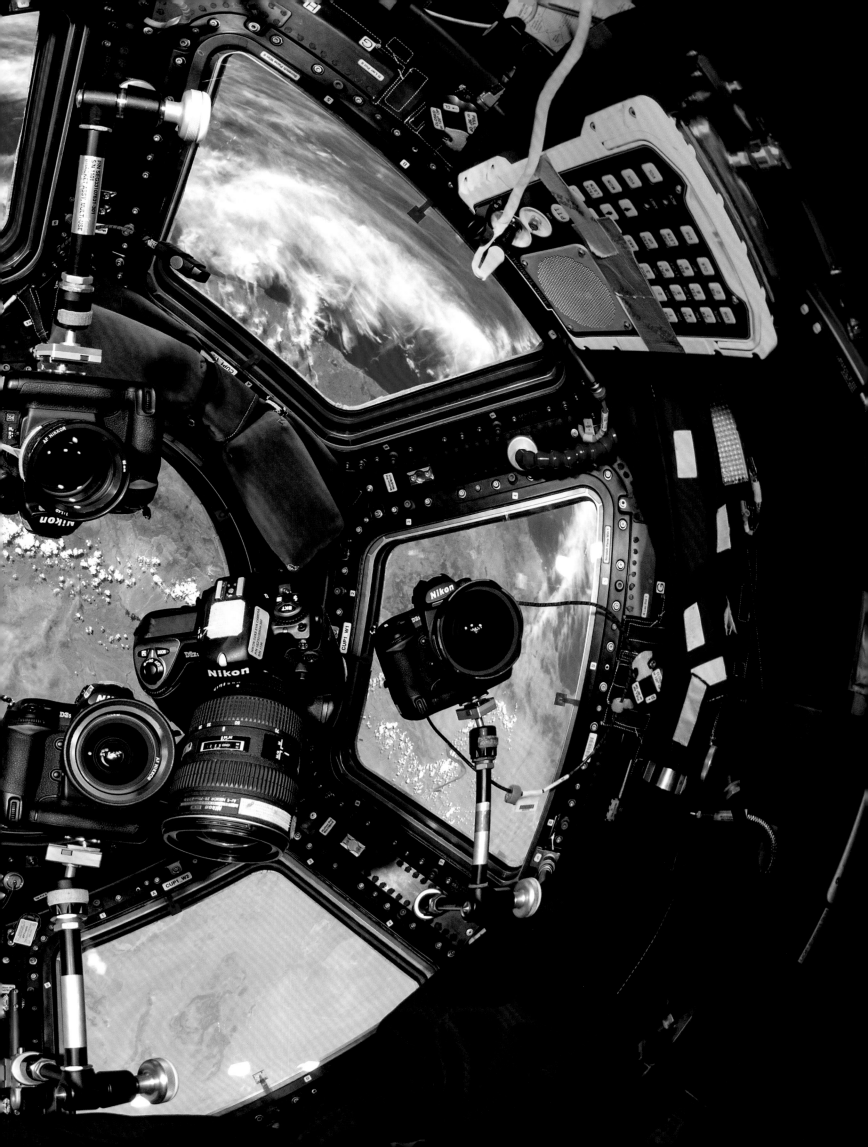

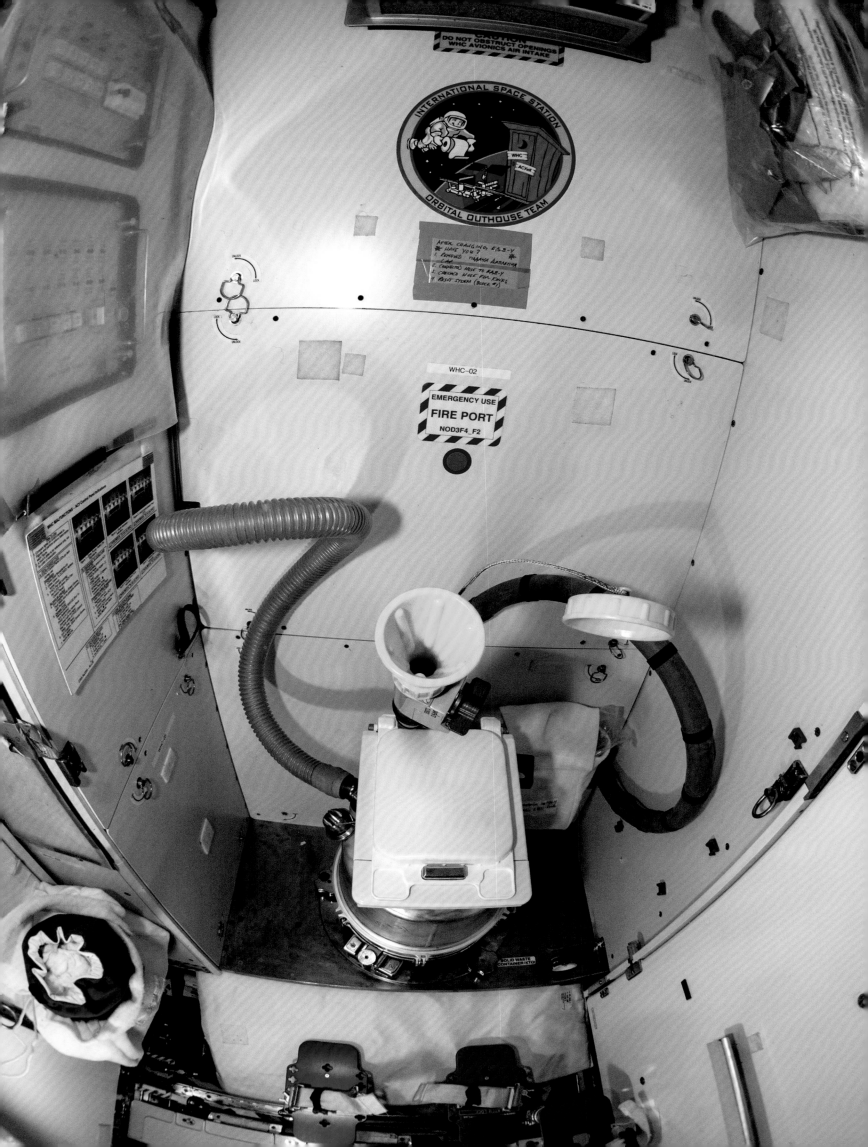

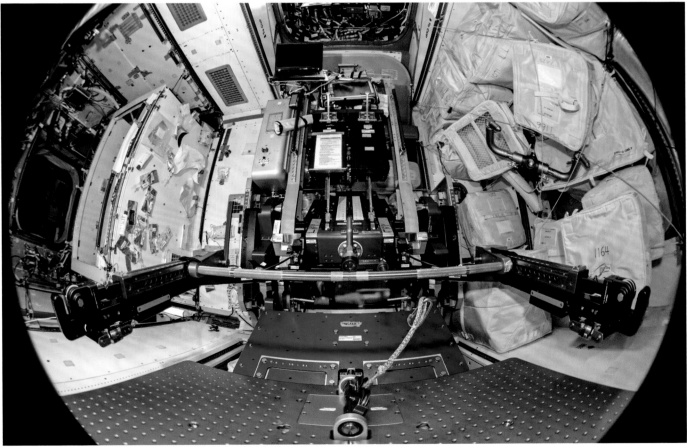

Space station toilet (L): the yellow funnel-looking thing is exactly that, attached to what is essentially a vacuum-cleaner hose. A view in Node 1, which serves as the LEGO-block connector for four other modules (top R). The beast, an ingenious machine that allows us to lift weights in a weightless environment, with loads up to 600 pounds (lower R). This machine can kick your butt, which is just what the NASA exercise trainers want.

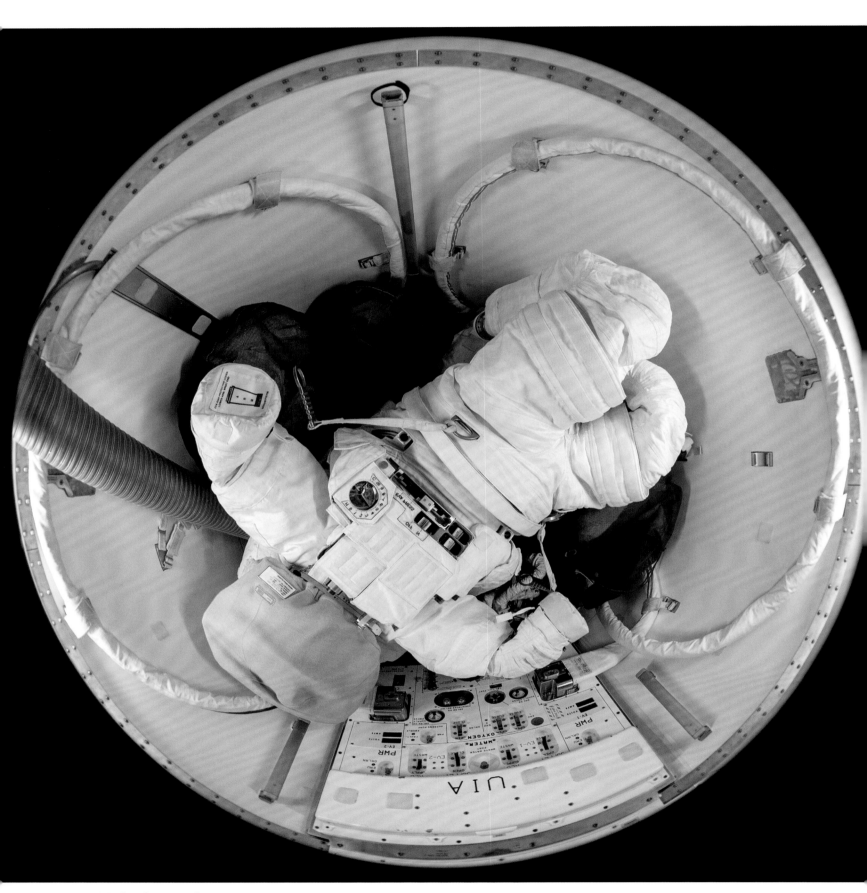

My business suit.

(Above) Crew training for earth-return in
their Soyuz spacecraft.
(Next spread) Space zucchini.

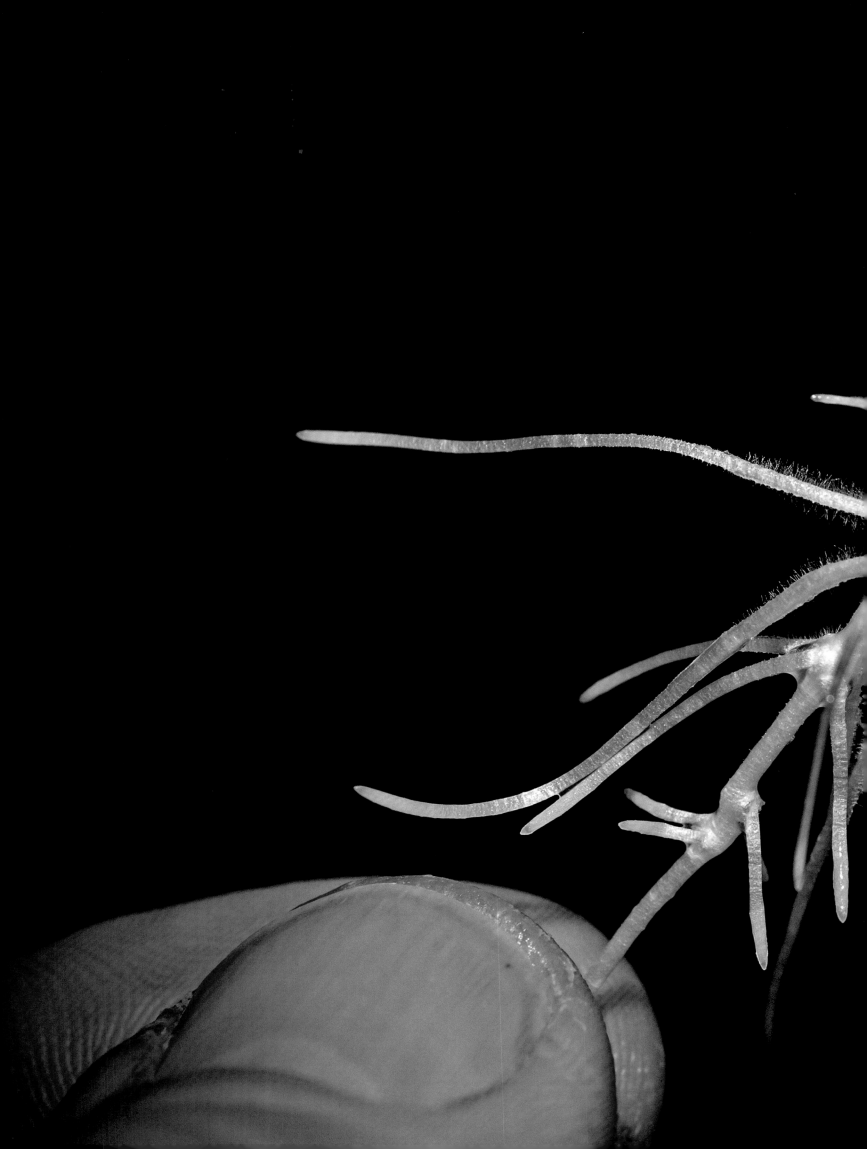

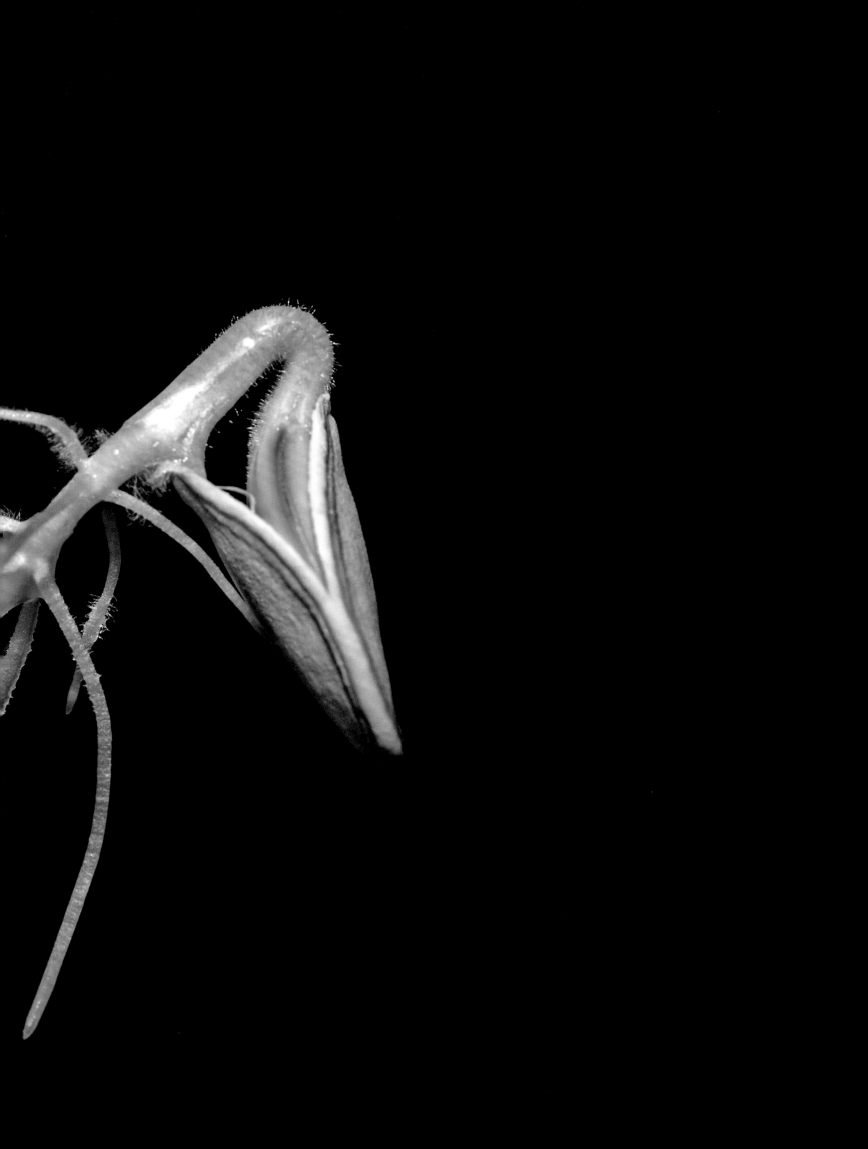

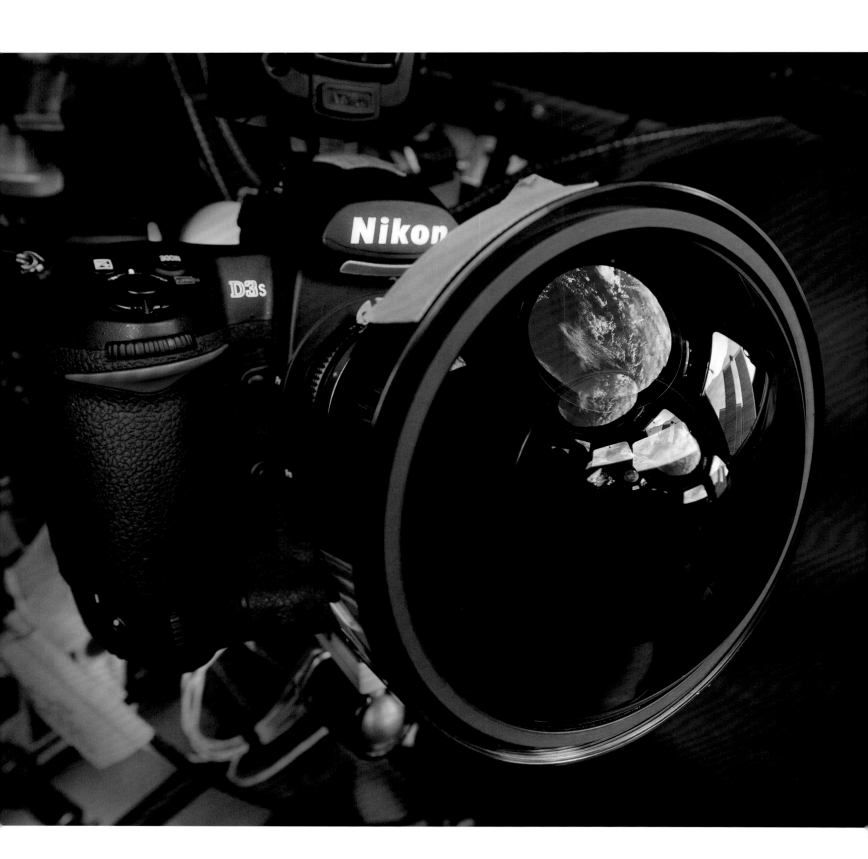

The world in a fisheye (L), and a world in a zero-gravity-grown wafer of ice under polarized light (R).

NIGHTTIME

Orbital night presents its own unique spectcle. The atmosphere glows faintly green under a sepia mantle, and meteors leave luminous trails as they burn through it. Passing comets, like delicate blooms, exhibit their brilliance for just a few days. Lightning storms flash, as if signaling to other storms half a continent away. Near the terminator, the line that separates day and night, noctilucent clouds gleam with the iridescence of an abalone shell. Satellites in orbits well beyond mine flare when they bounce the direct rays of the sun in our direction. Moonlight on a cloud-covered Earth can be so bright that it demands sunglasses. Rockets launching toward the space station trace lines that ultimately intersect with ours. When a spacecraft approaches, carrying new crewmembers or fresh supplies, it pauses at some distance, waiting for the opportune moment to dock. The ships snort fire from engine-nozzle nostrils, like dragons announcing their intention to seize the castle.

Auroras are diaphanous incandescent displays. Intense greens, reds, and blues move across your field of view like phosphorescent amoebas. The greens swirl below our orbit, and the reds flow by at our same altitude. We fly through an aurora, and for a moment it is as if we have suddenly been miniaturized, and inserted into a neon sign.

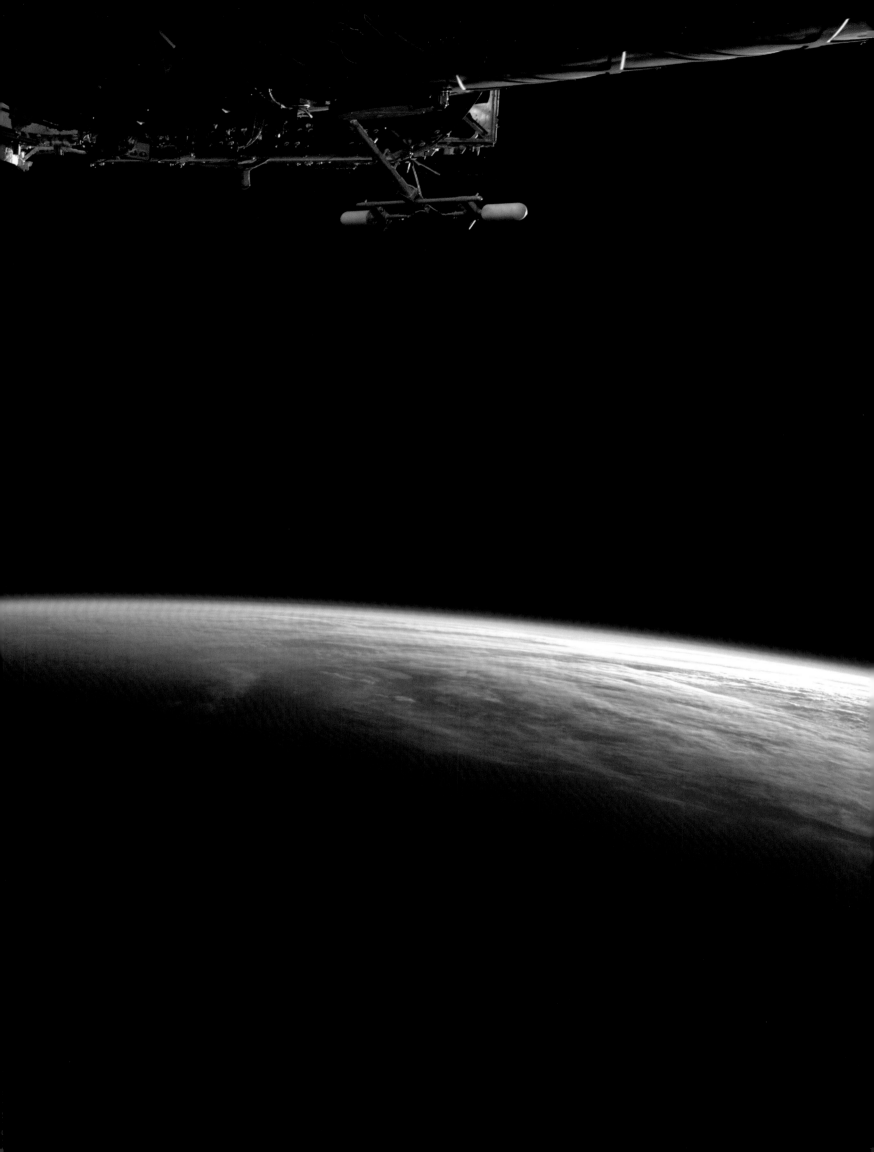

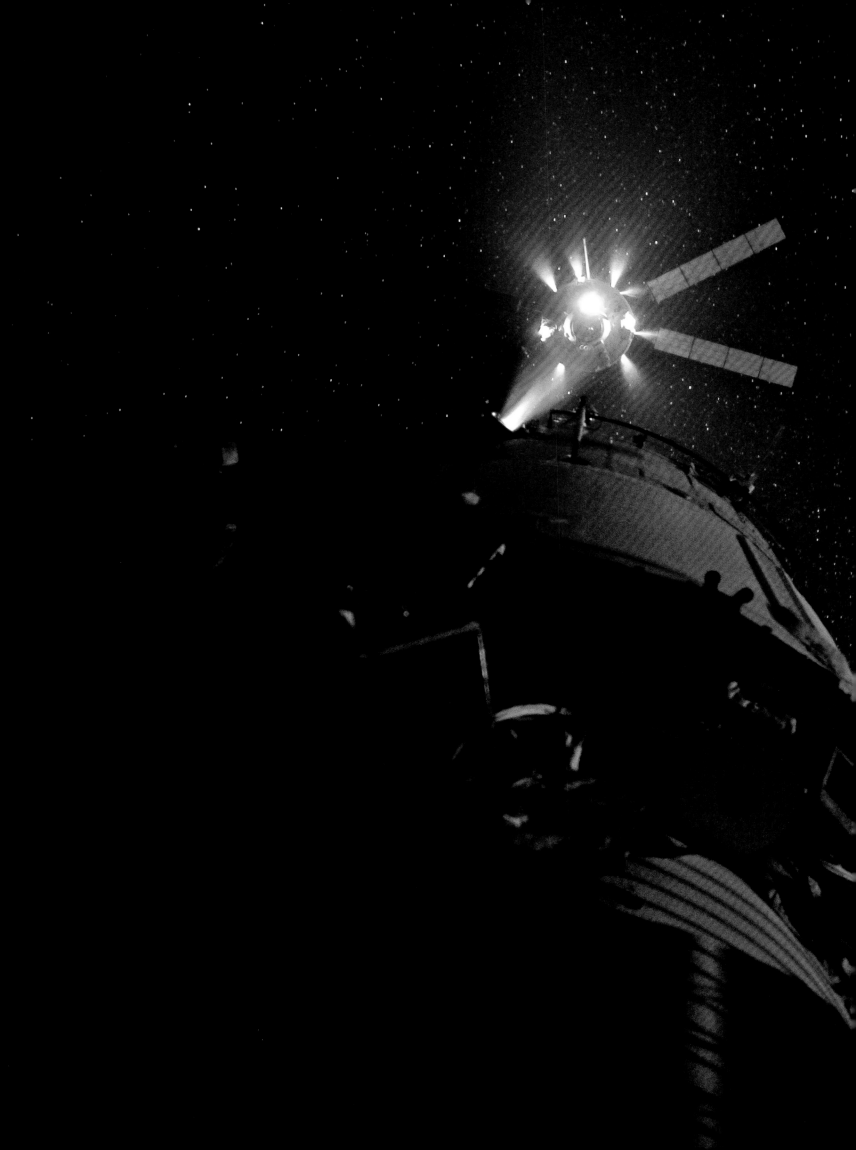

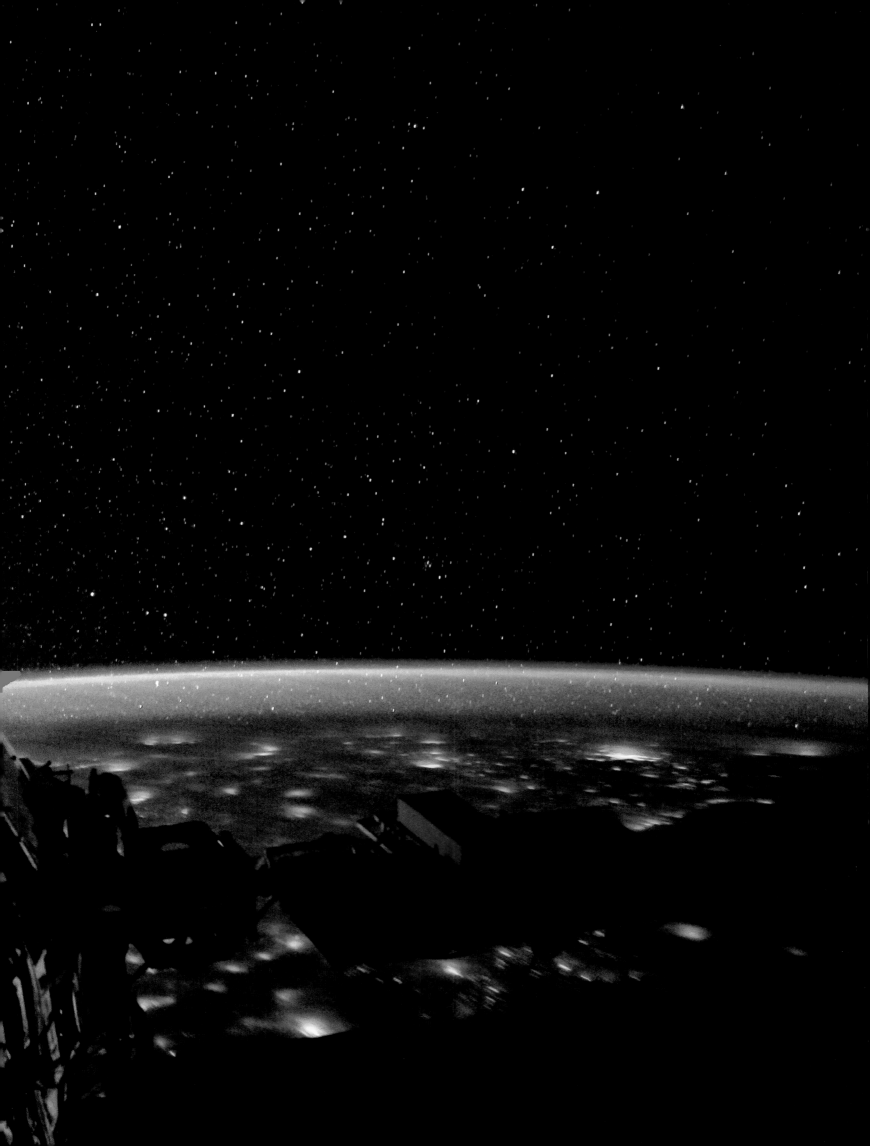

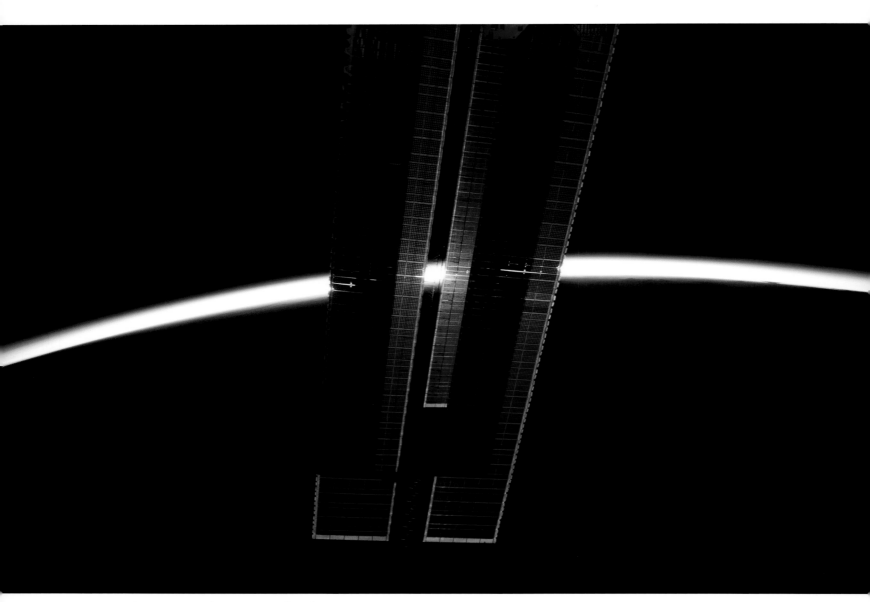

(Previous Spread) Snorting fire from its
nozzles, a European Space Agency un-piloted
cargo vehicle approaches the International
Space Station.

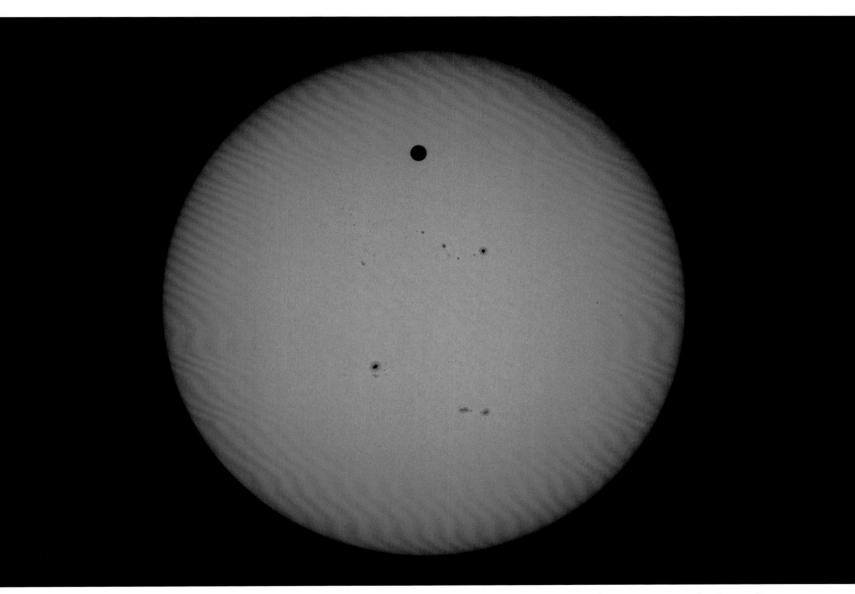

(Above) Transit of Venus across the face of the sun on June 5, 2012.

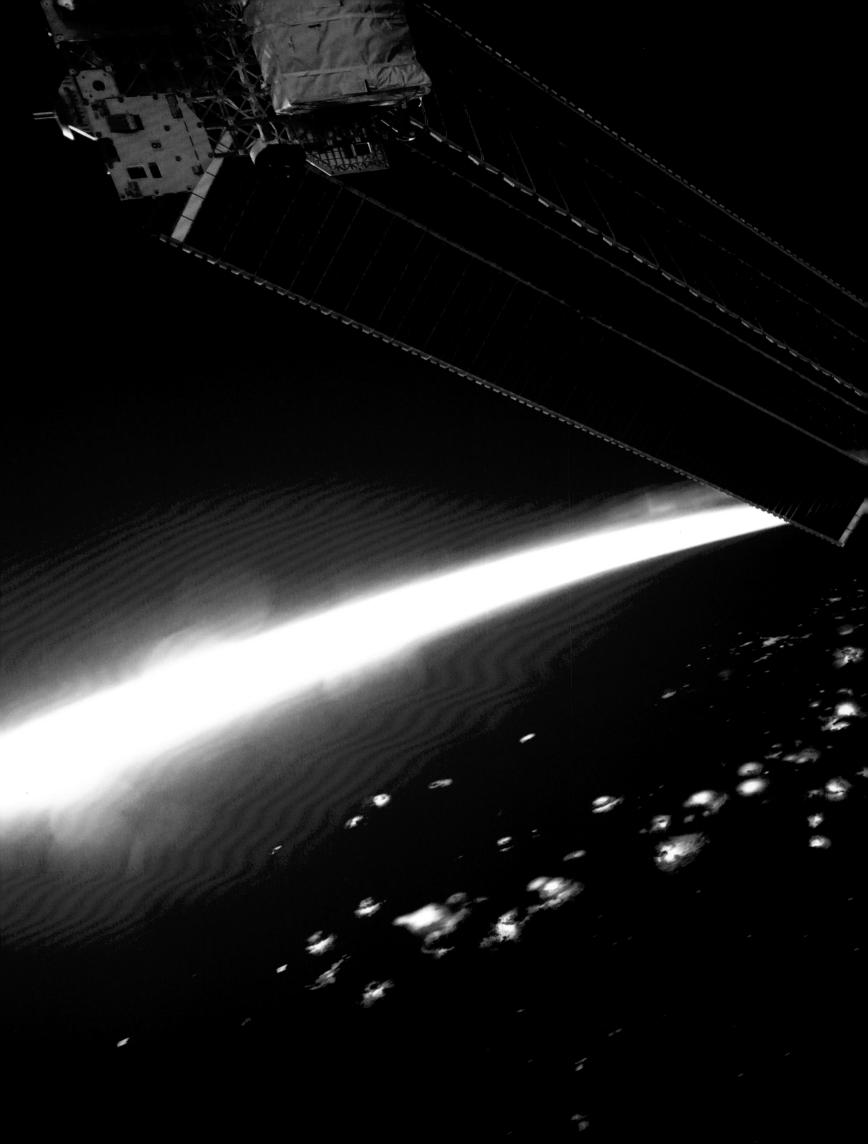

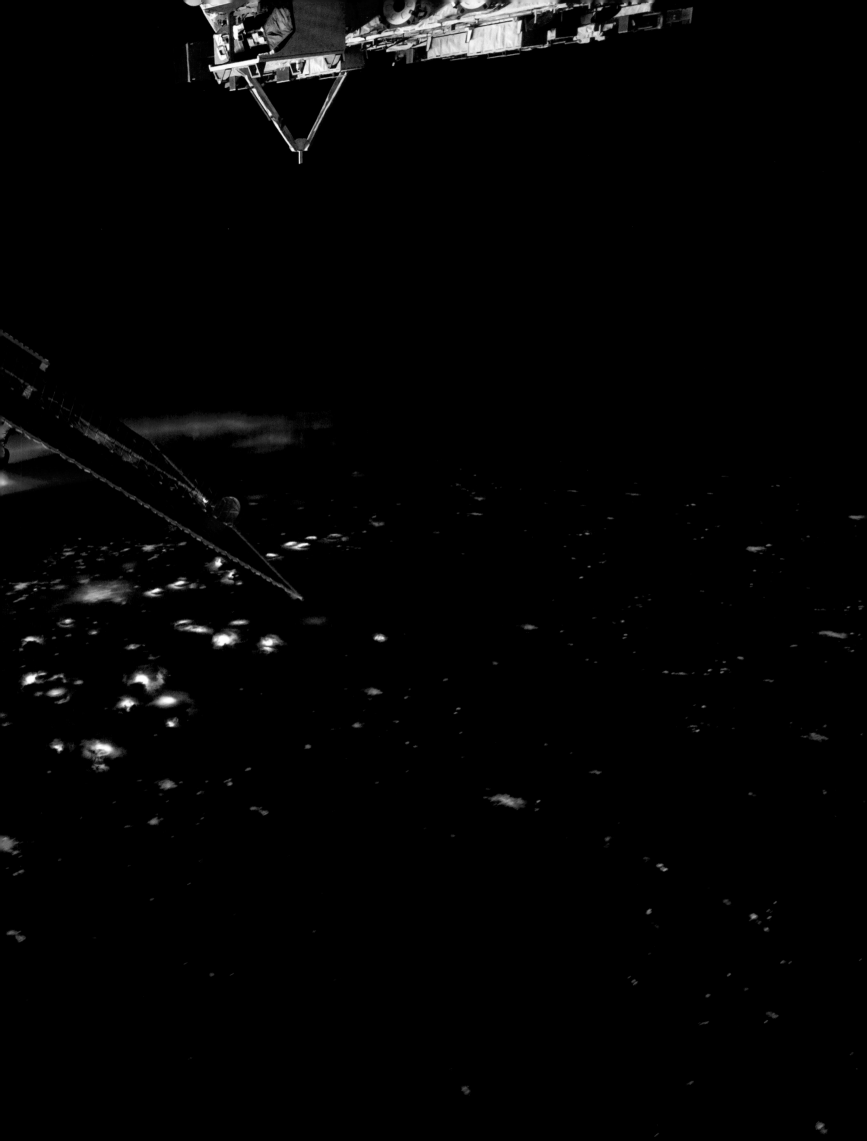

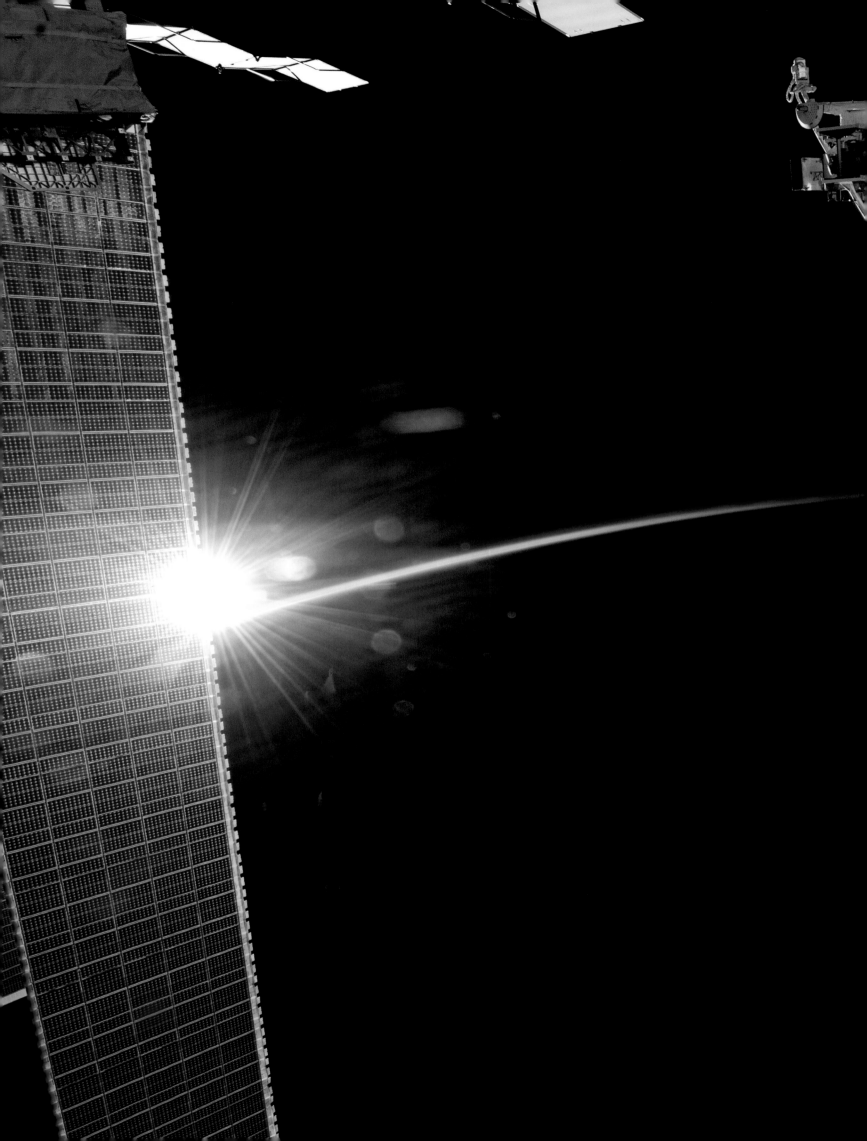

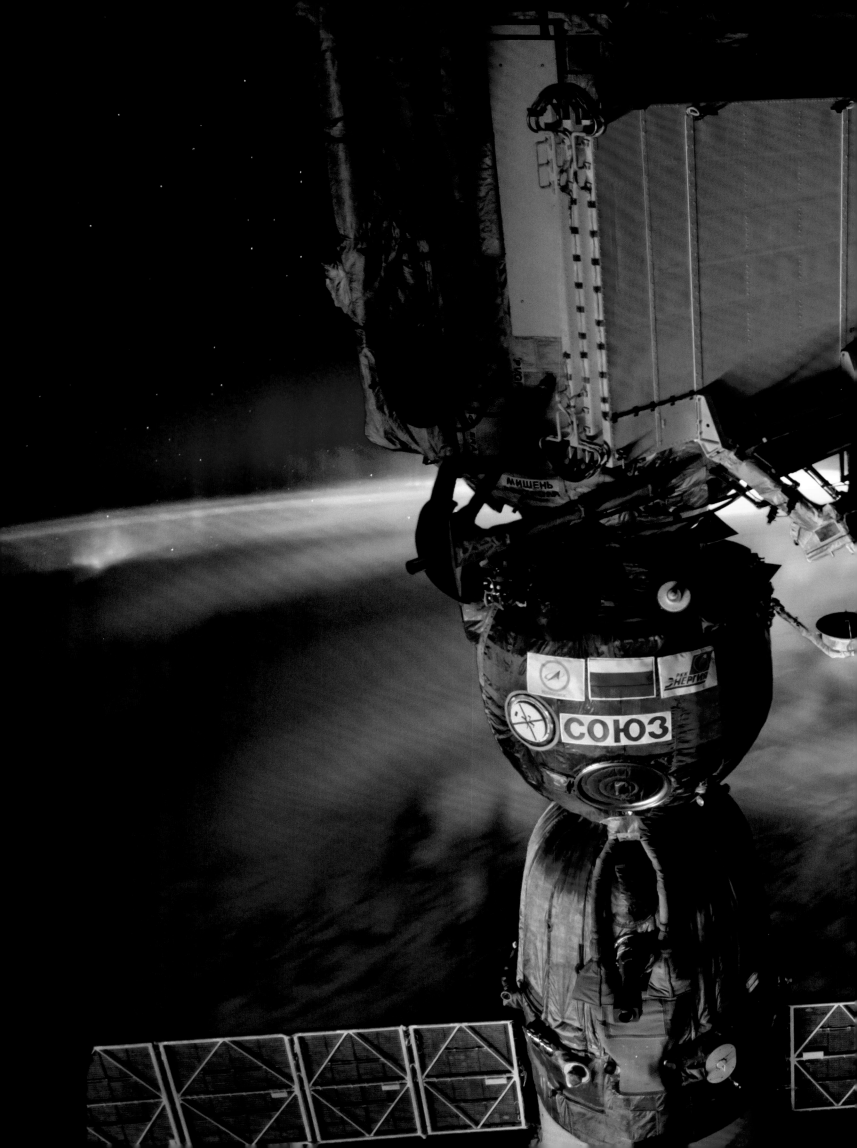

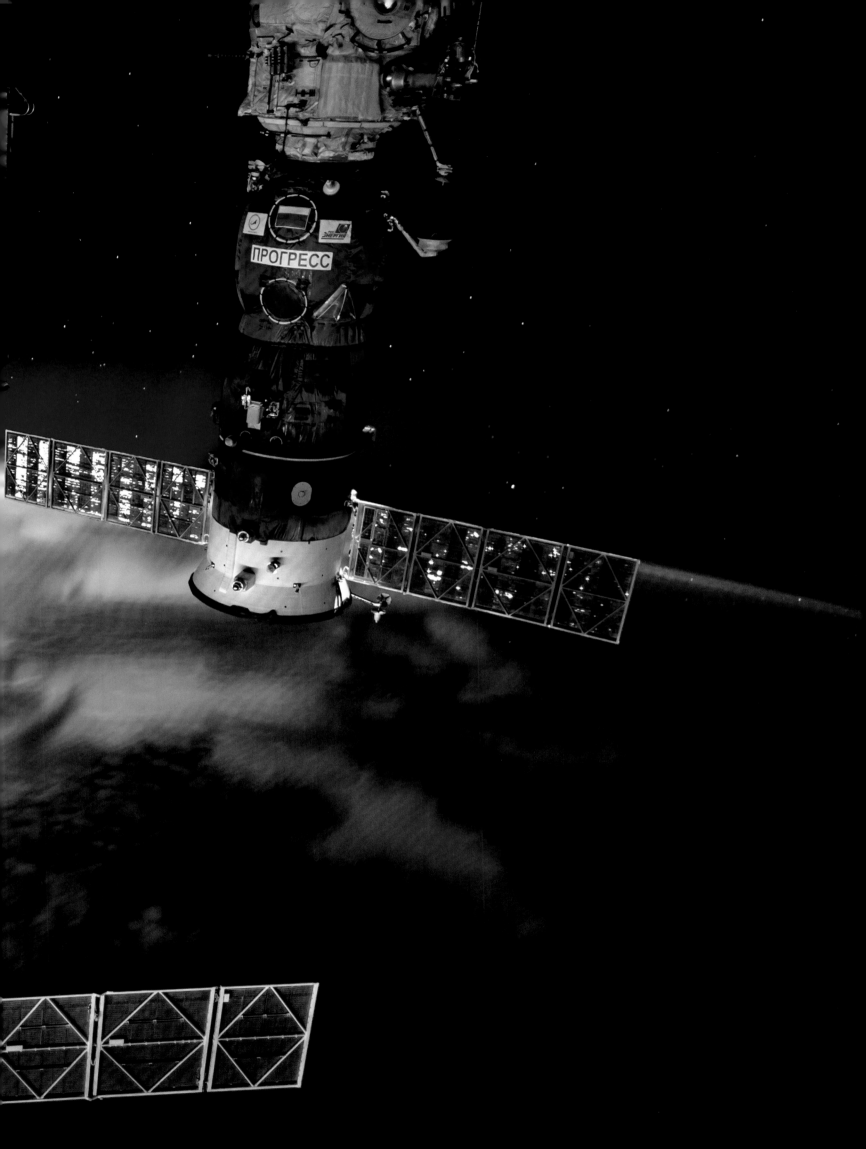

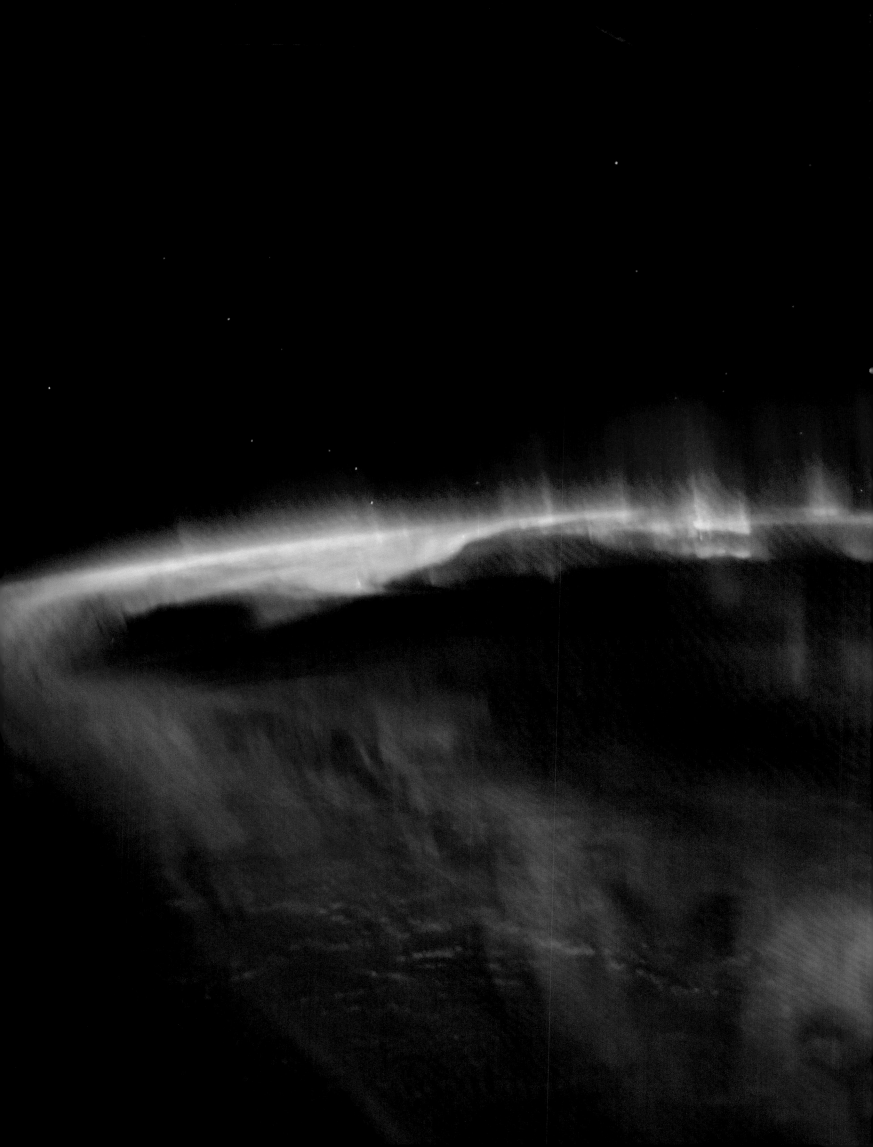

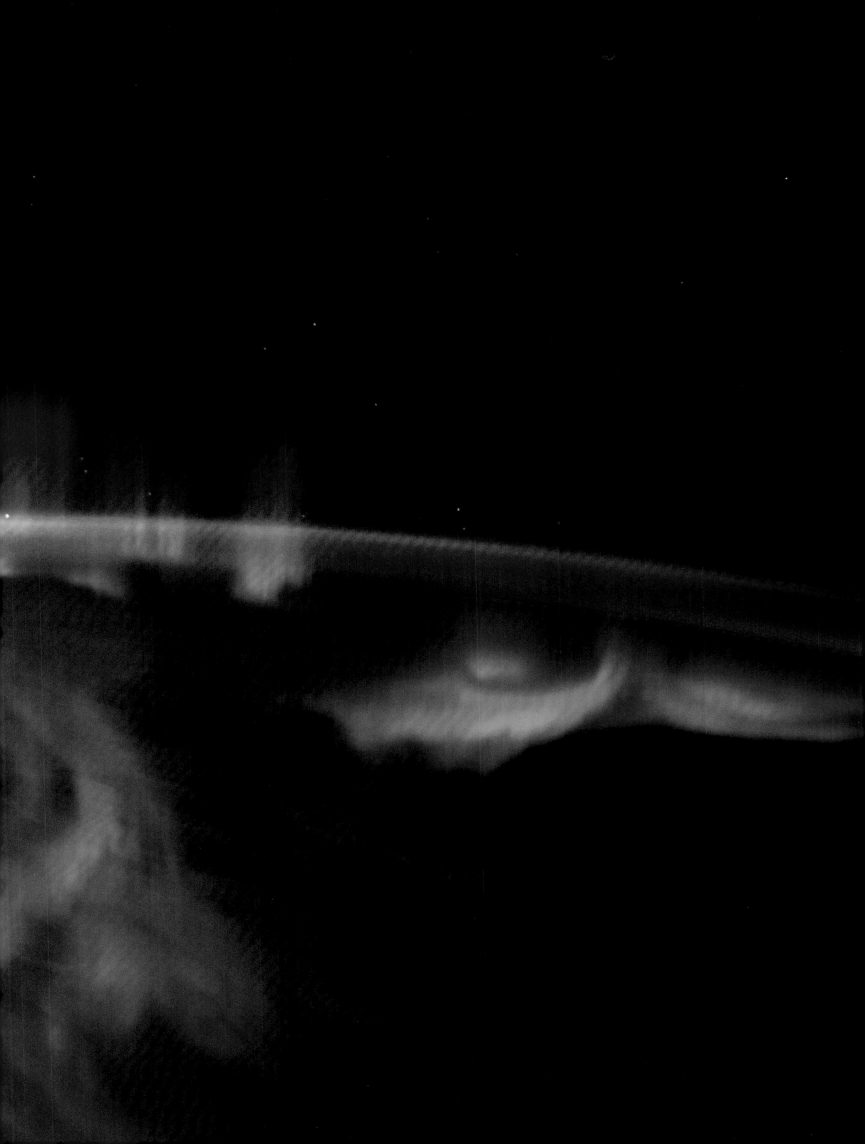

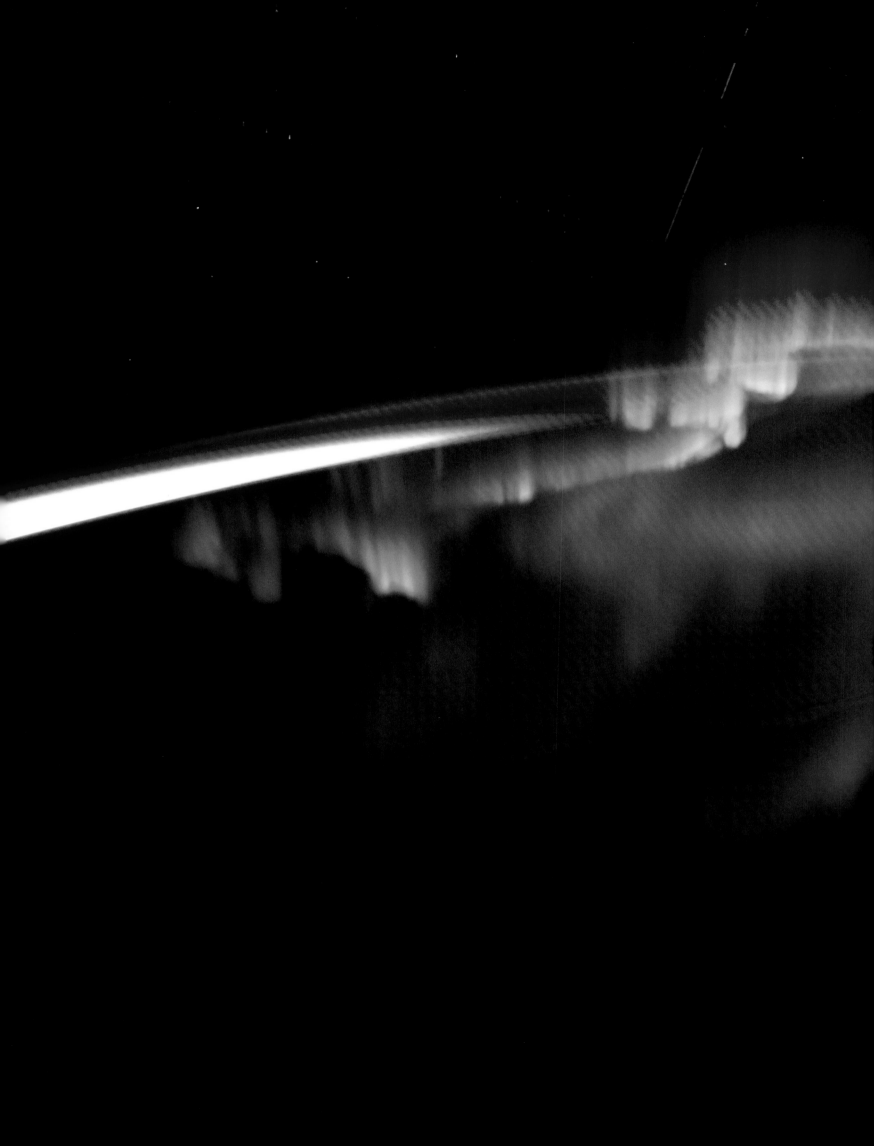

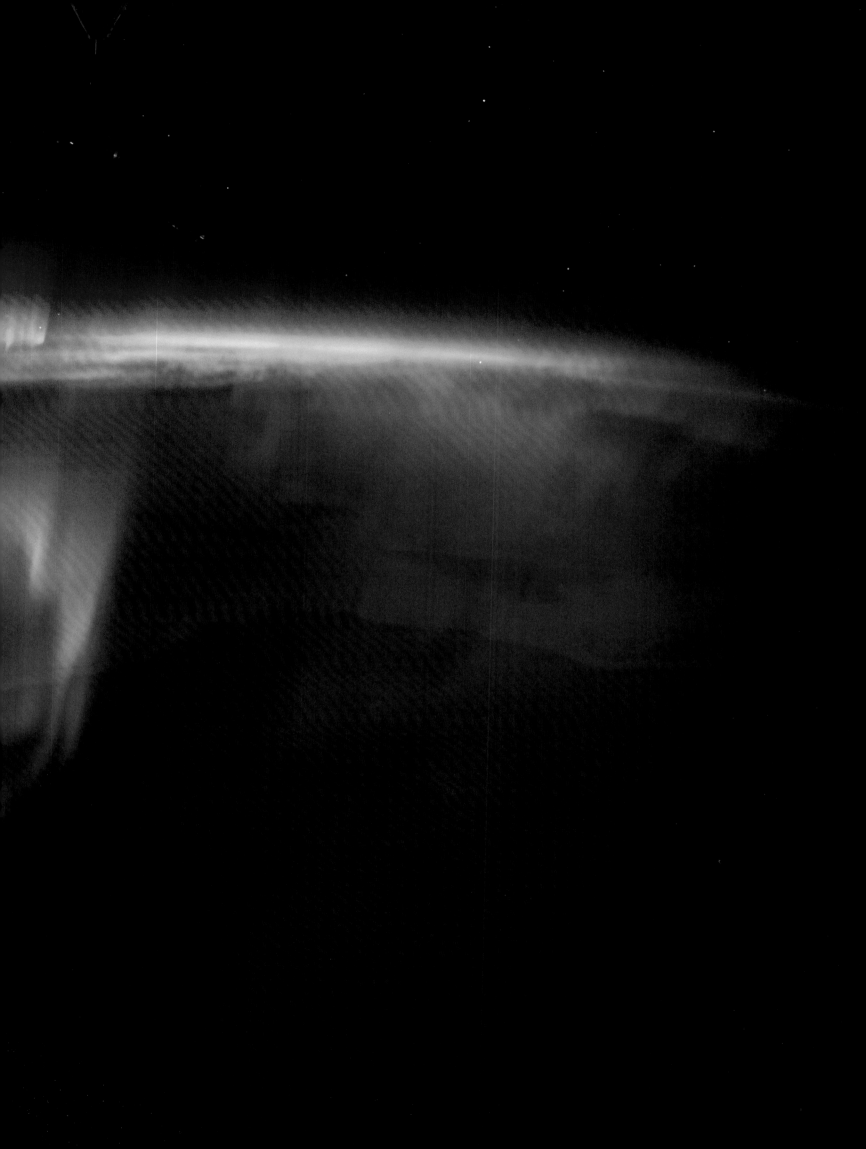

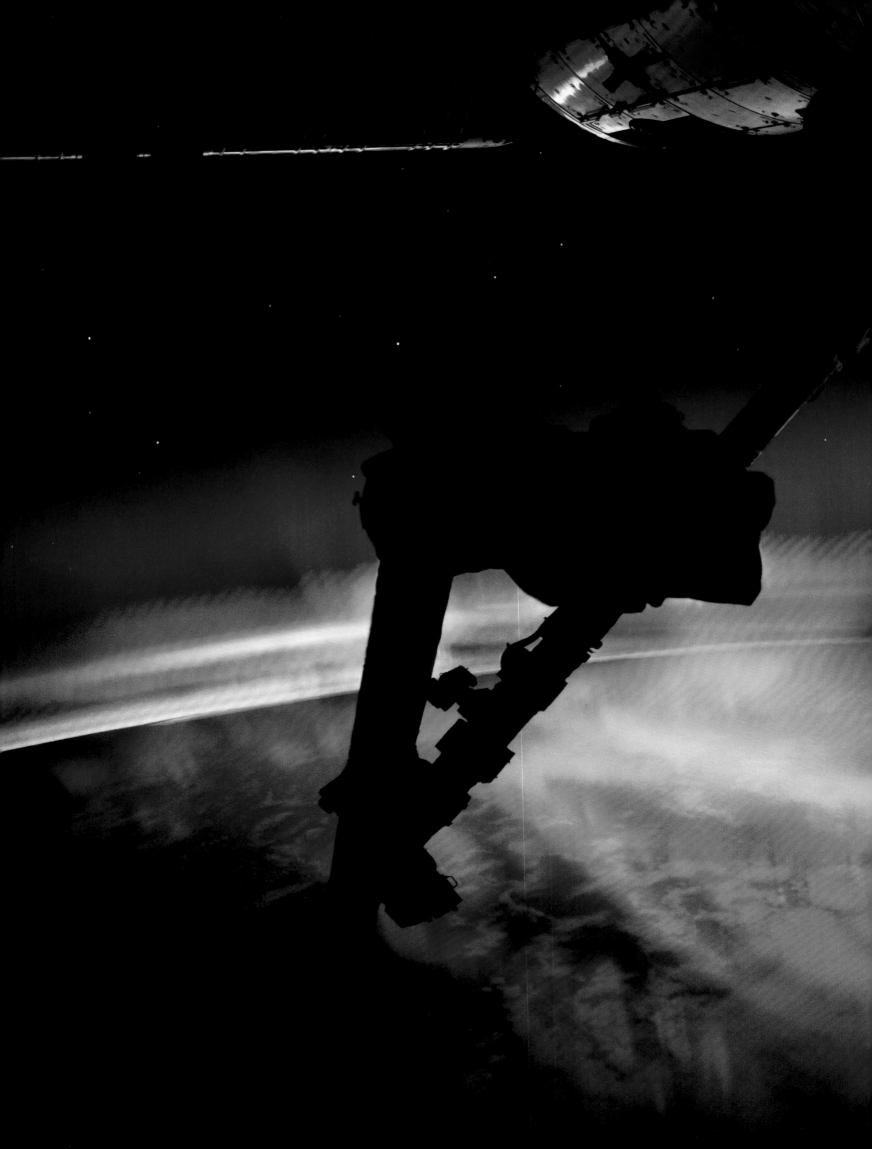

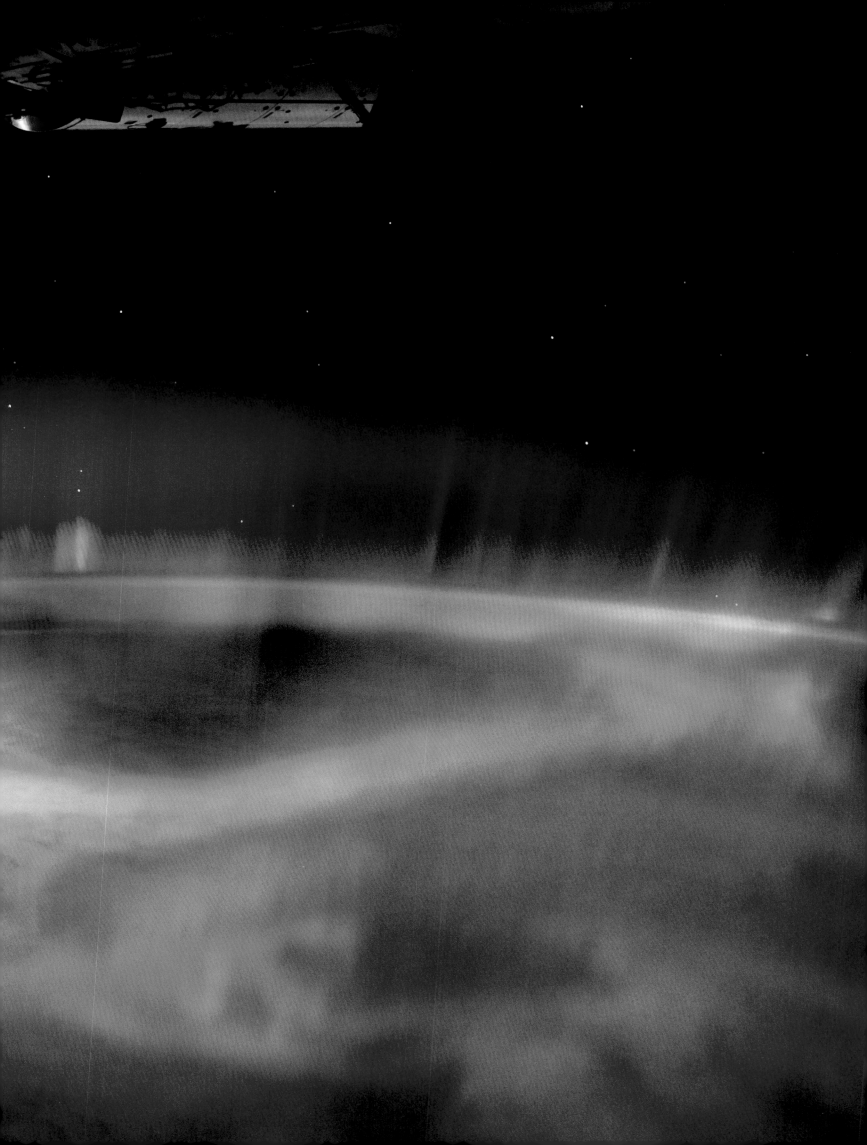

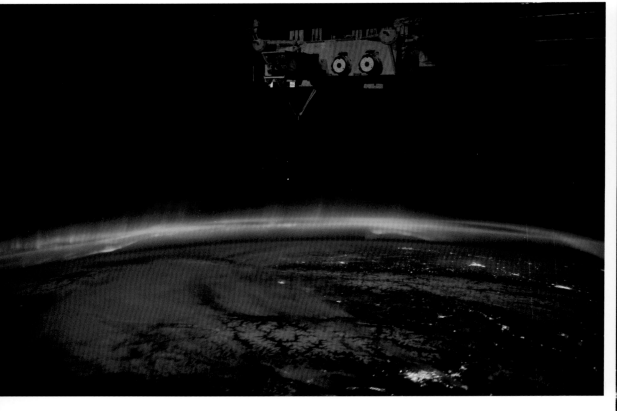
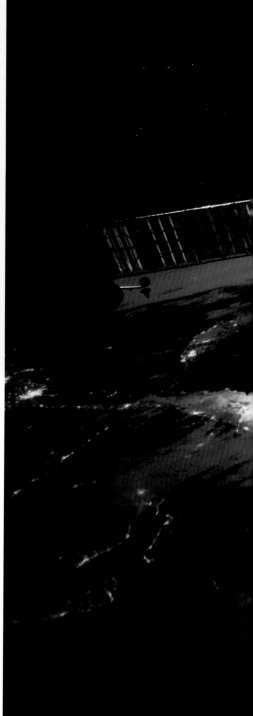

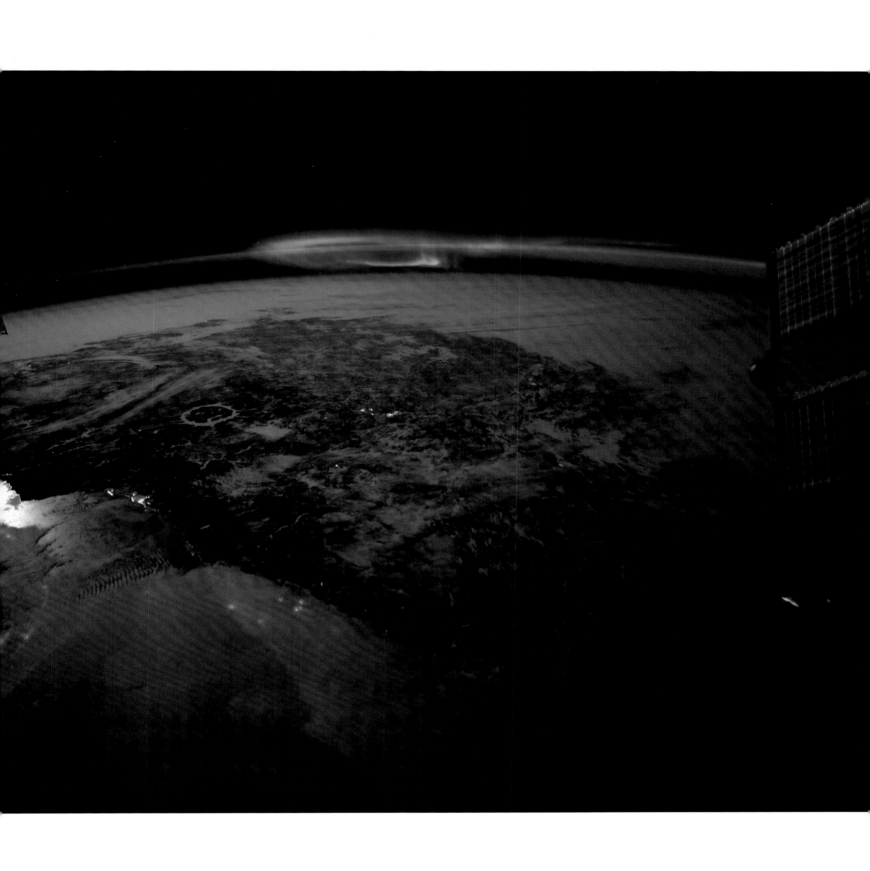

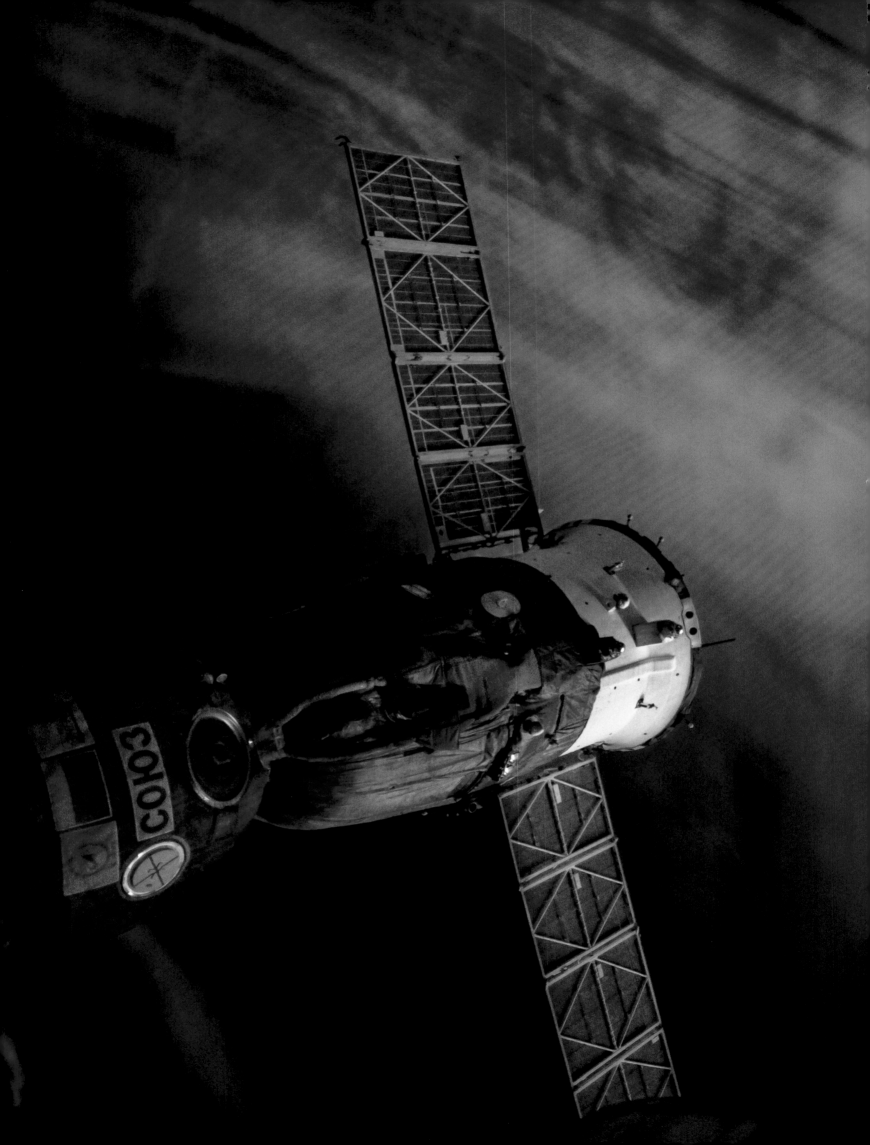

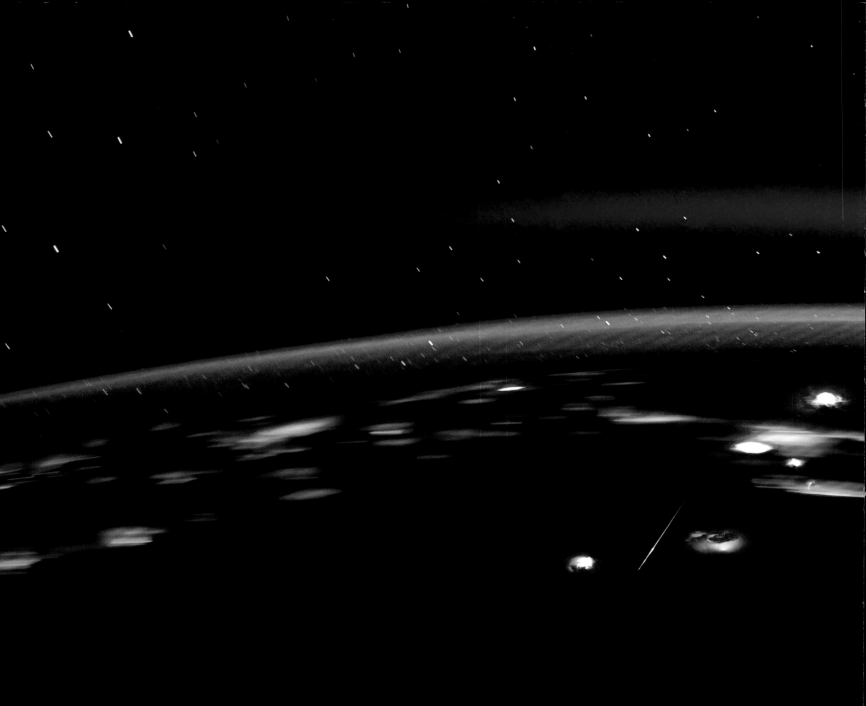

A meteorite from the late-April Lyrid meteor
shower burns up over Florida. A cosmic ray
streak appears as a multicolored dashed line.

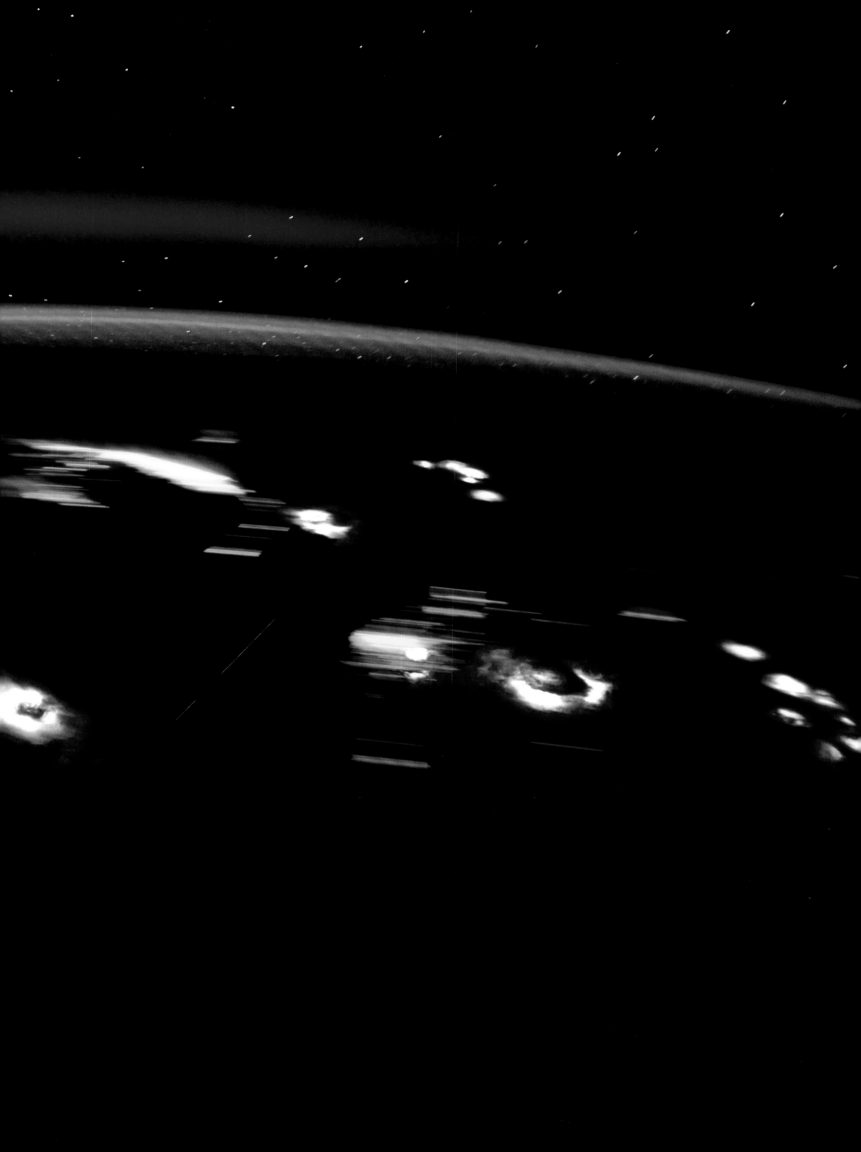

CITIES BY NIGHT

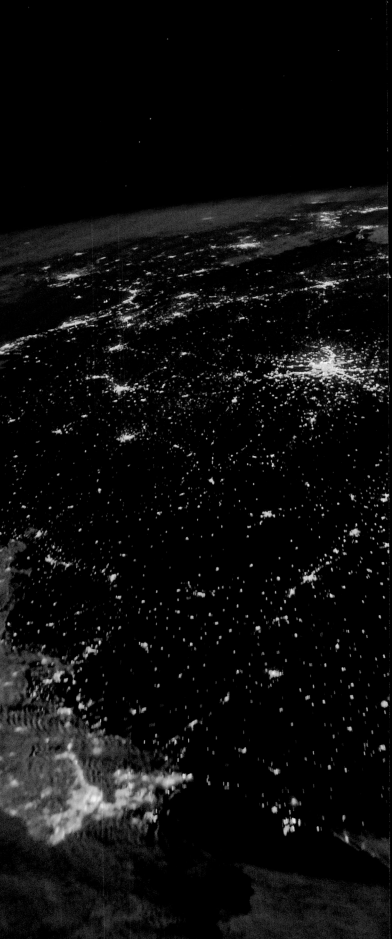

Humans scatter our lights across the nightscape, pushing back the darkness in an impulse nearly as old as humanity itself. The patterns our lights create are striking from orbit. From fire and candlelight to single electric bulbs and brilliant stadium arrays, lights empower us to effectively extend our lifetimes, by allowing us to work, play, communicate and create during as many hours of the day and night as we choose.

From above, lights accentuate the places where people want to live, and darkness marks places where we prefer not to be. Dark and light tell a story—the story not only of where we are now, but also of where we have been. What was once a meandering cattle trail is now a super highway illuminated with sodium vapor lights. An urban core shaped by a modern master plan appears as a matrix laid out in a perfect grid. Older cities have more organic, even chaotic shapes. Oil fields appear as a pattern of mottled white spots; and fishing vessels surrounded by dark ocean look like star clusters in the night sky, creating new constellations for the zodiac. The scattered lights of the countryside form fractal patterns that resemble a snapshot from Mandelbrot space.

I've lived in space for months on end. Light patterns readily become a guide to the part of the world passing below. Europe is marked by city centers filled with glowing tangled webs. Cities in the western United States have distinctive grids. South American cities are diffusely illuminated throughout the entire urban area. India is a misty expanse dotted with smoky village fires. Cities in Asia glow blue-green, the signature of mercury-vapor lights. The Amazon Basin is velvety black—one of the last great refuges for Nature's dark. And Las Vegas may very well be the brightest spot on Earth.

Our city lights are not designed by how they appear from orbit. Their colored patterns are a beautiful unintended consequence of civilization. They radiate into space a message about who we are.

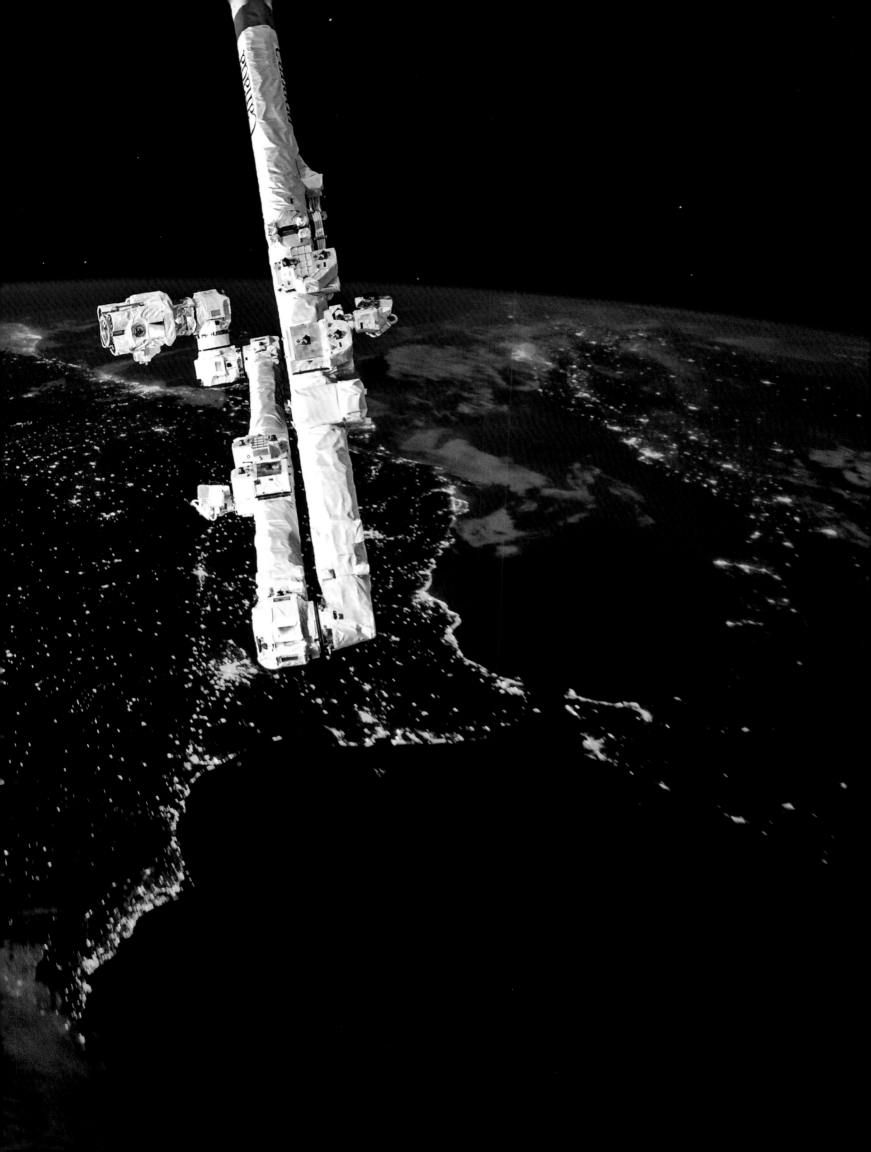

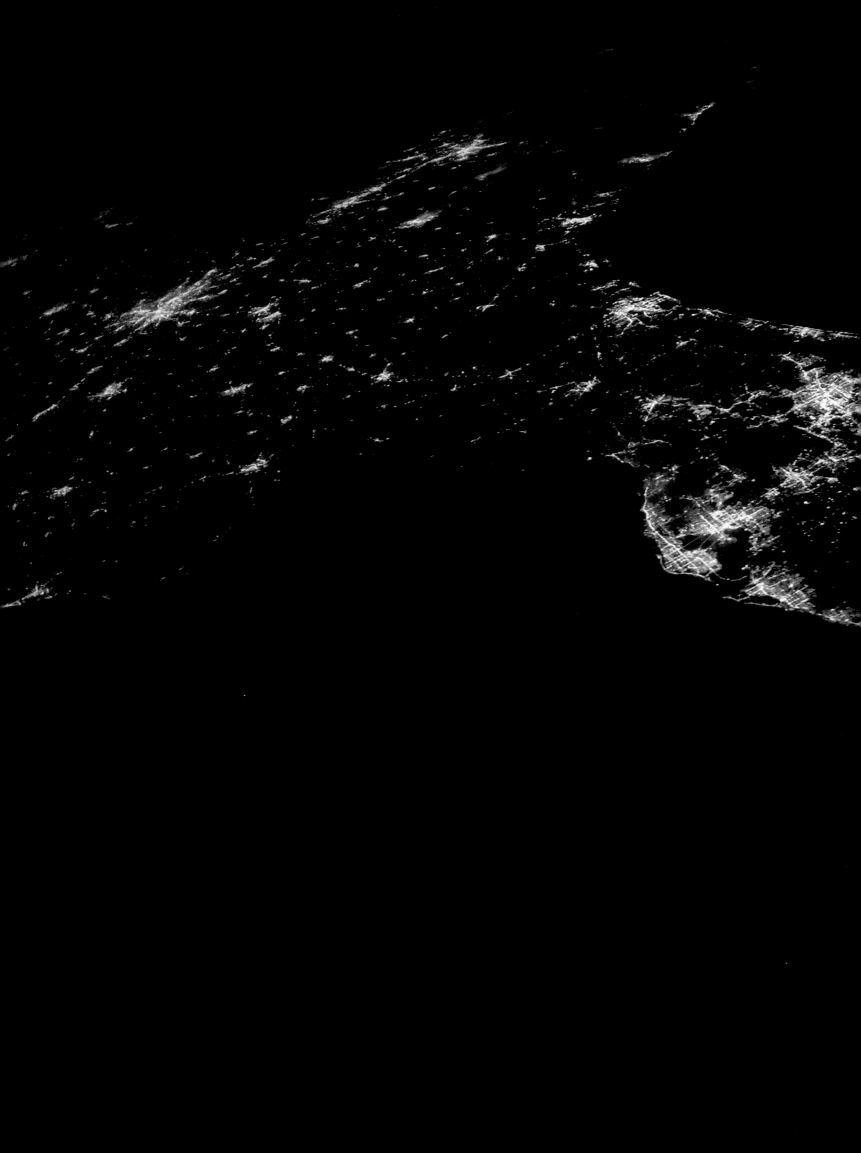

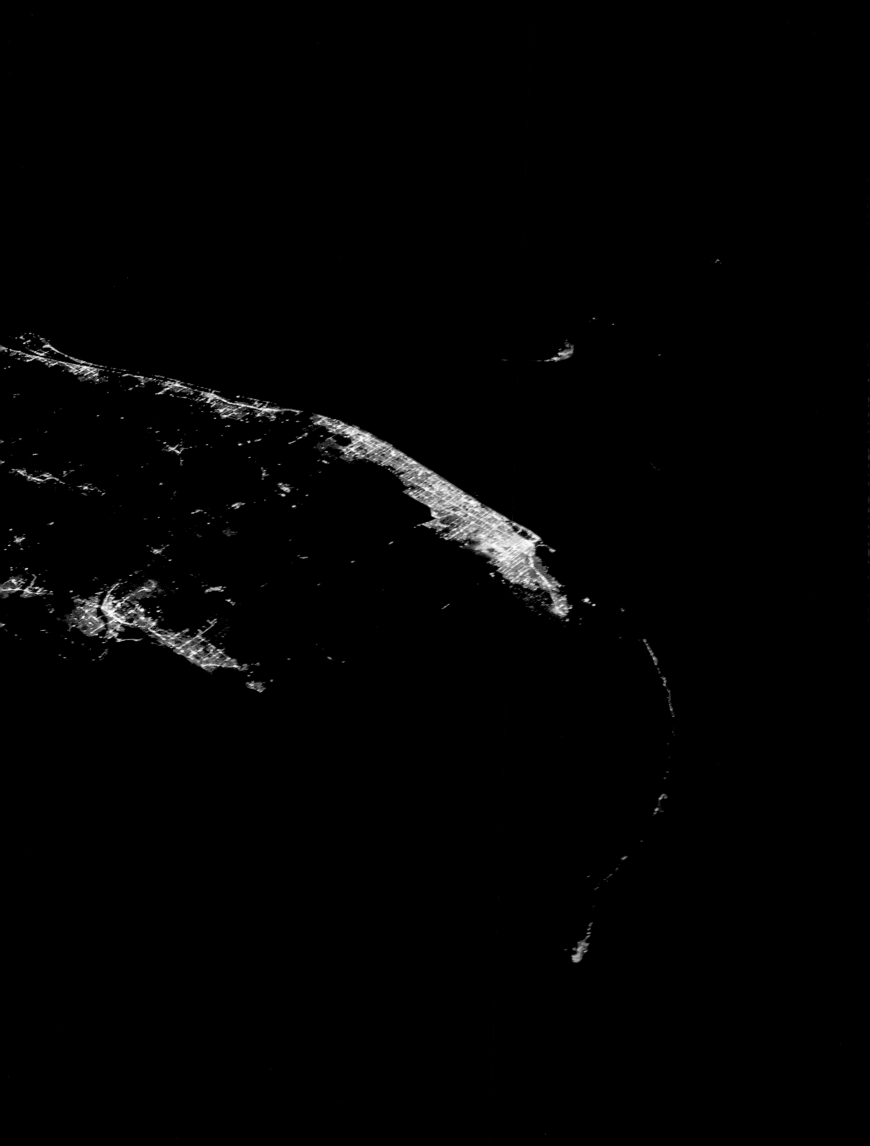

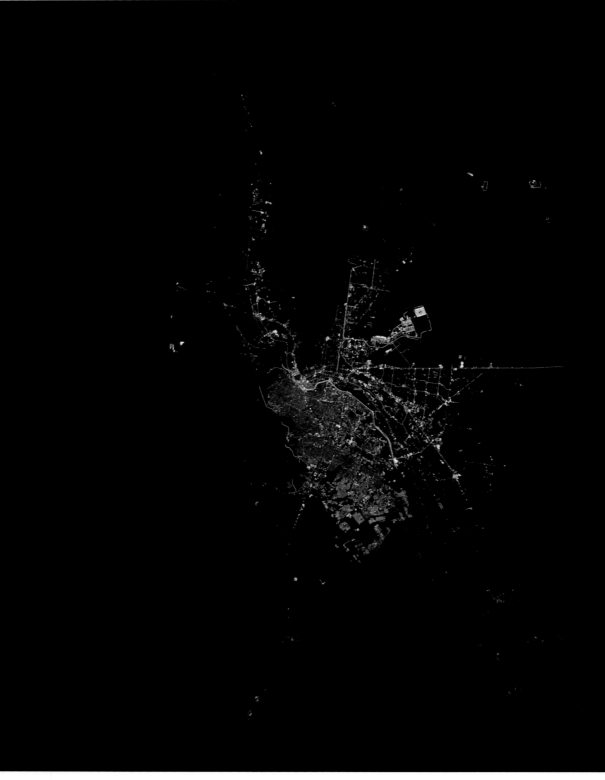

(Opening spread) Spain and the Straight of
Gibraltar.
(Previous spread) The Florida Keys, Miami,
Orlando, and Tampa, Florida, and north up
to Atlanta, Georgia.

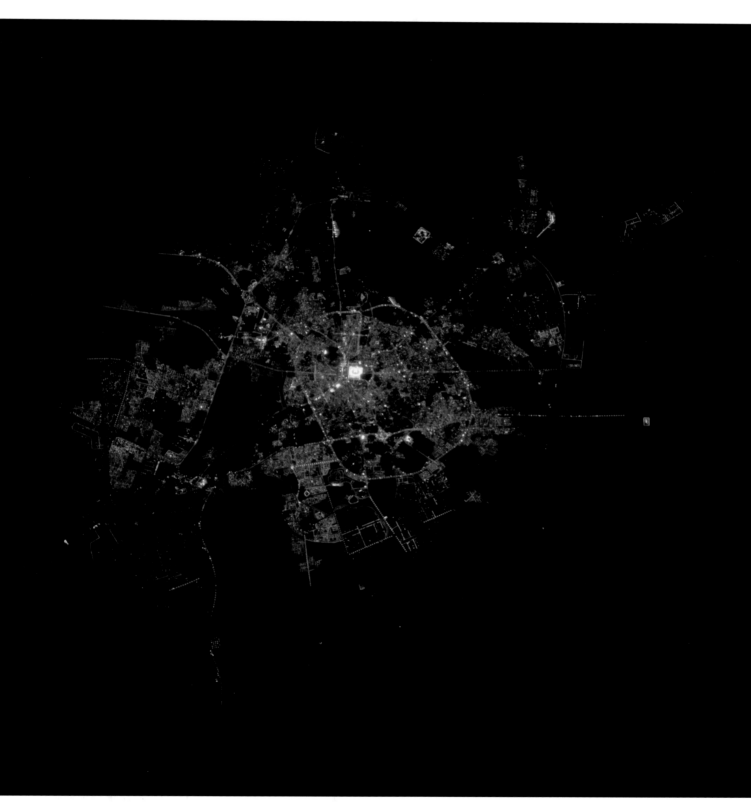

(Left) El Paso, Texas-Juarez, Mexico; El Paso shows a north-south-east-west lighted grid with darker regions in between. The whole urban area of Juarez is lit.

(Right) Medina, Saudi Arabia. The brightly illuminated center is the Al-Masjid an-Nabawī mosque.

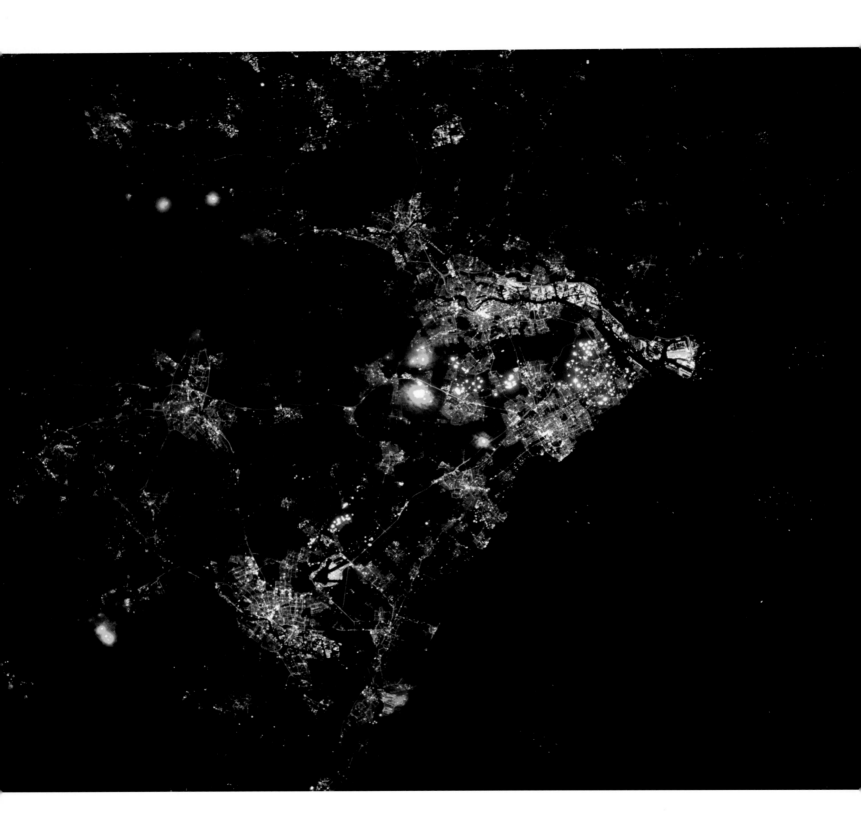

(Left) Rotterdam, Hague, Leiden, the Netherlands.
(North is at the bottom of this frame. Artist's choice.)
(Right) Yentai, China.

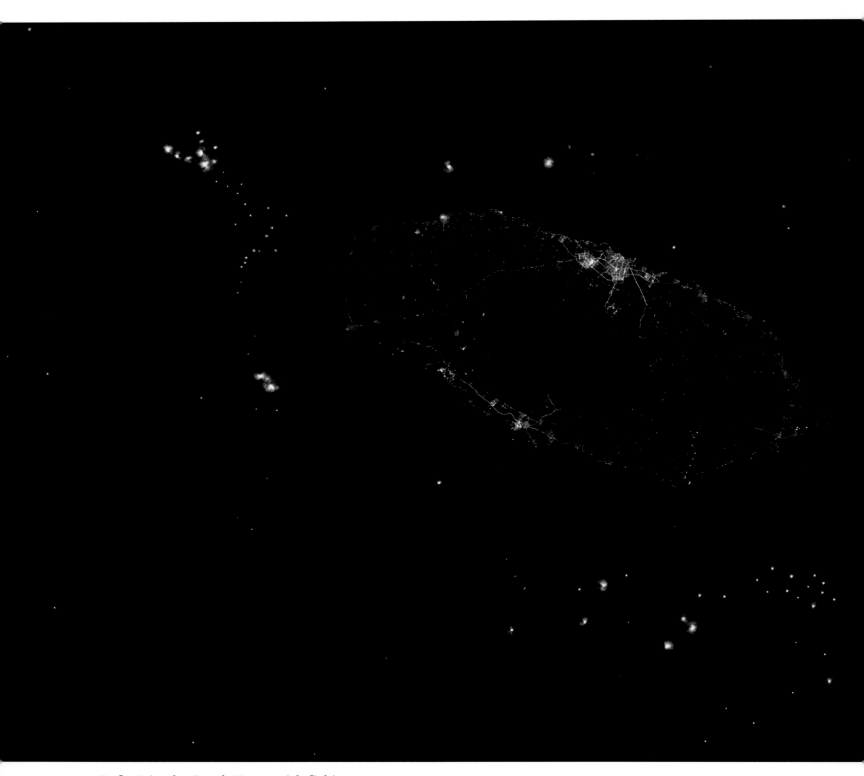

(Left) *Jeju-do, South Korea with fishing boats in the surrounding sea.*
(Right) *Fishing boats create floating nebula in the South China Sea.*

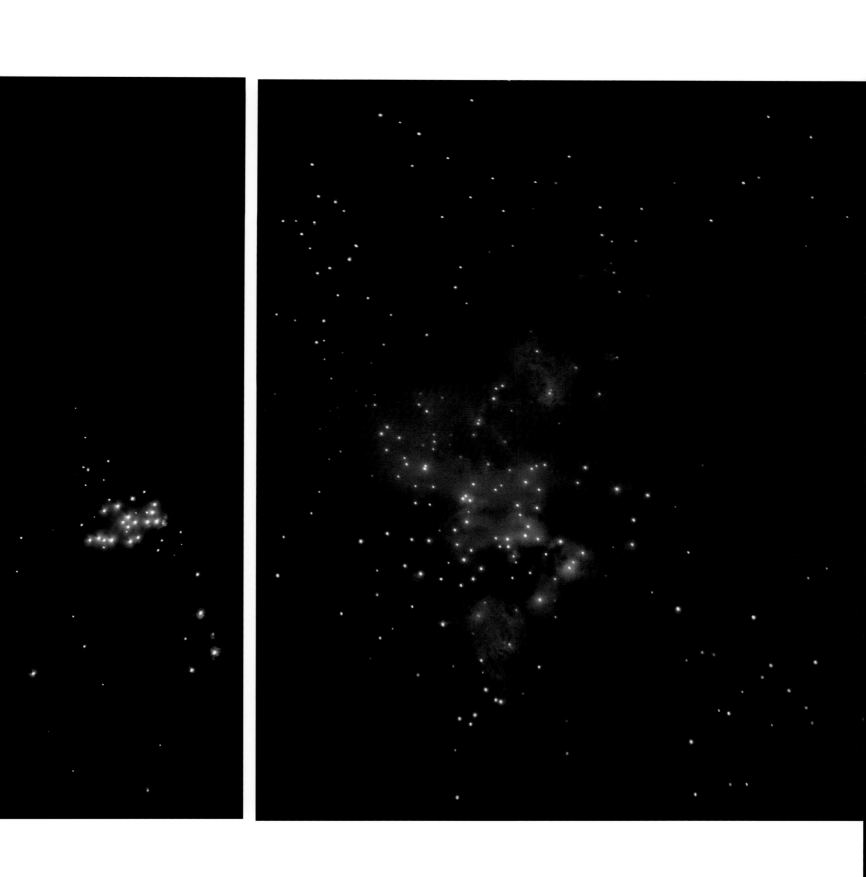

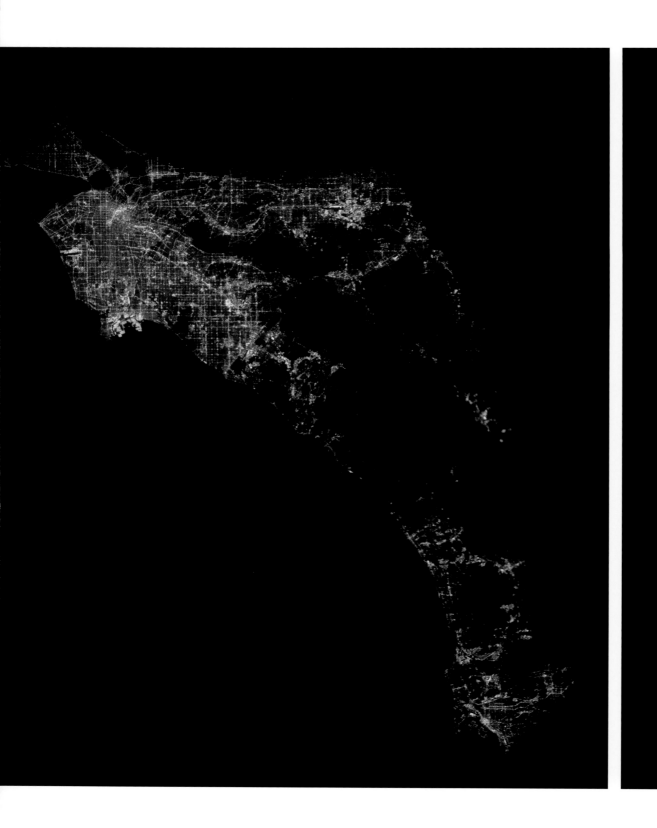

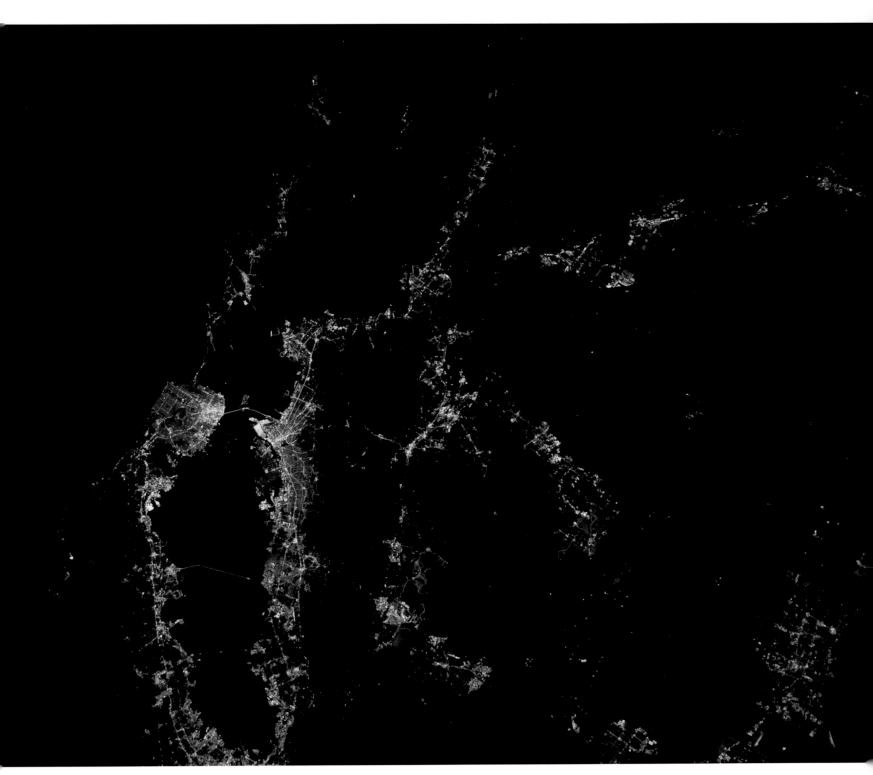

(Left) Los Angeles in the north and San Diego to the south.
(Right) The San Francisco Bay area.
(Next spread) The Nile River. Nearly 240 million people live along its banks.

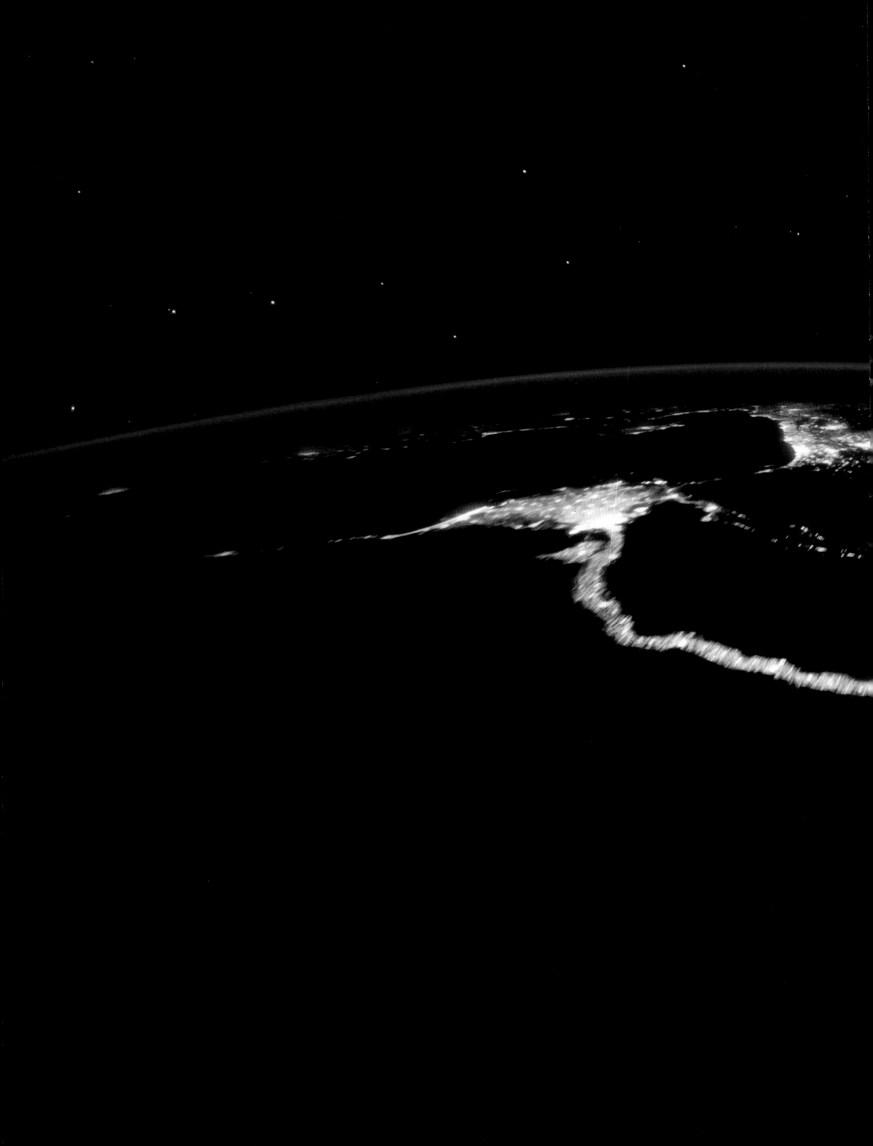

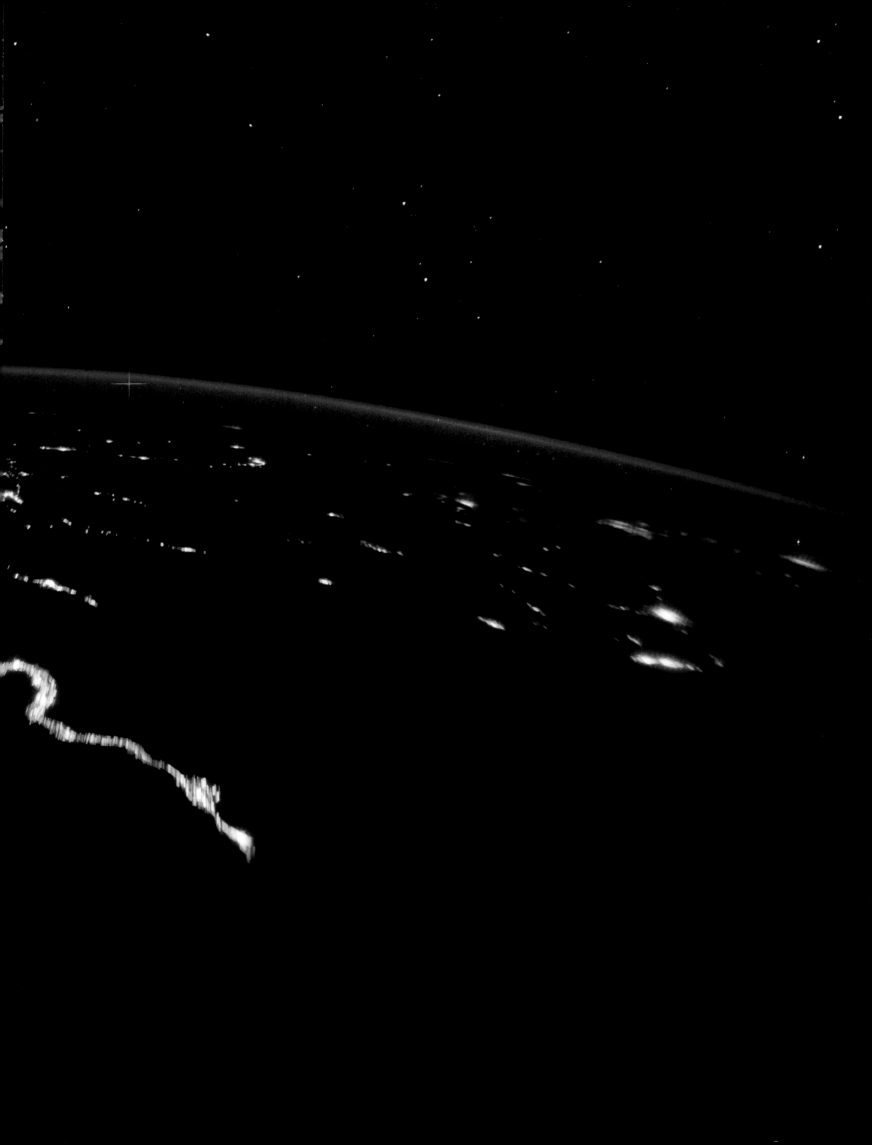

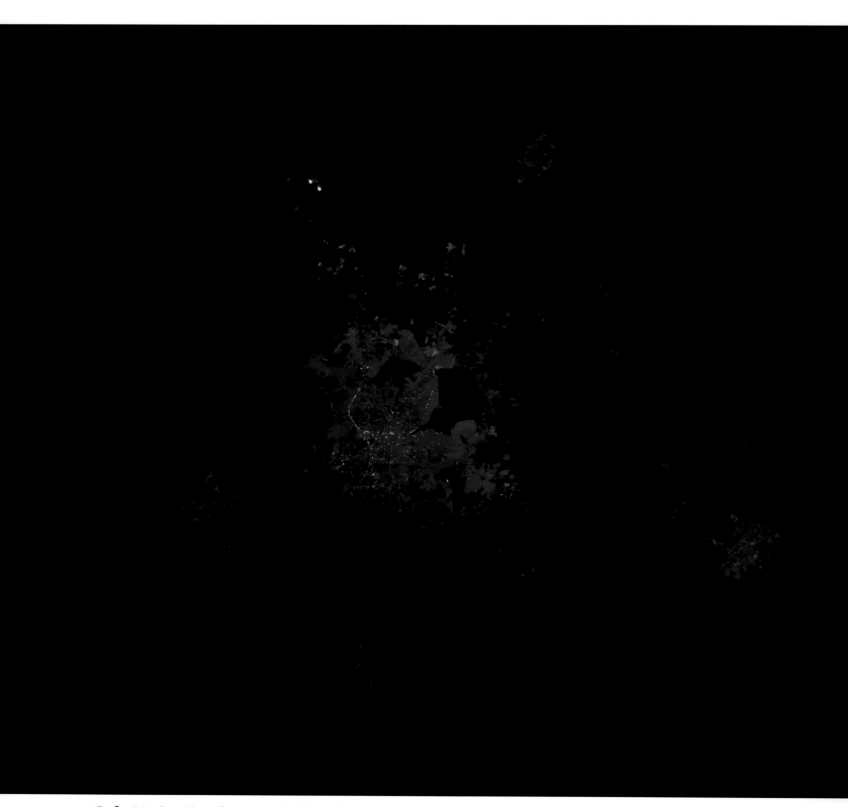

(Left) *Mexico City photographed in infrared.*
(Right) *Somewhere over the Middle East.*

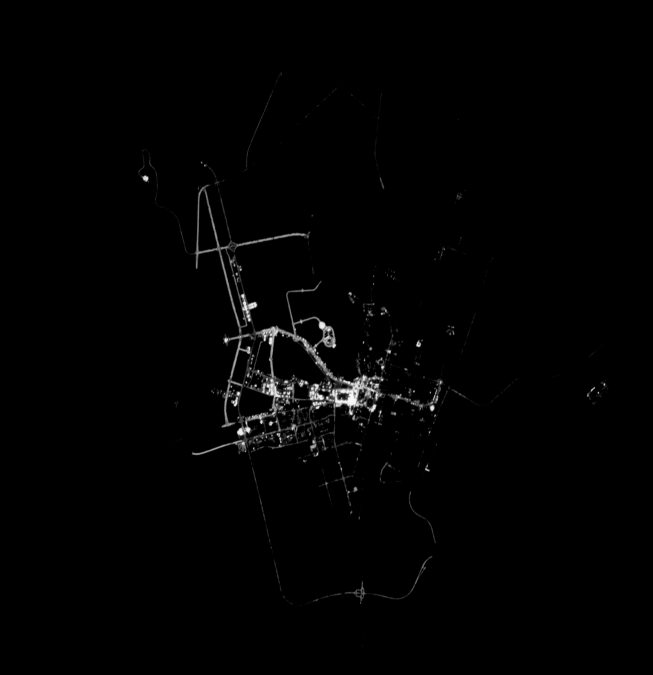

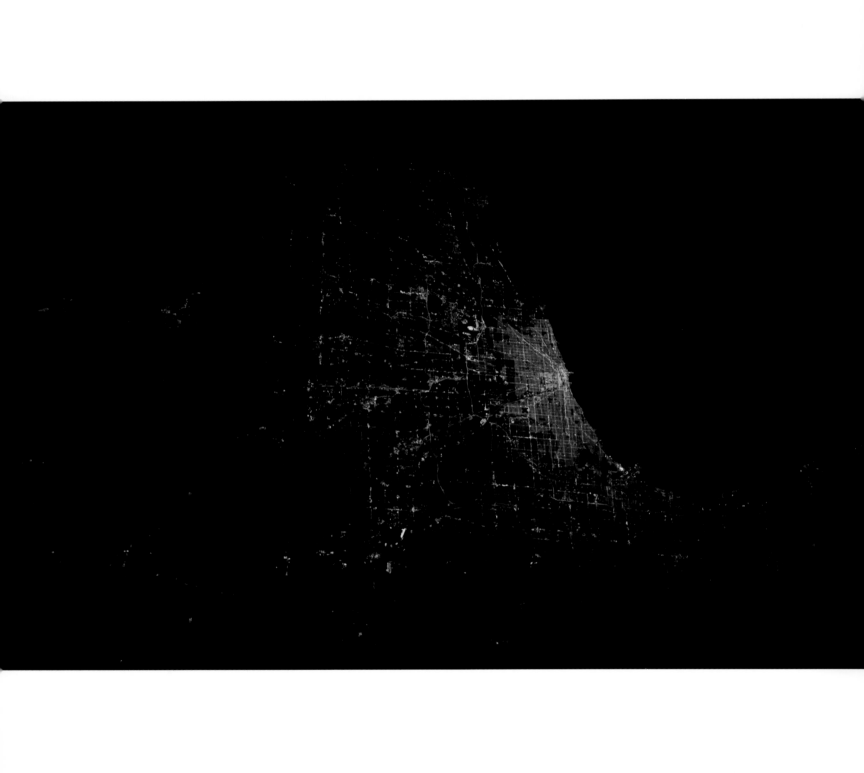

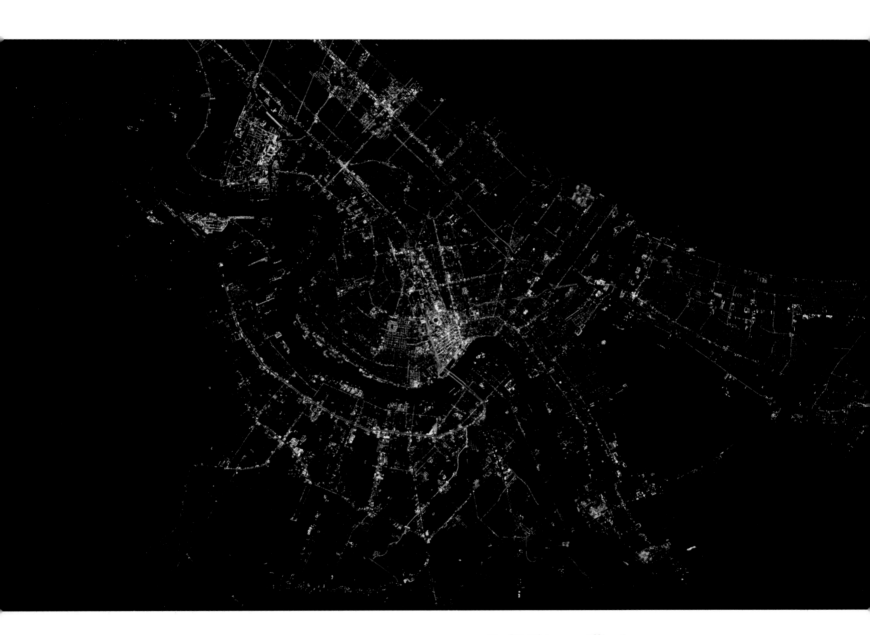

(Left) Chicago, Illinois.
(Right) New Orleans, Louisiana.
(Next spread) Melbourne, Australia (L) and
Kuwait City (R).

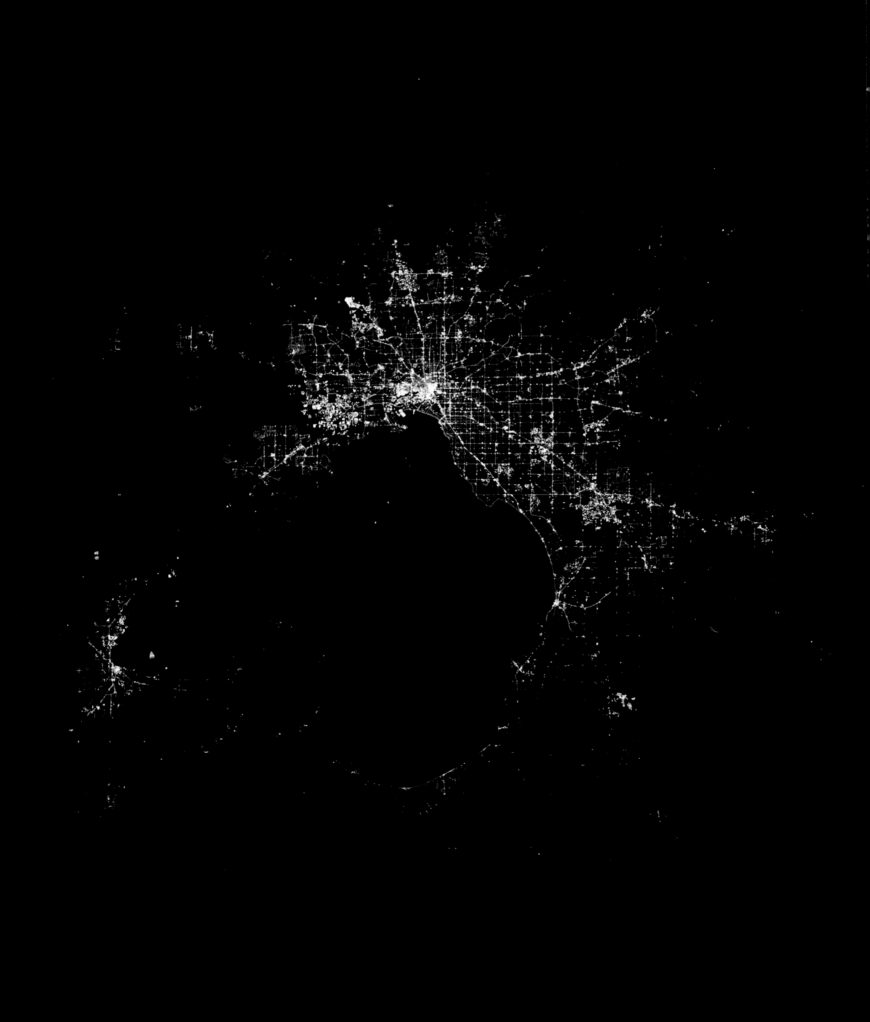

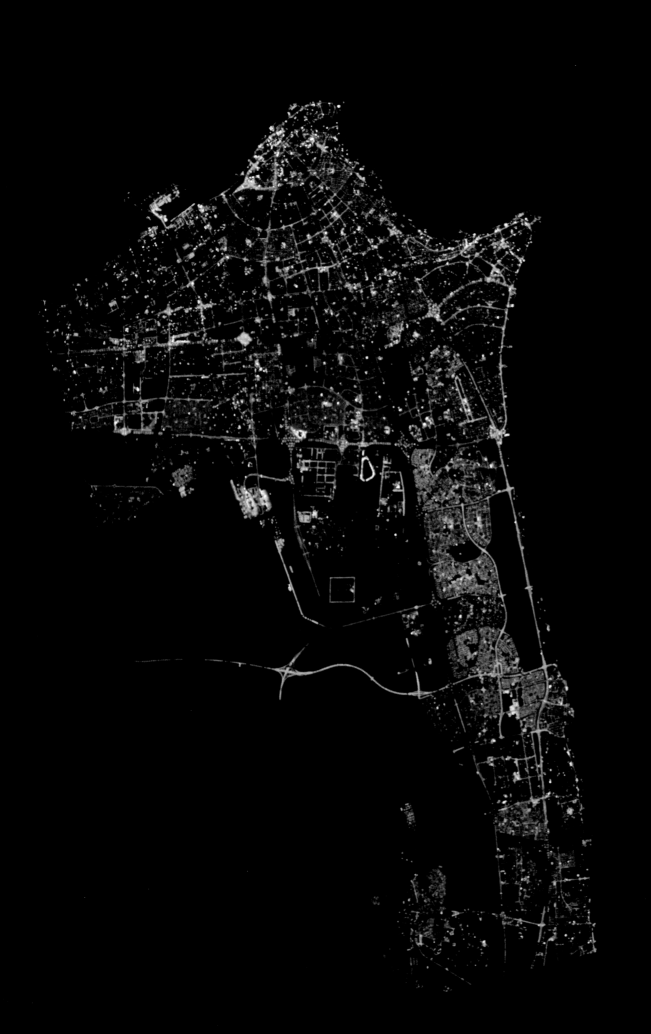

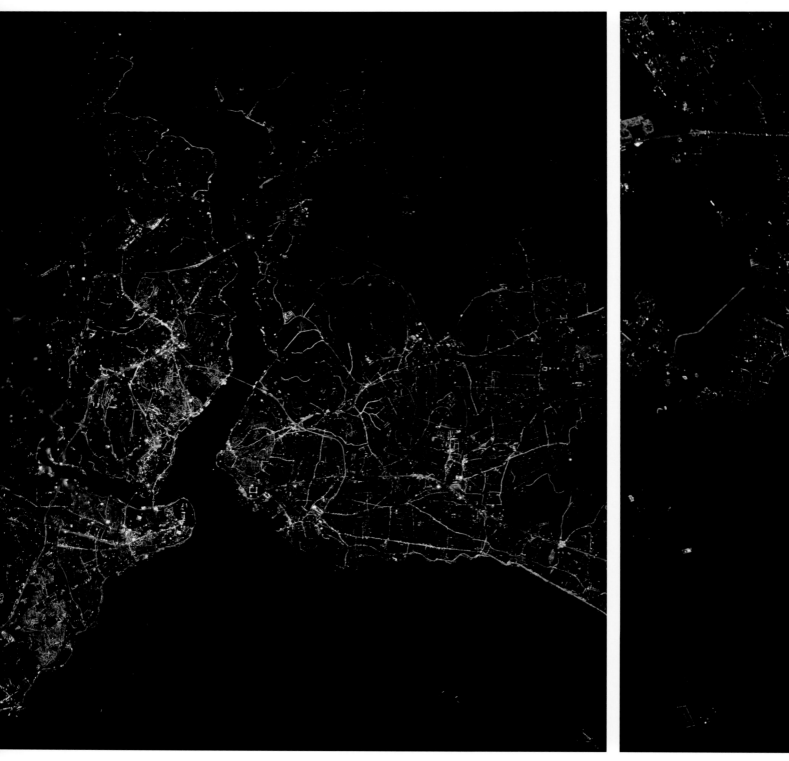

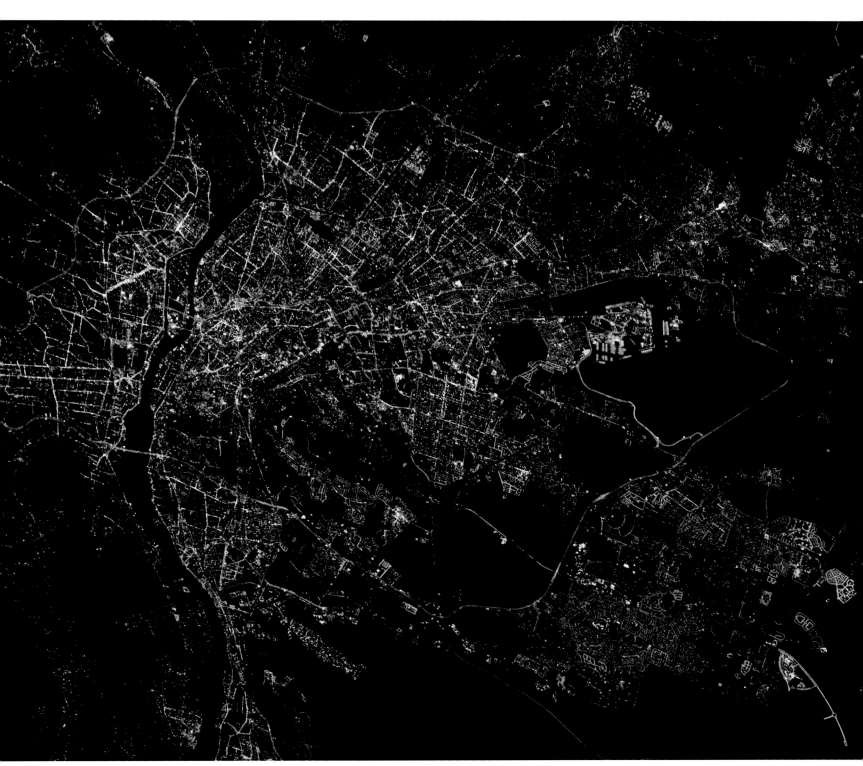

(Left) The Bosphorus, Turkey. A strait
connecting the Black Sea to the Sea of Marema.
(Right) Cairo, Egypt. (Can you find the pyramids?)
(Next spread) The Panama Canal (L) and
Monterey, Mexico (R).

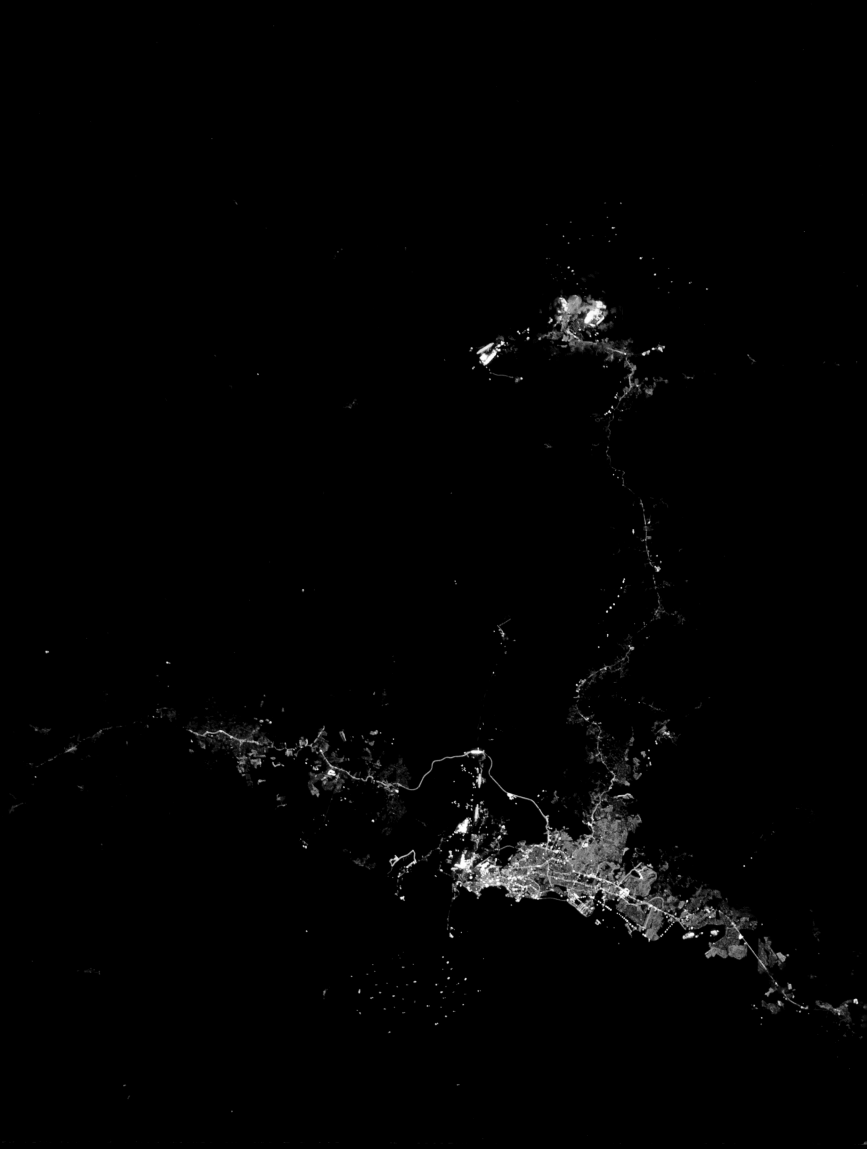

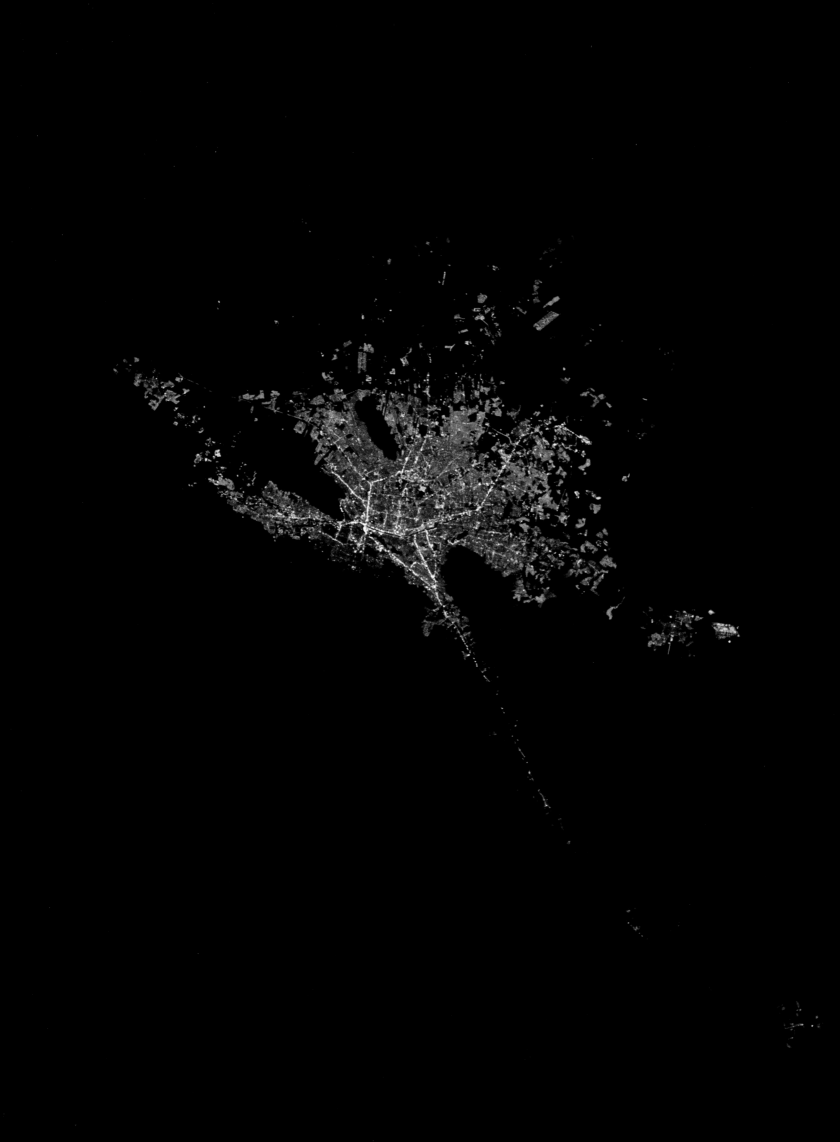

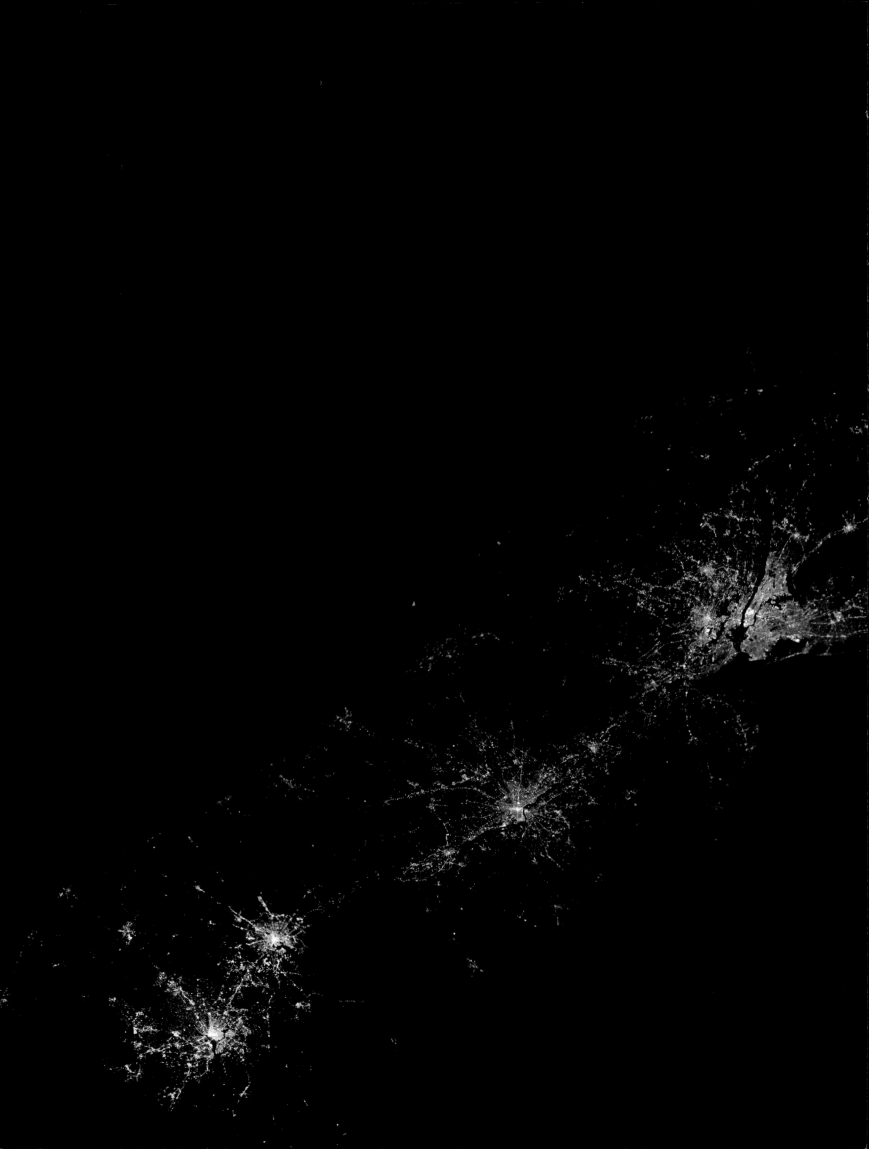

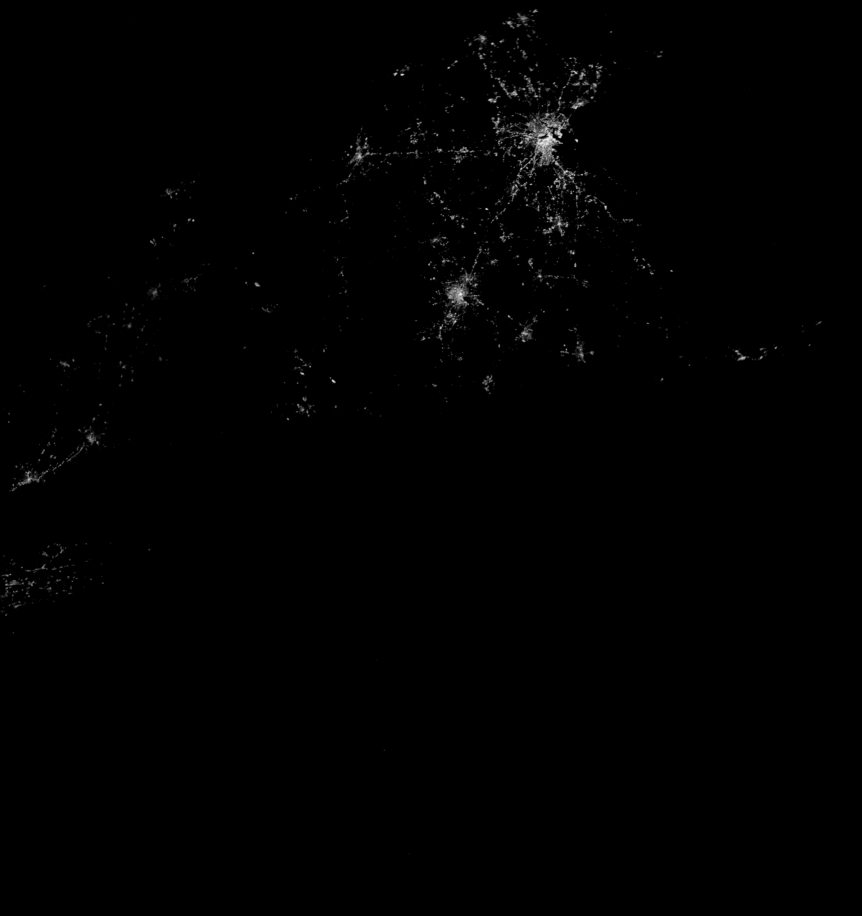

The U.S. east coast, from (bottom to top) Washington, DC, to Baltimore, Maryland, Philadelphia, Pennsylvania, New York City, and finally Boston, Massachusetts.

STAR TRAILS

Photographs can show us things that unaided human eyes cannot see. Mount a camera on a tripod, point it at the heavens, and open the shutter, and you can capture an image of curving streaks of starlight that reveal information about our planet and its position in the solar system. I have made such time exposures of space from Earth, so when I had the chance, I figured it was only fitting to make time exposures of Earth from space.

I am a shameless techno-uber-geek, and I can expound on the wonders recorded in my images at lengths that can drive even my most science-minded colleagues into abrupt, if polite, retreat. But these images resonate with something inside me. They don't show anything you could actually see just by looking out a space station window. They record surreal truths about our planet and its place in the universe. Curving lines of color define something recognizable yet tantalizing. We see an image that does not quite fit within our Earth-honed frames of reference. Periodic white flashes create dots and dashes, as if someone, or something, is sending a Morse-code message into space. A mysterious horizon challenges the mind to identify exactly what planet we're seeing. Silhouettes of machinery, like techno-ghosts, paint human builders into the story. Where is this place? Is this a natural event or a moment of surreal imagination?

Focused intently on the intersection of science and art, these images provoke new perceptions.

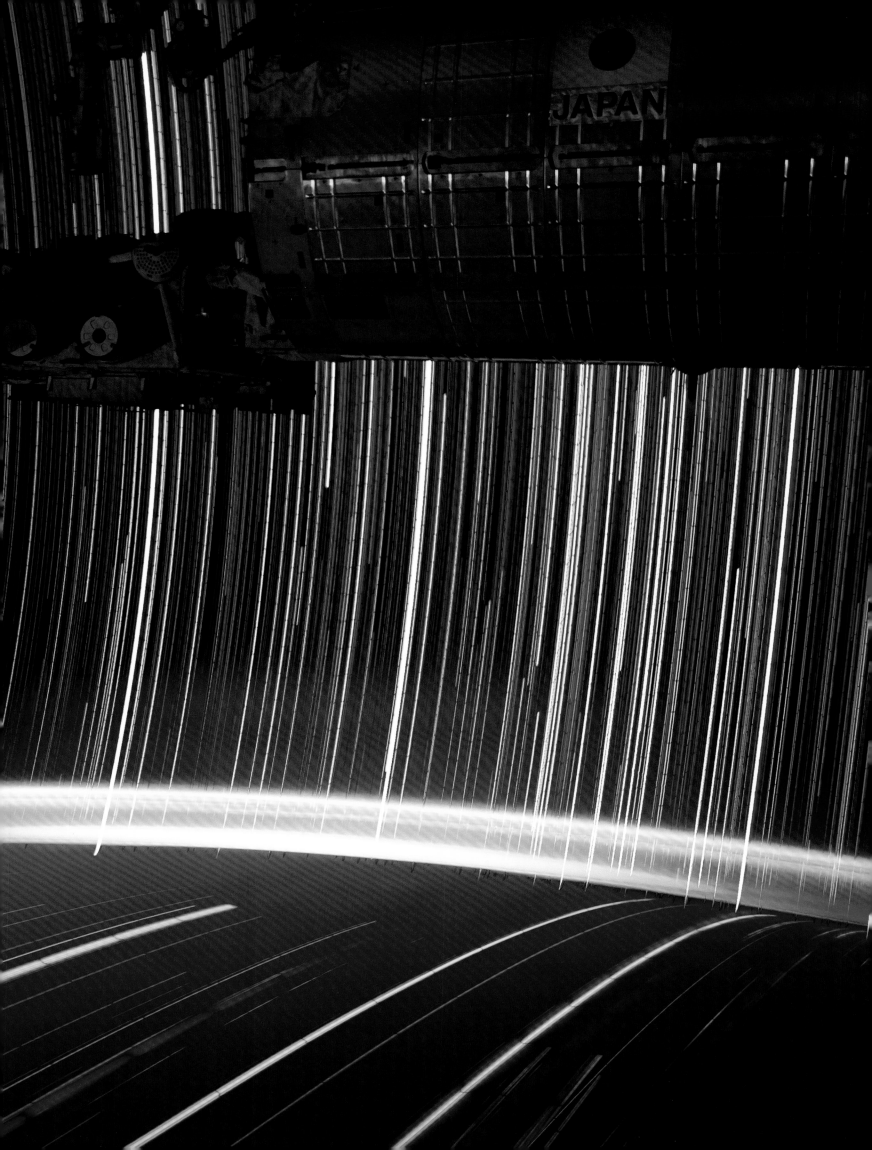

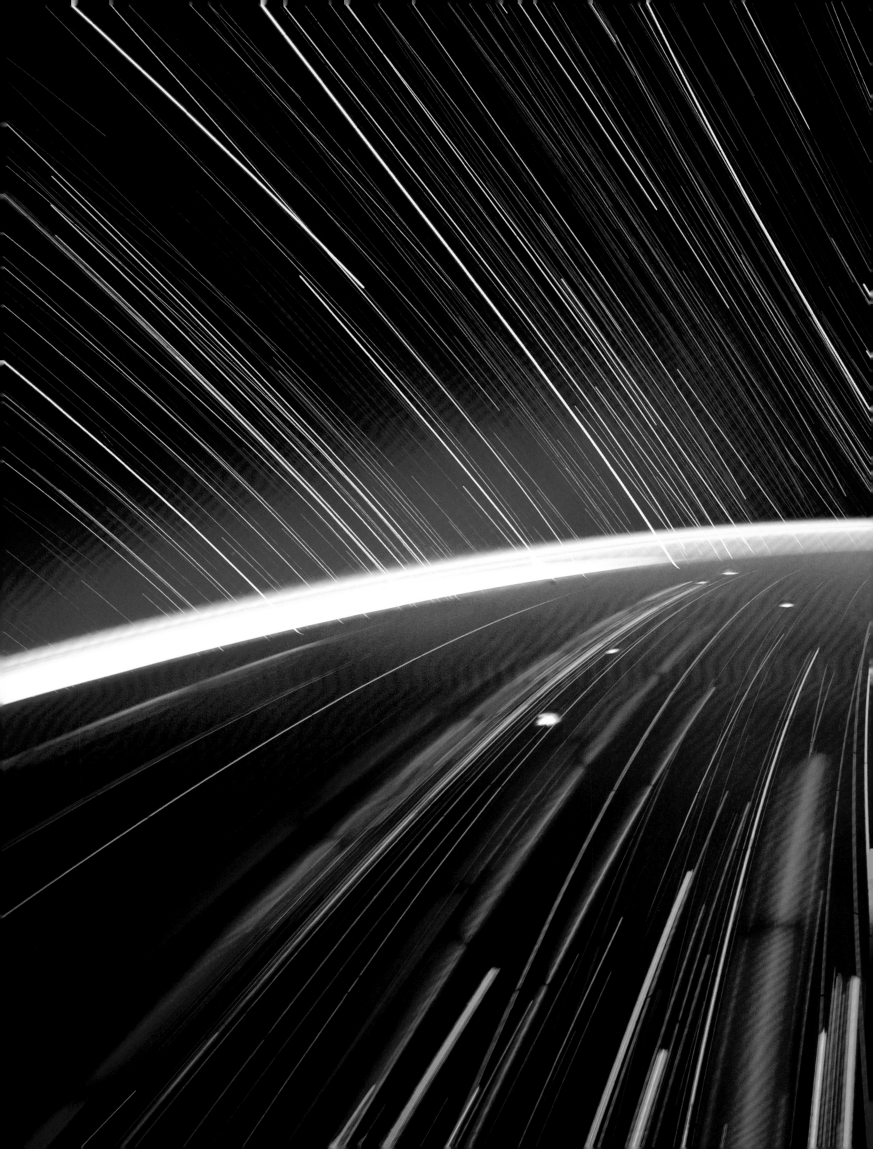

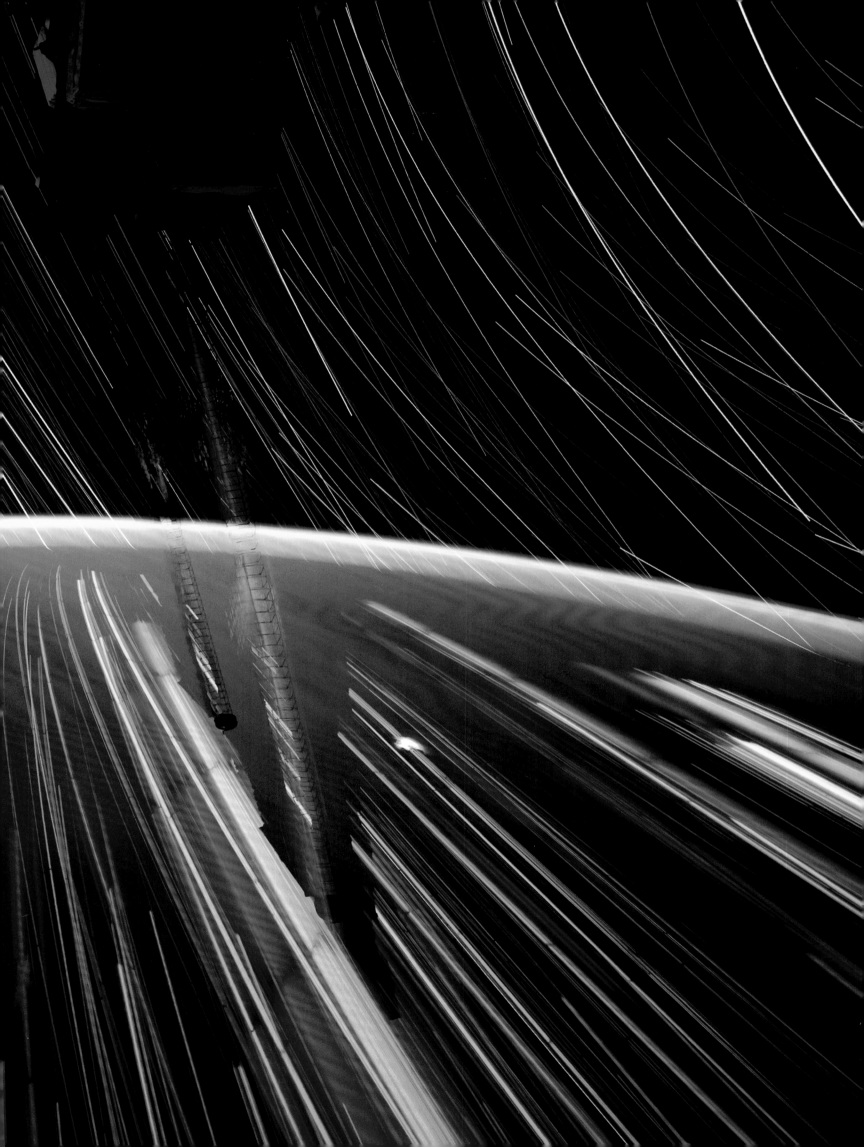

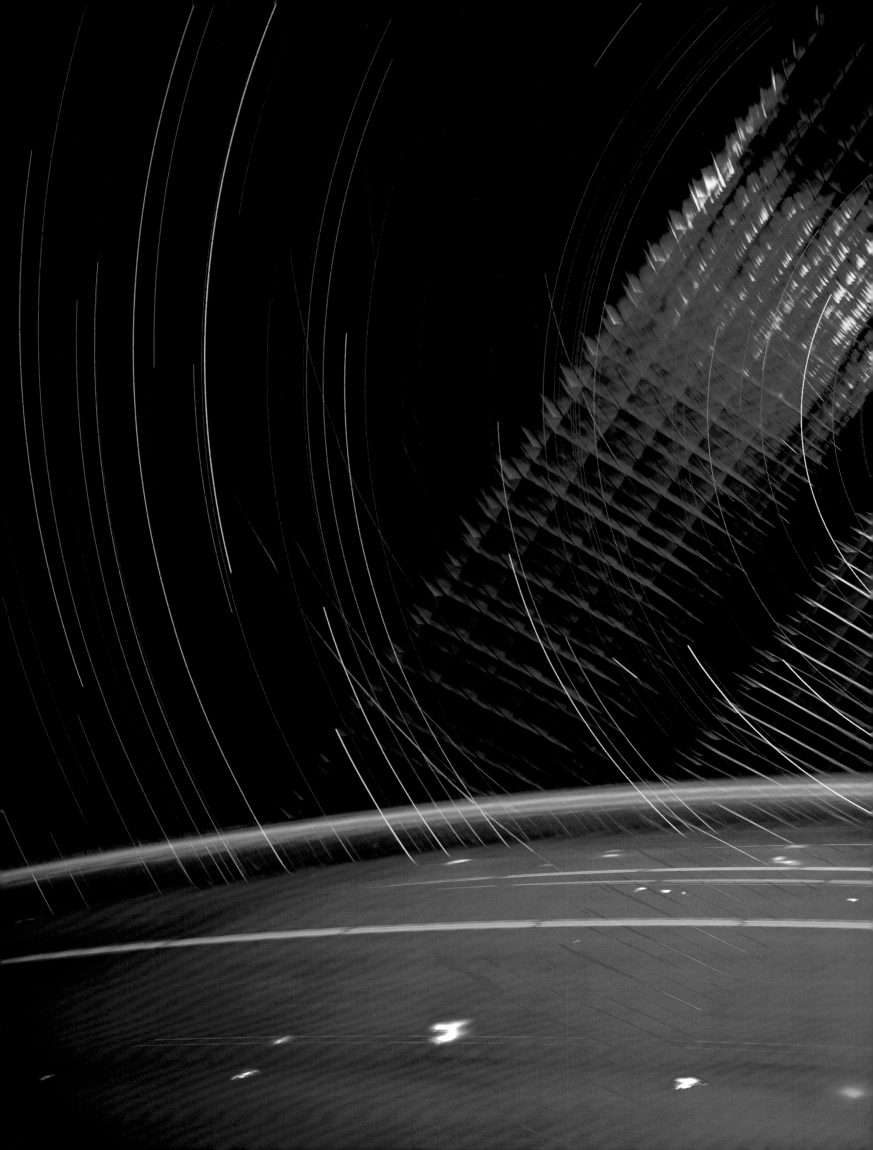

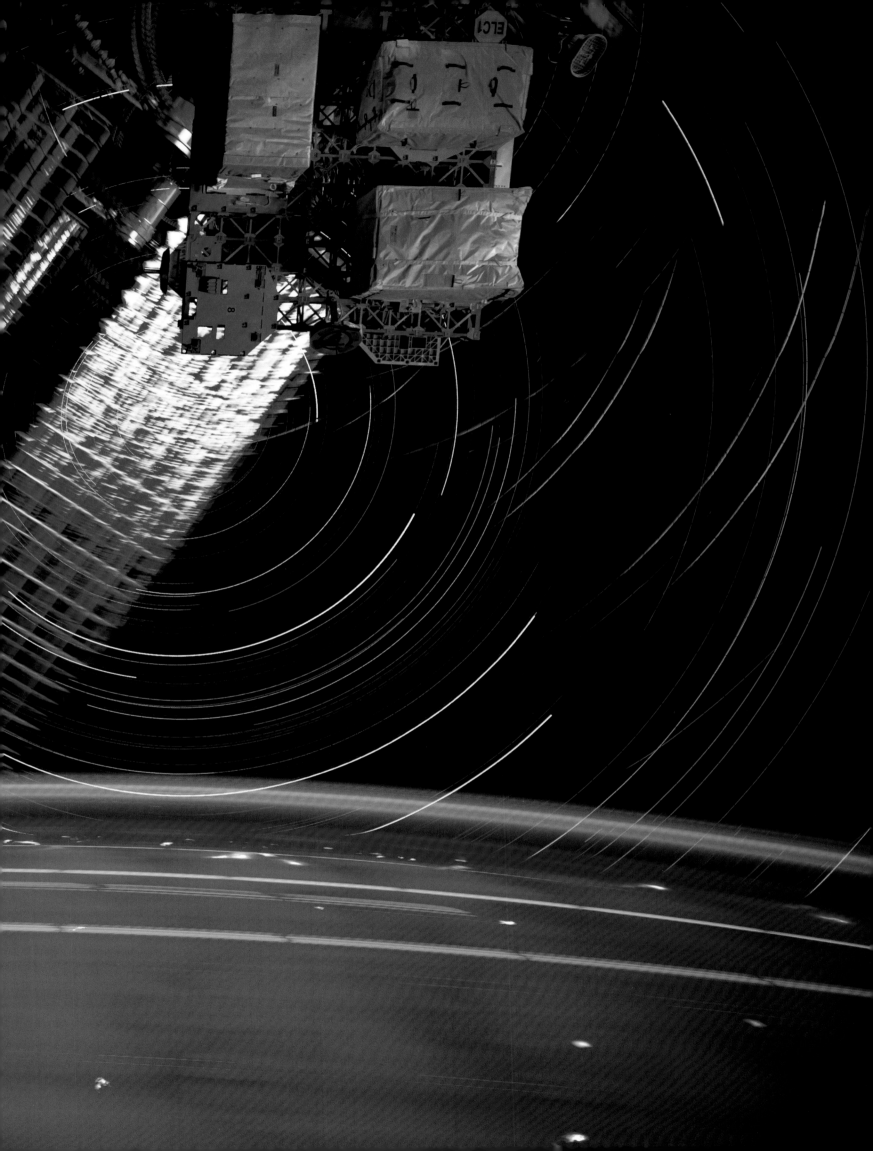

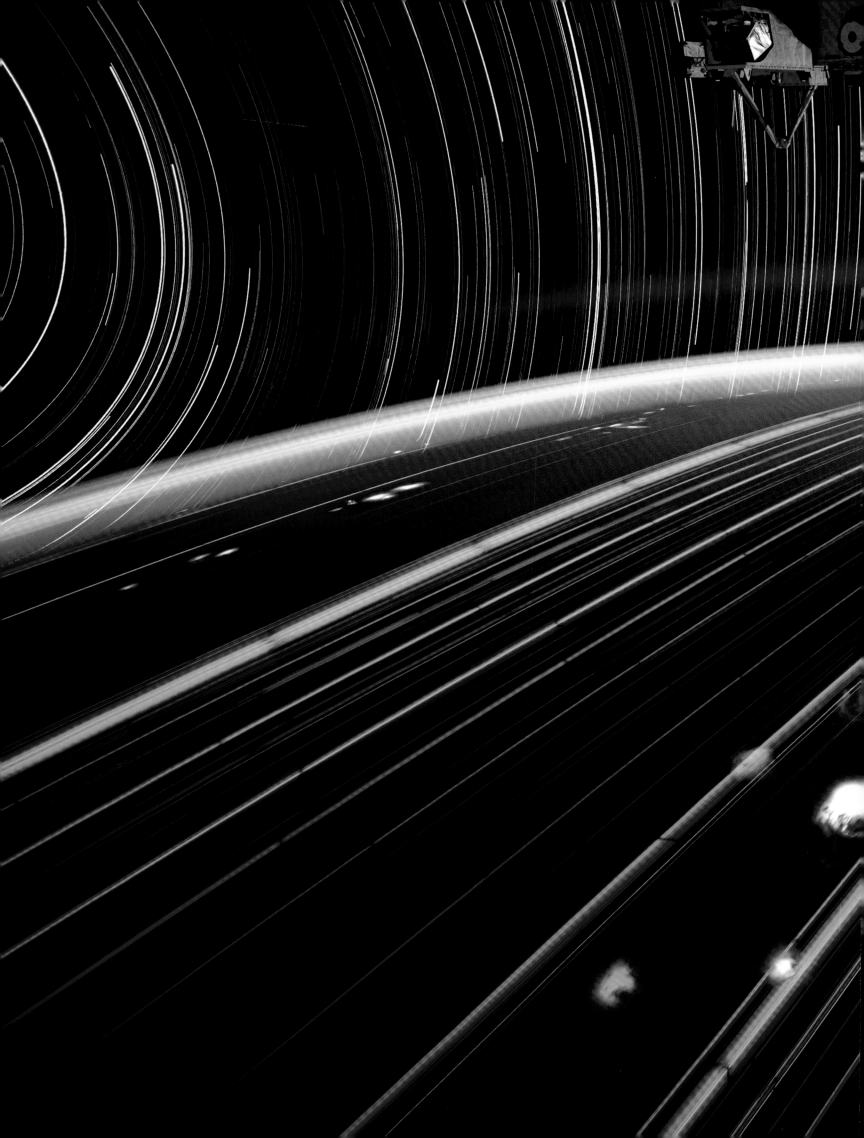

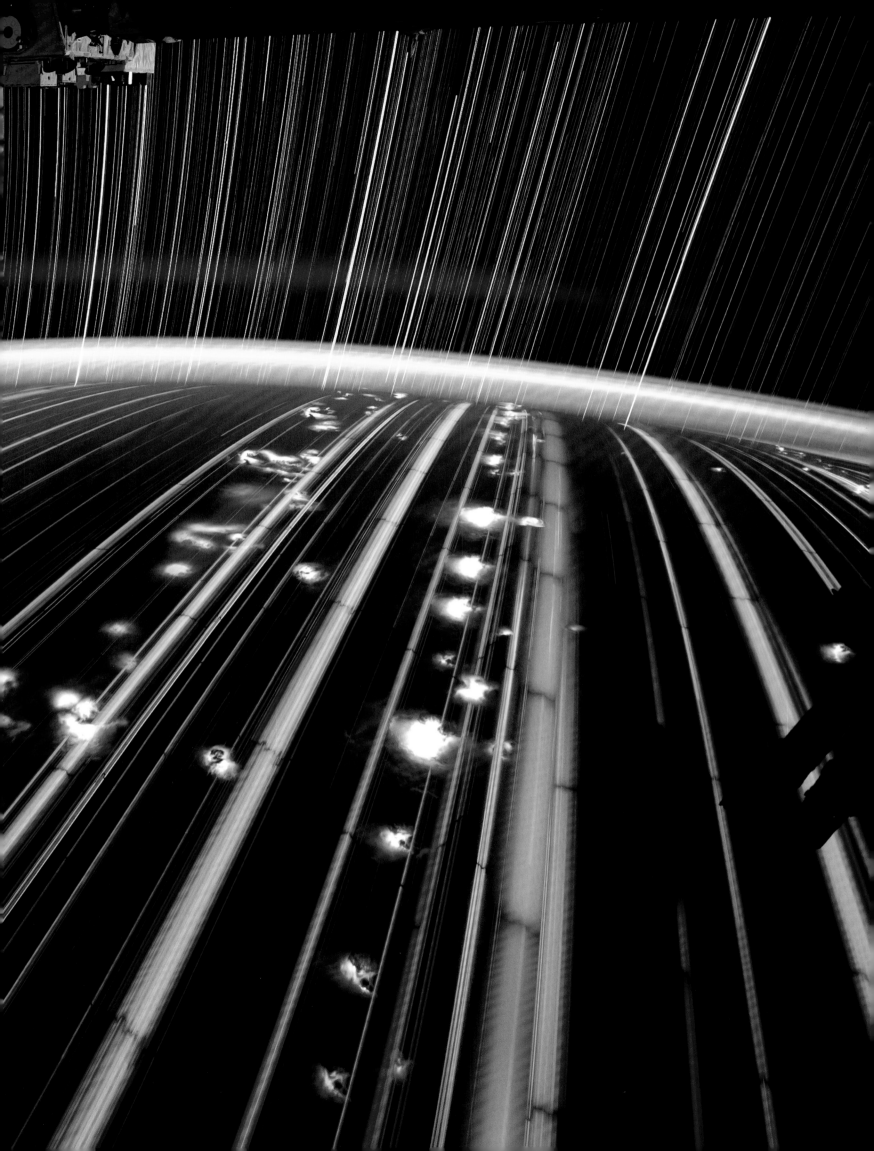

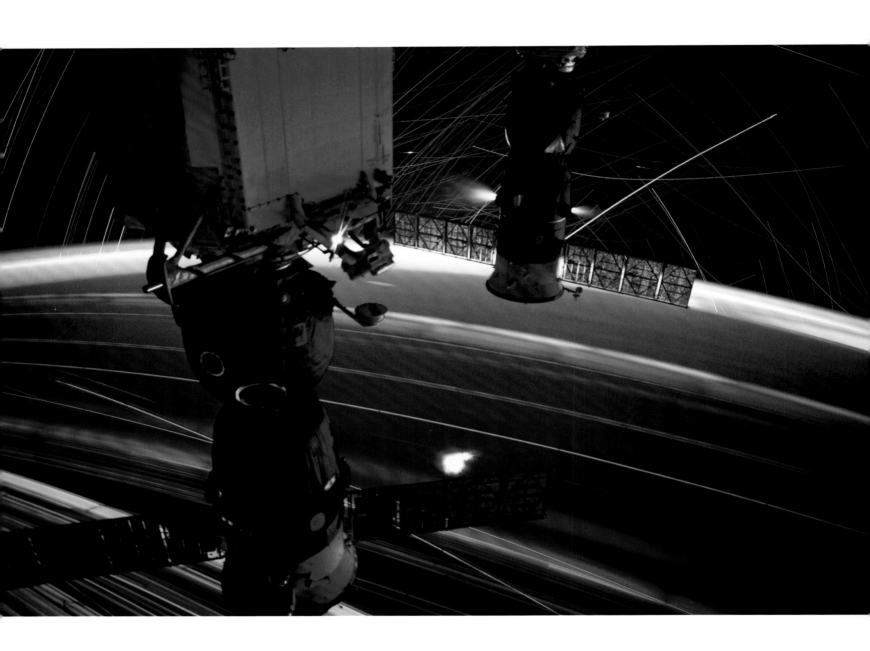

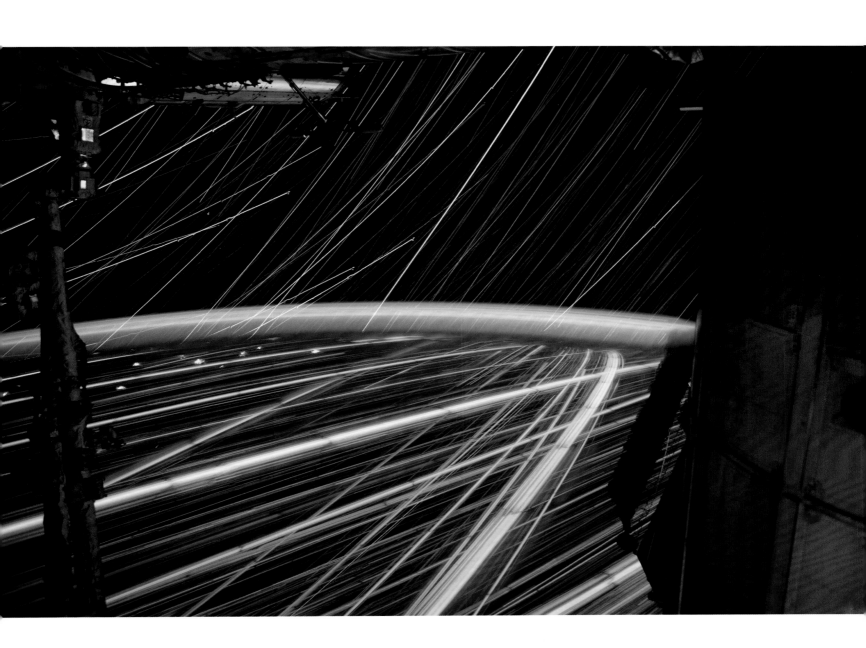

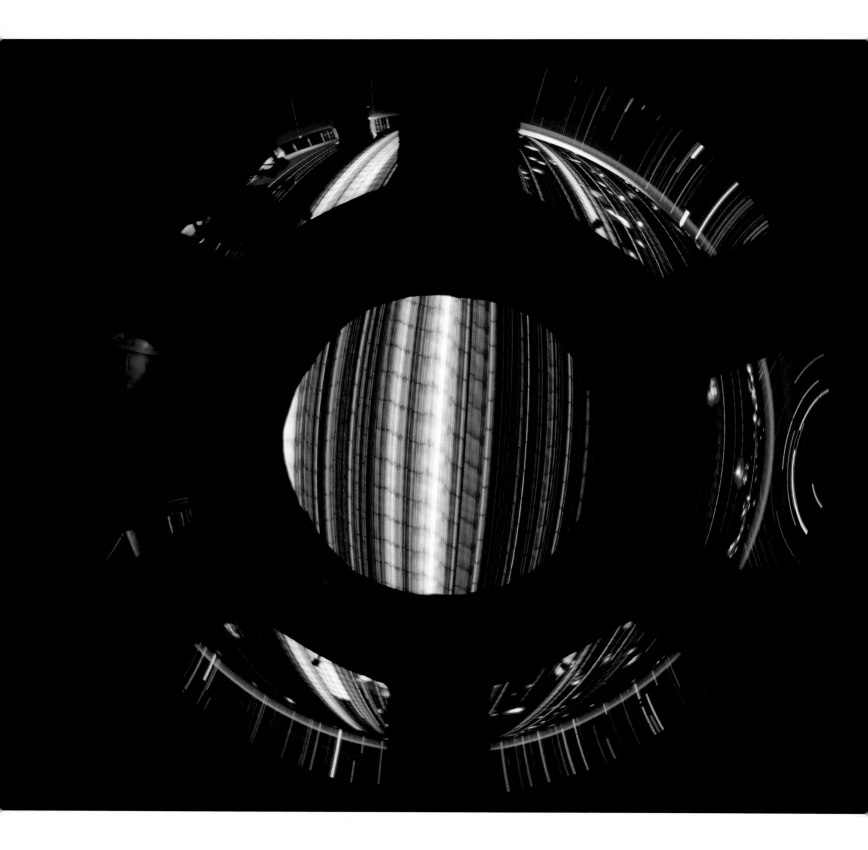

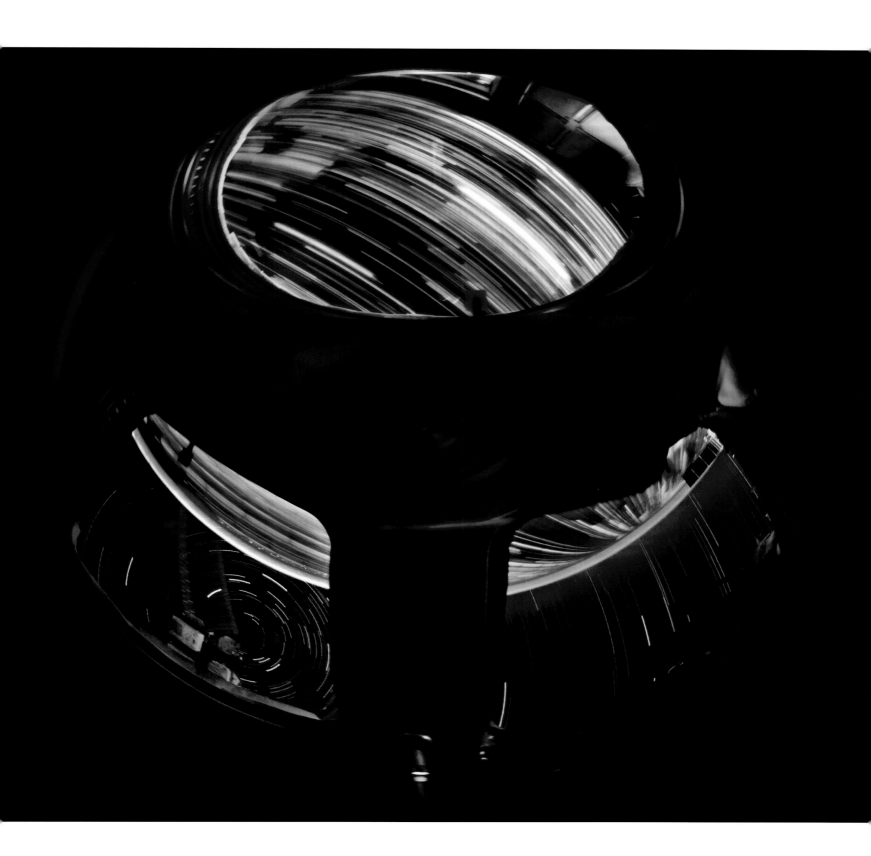

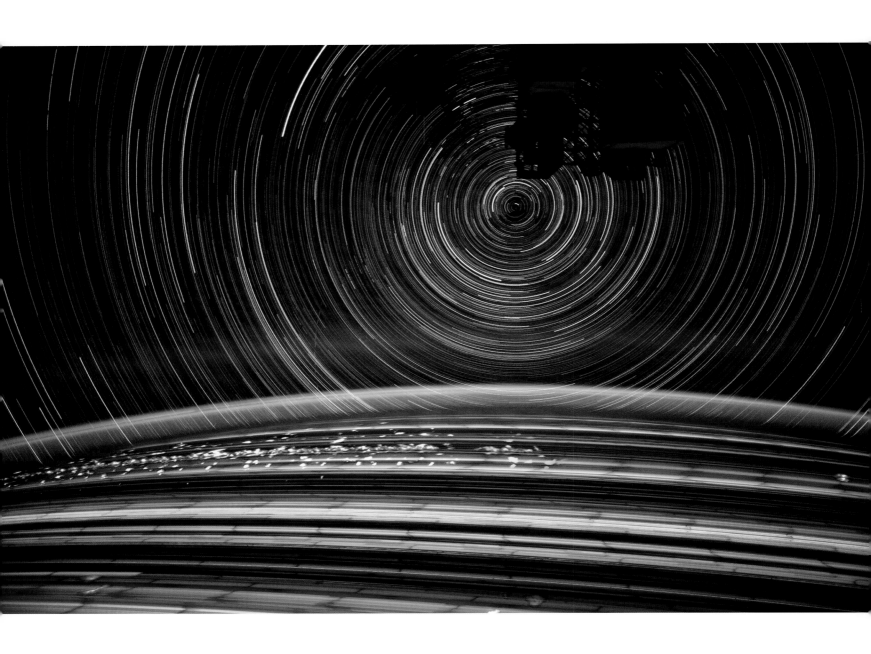

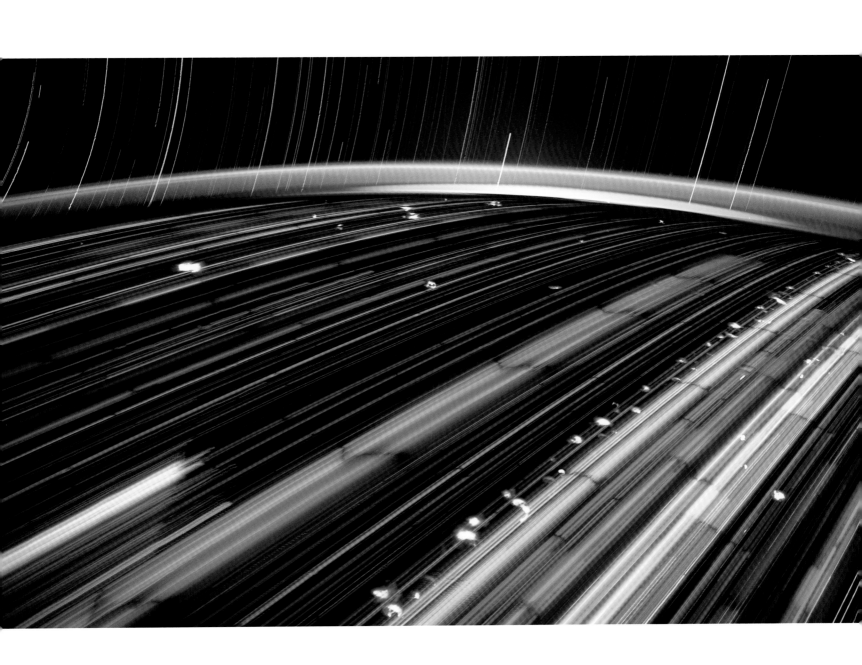

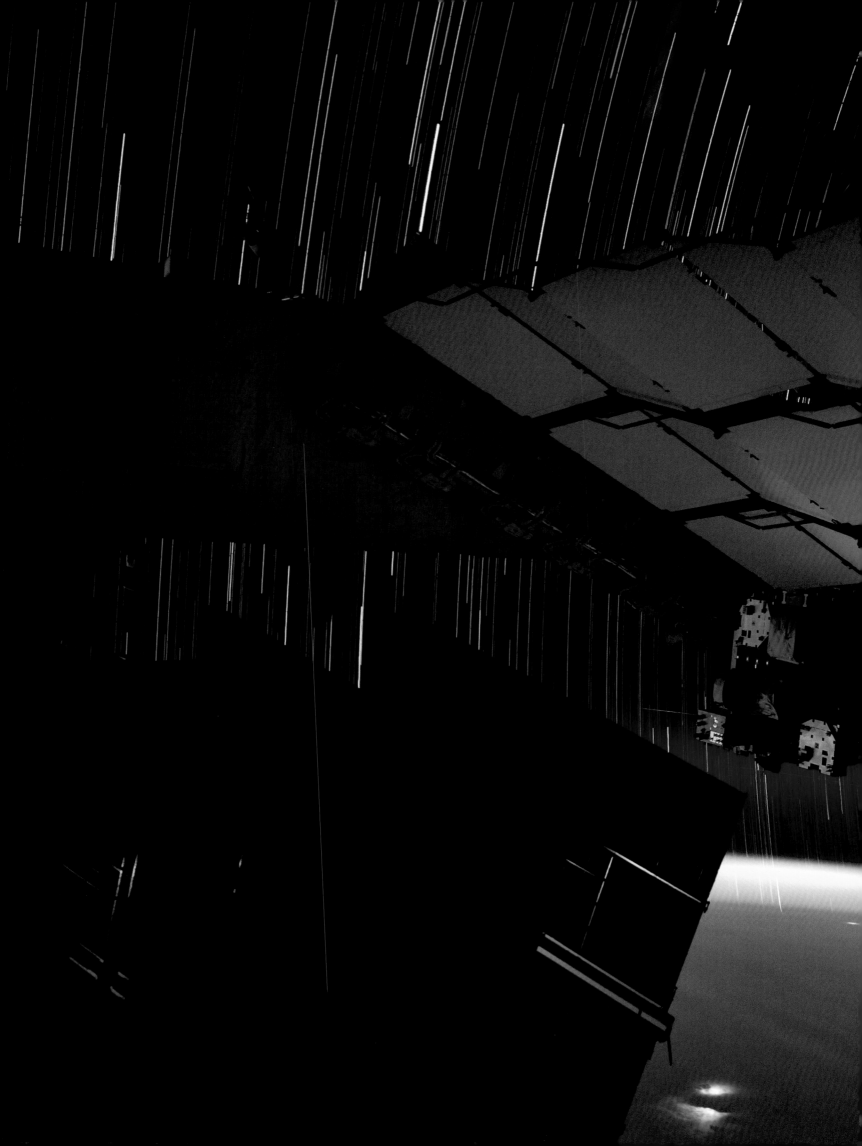

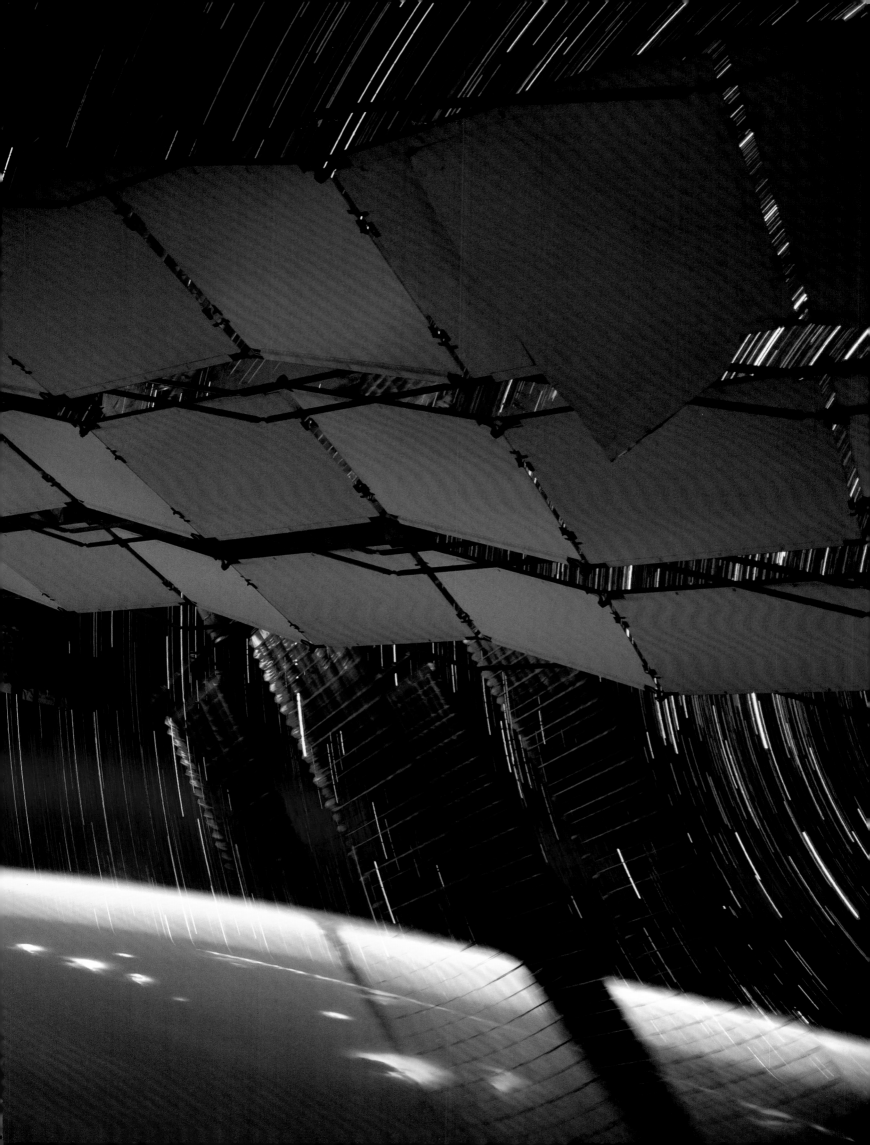

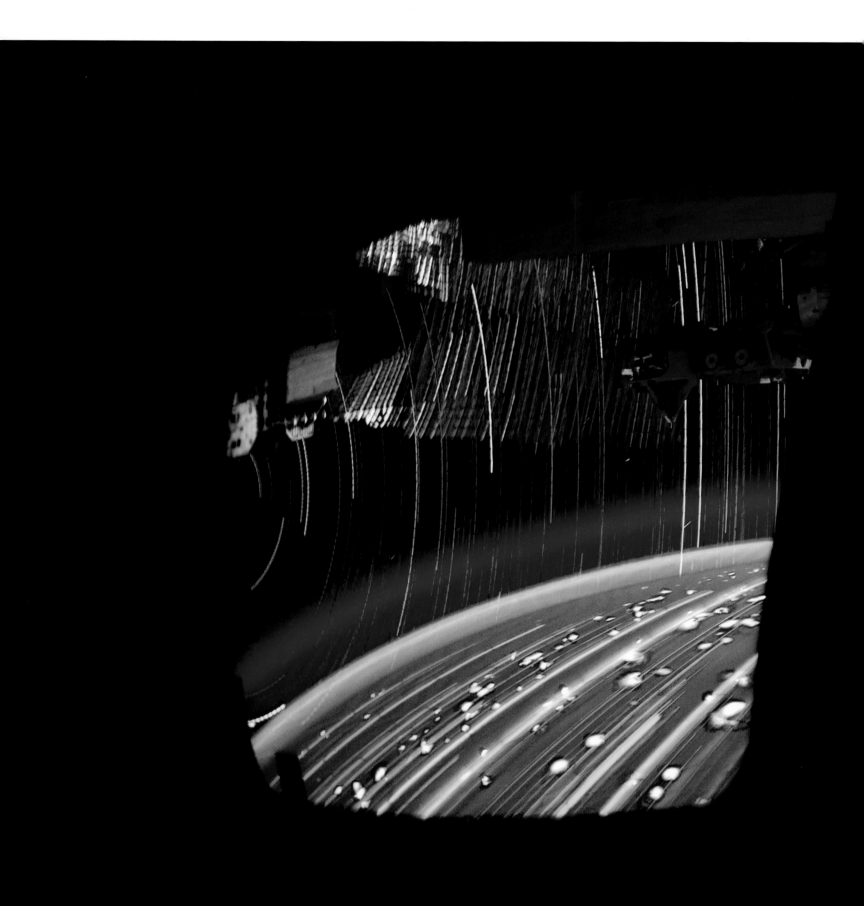

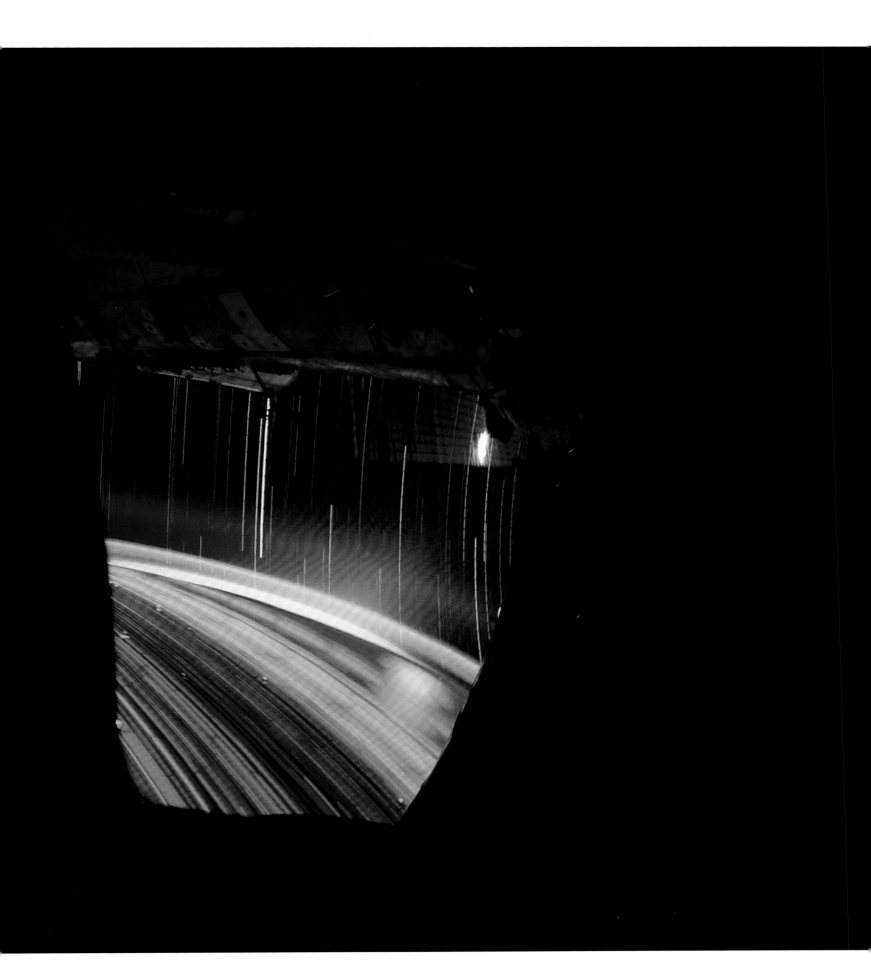

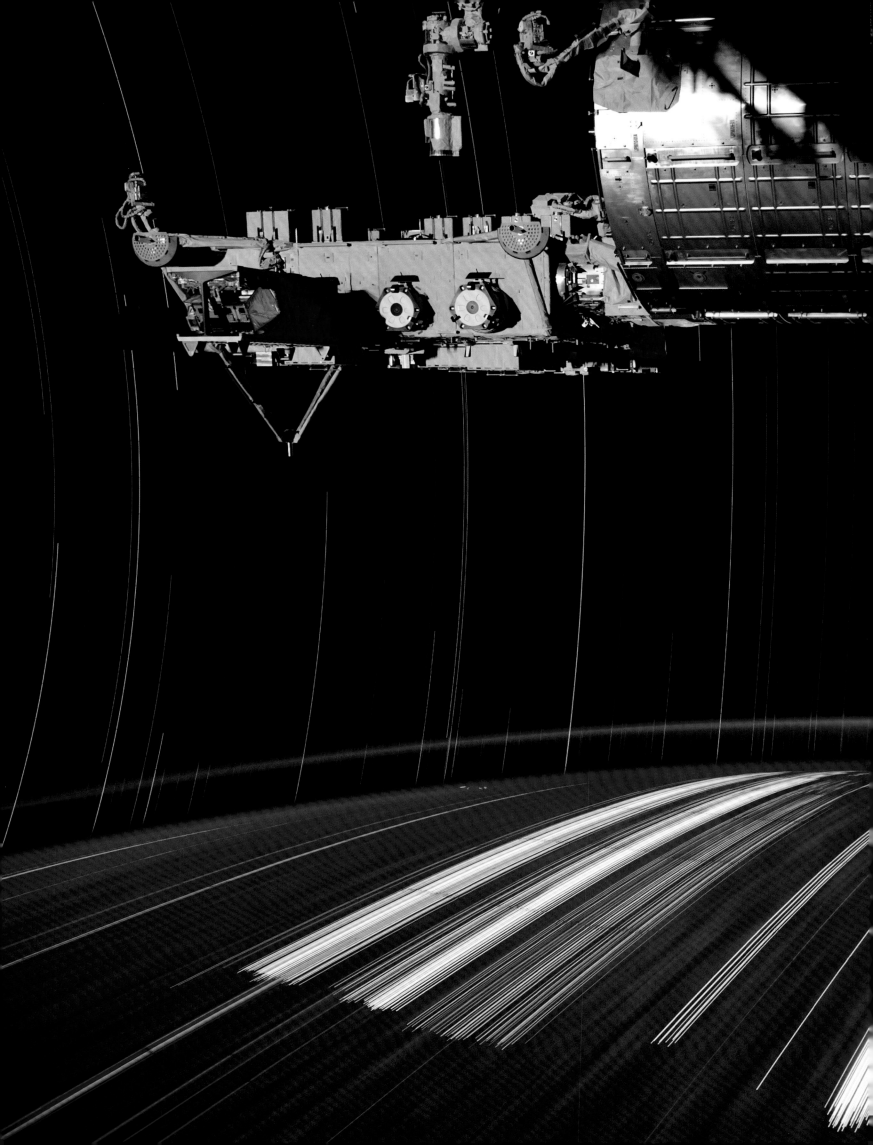

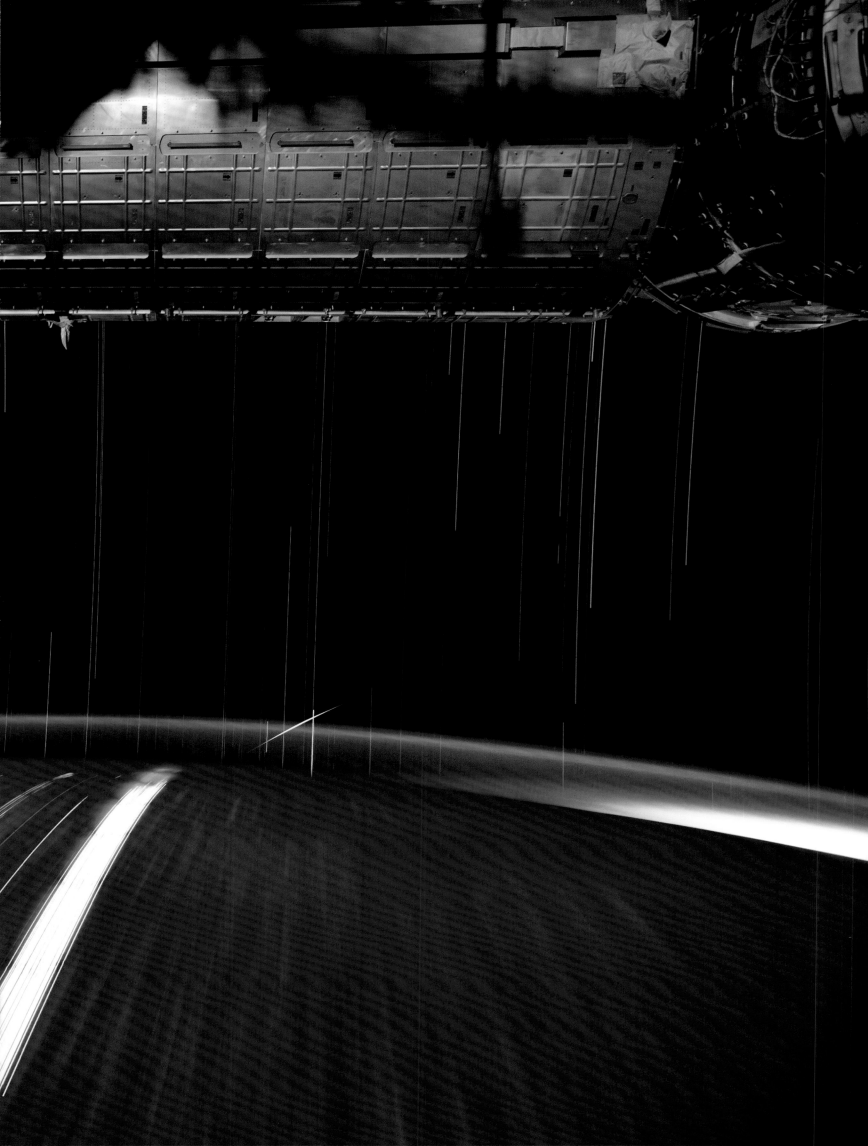

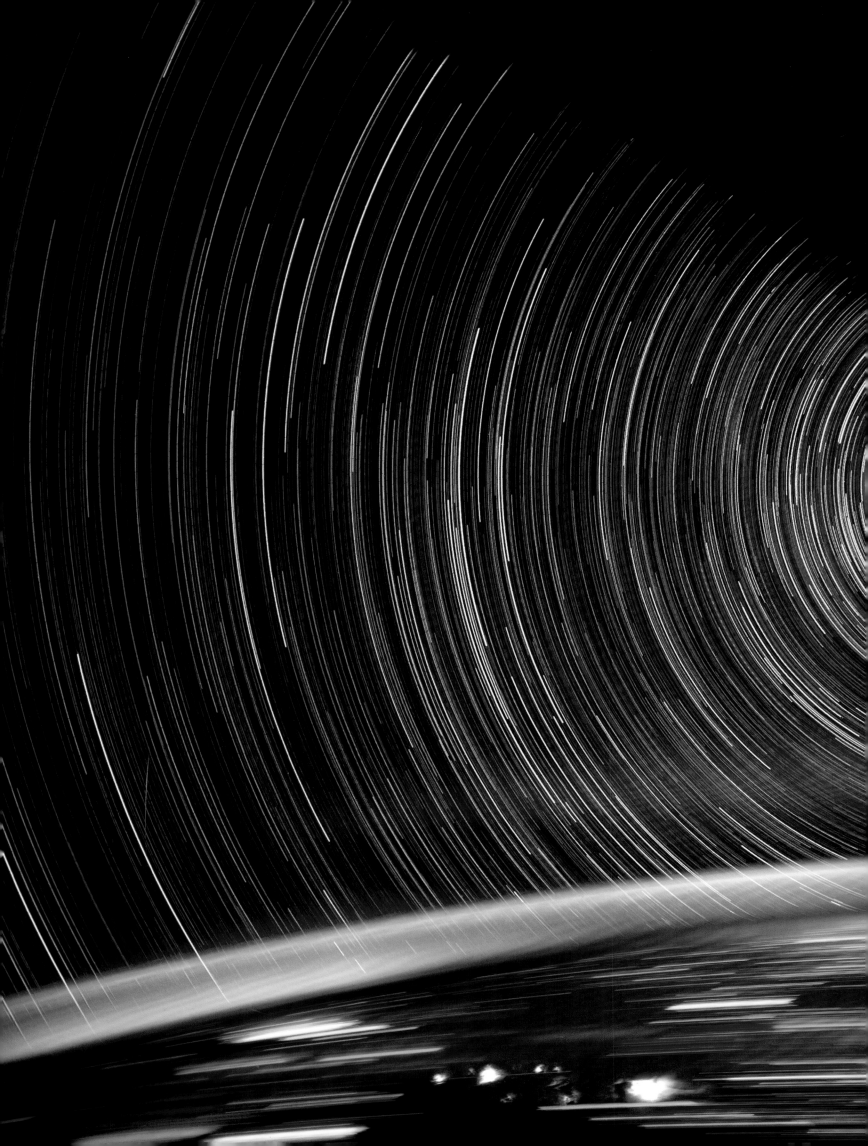

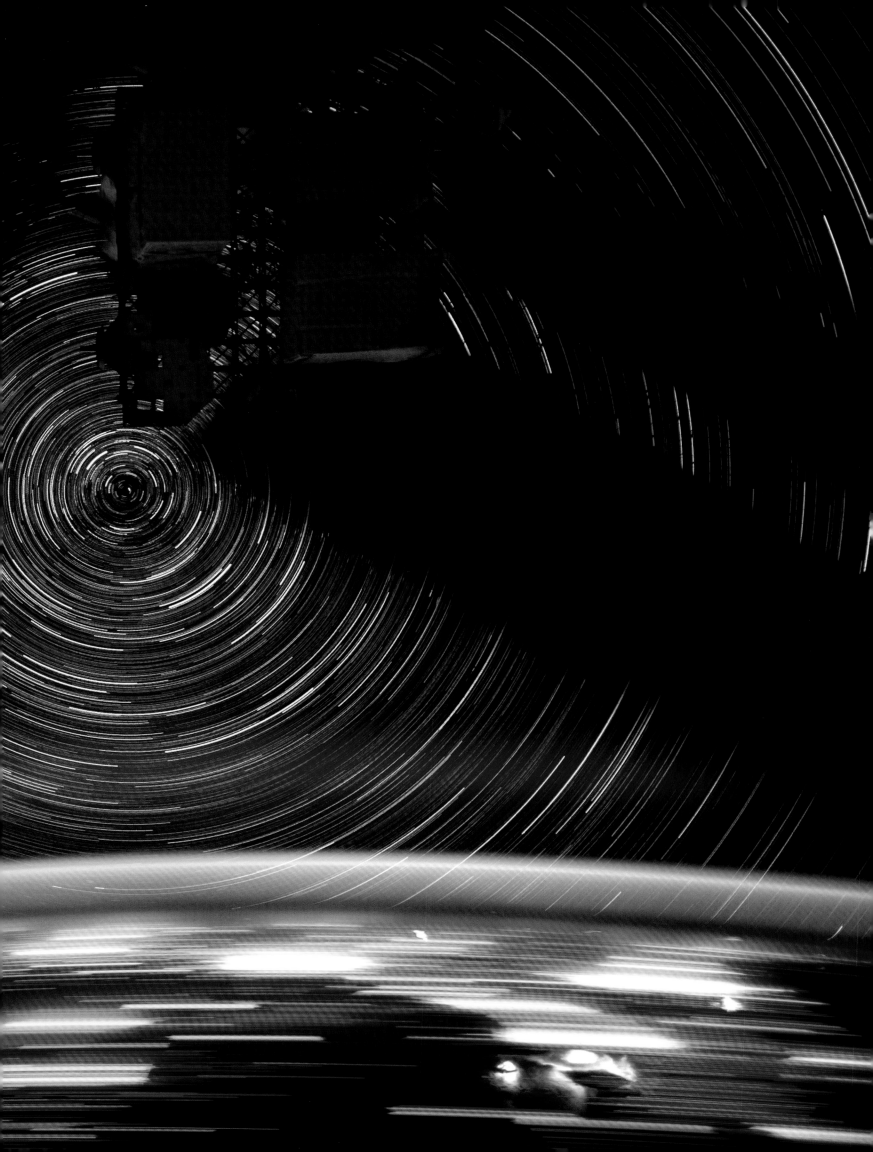

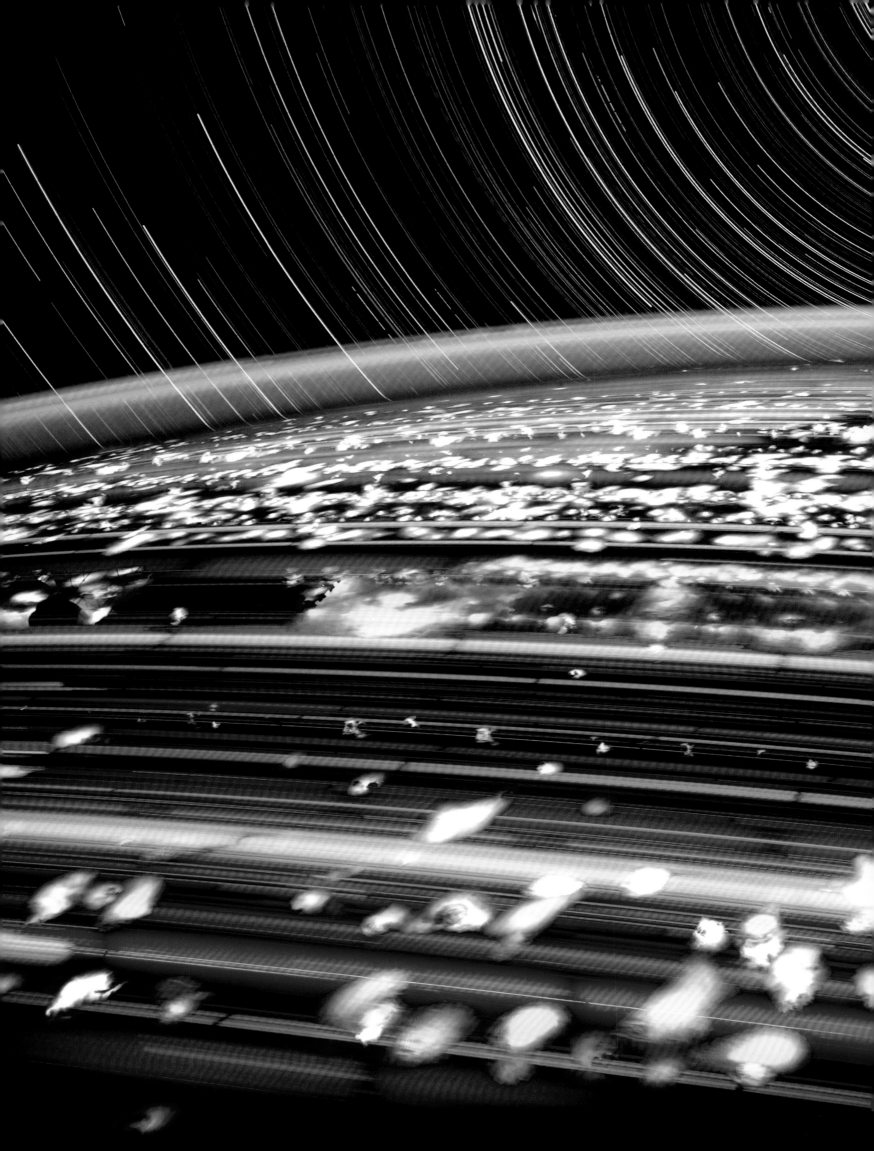

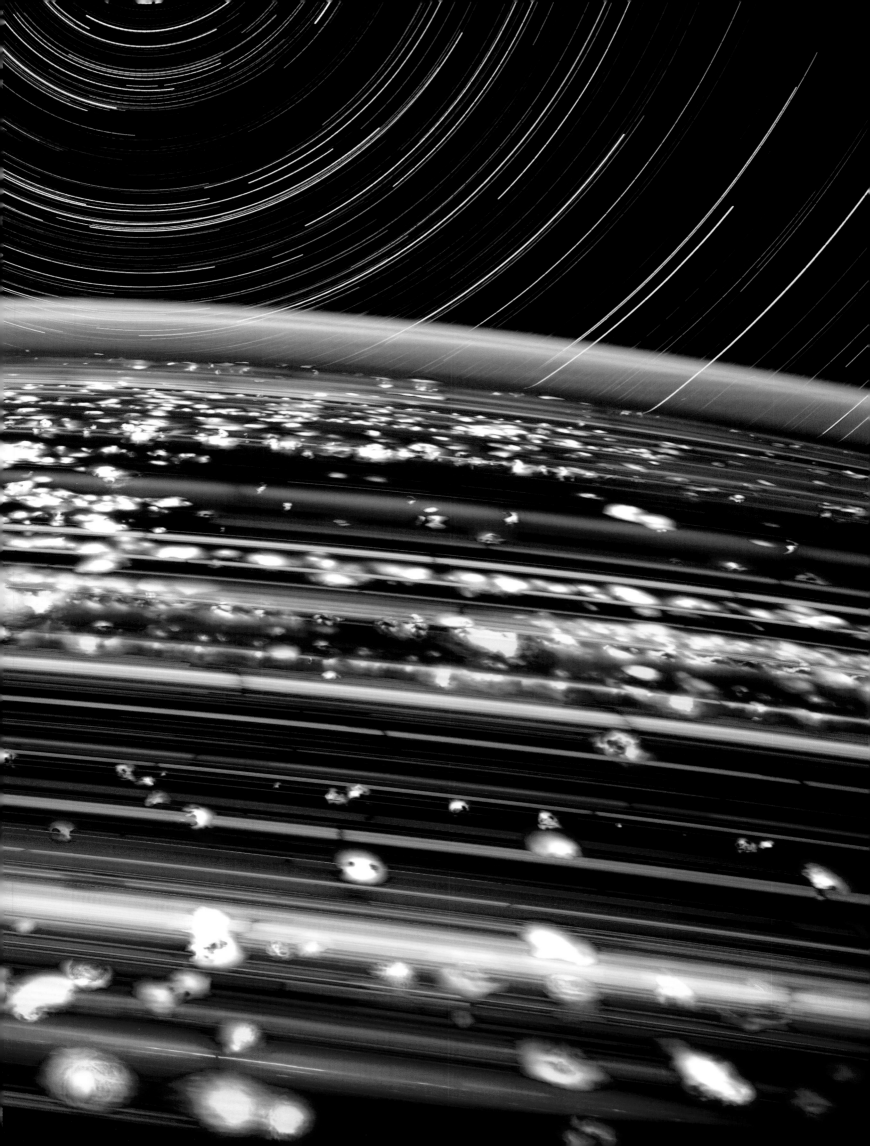

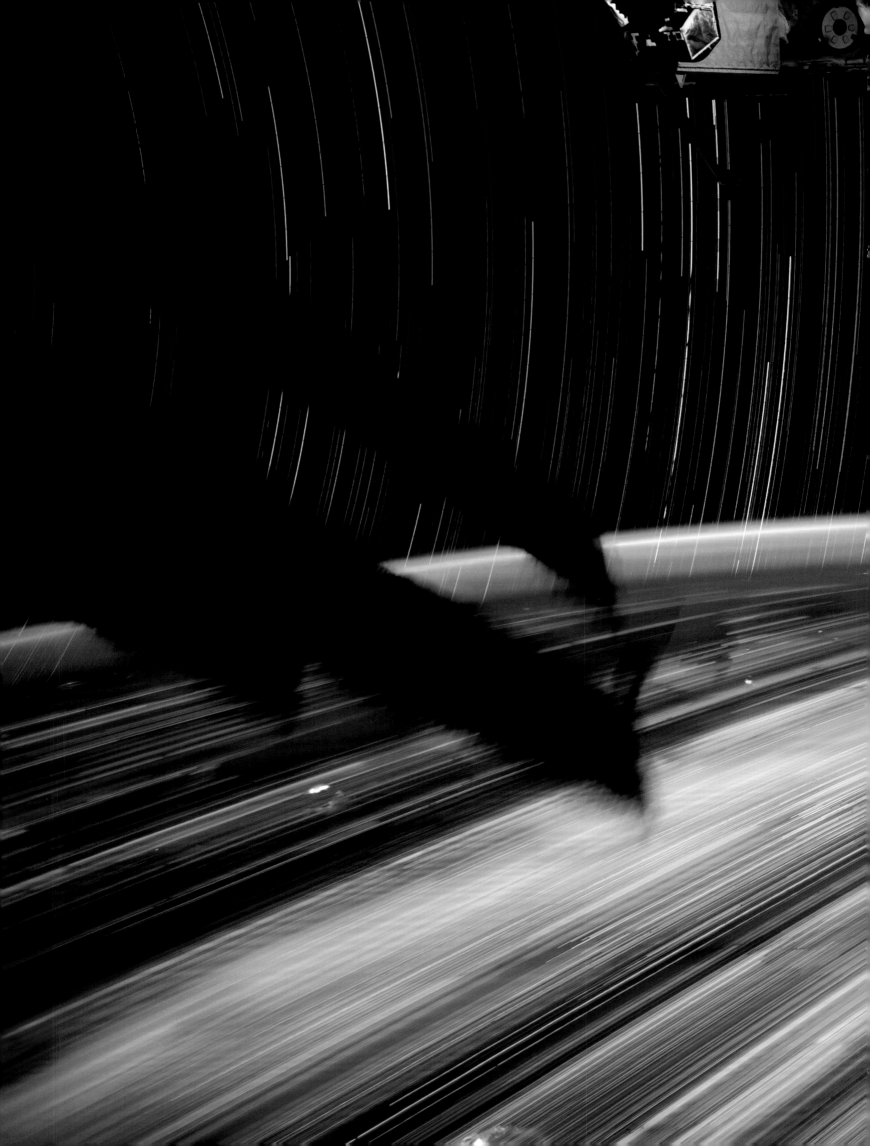

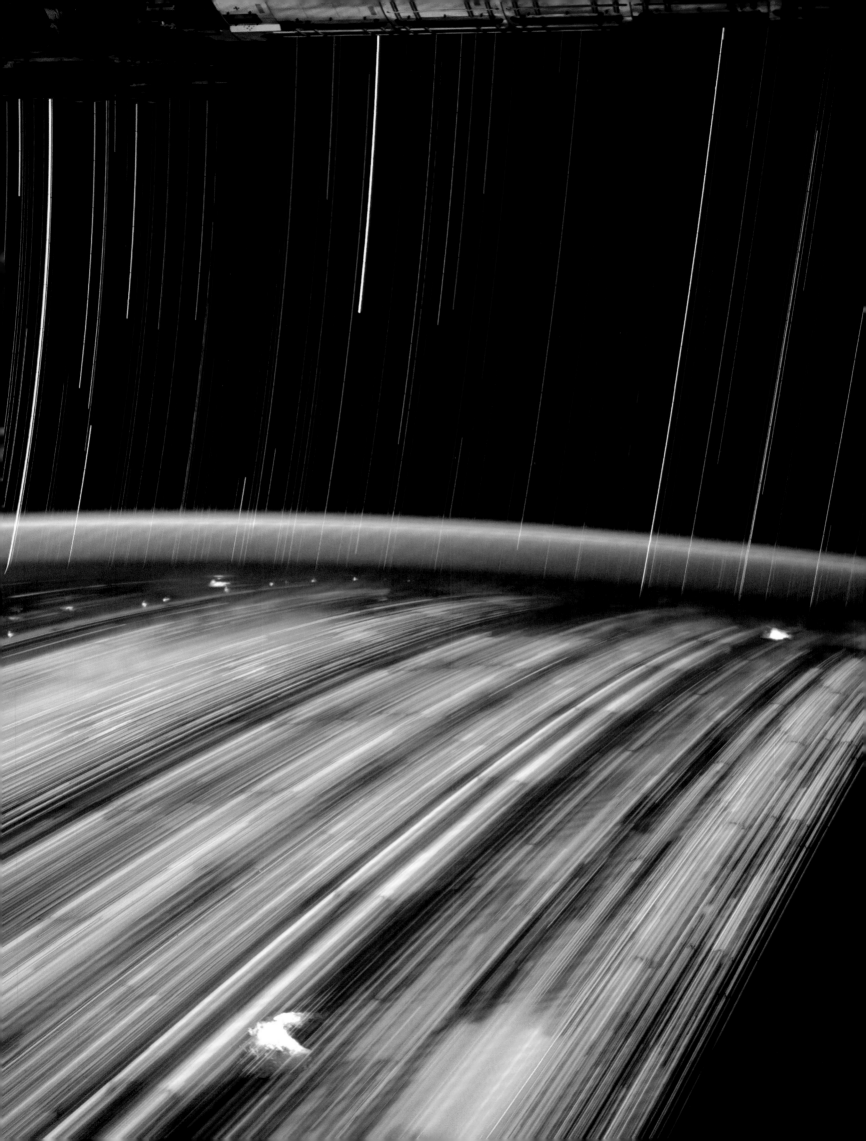

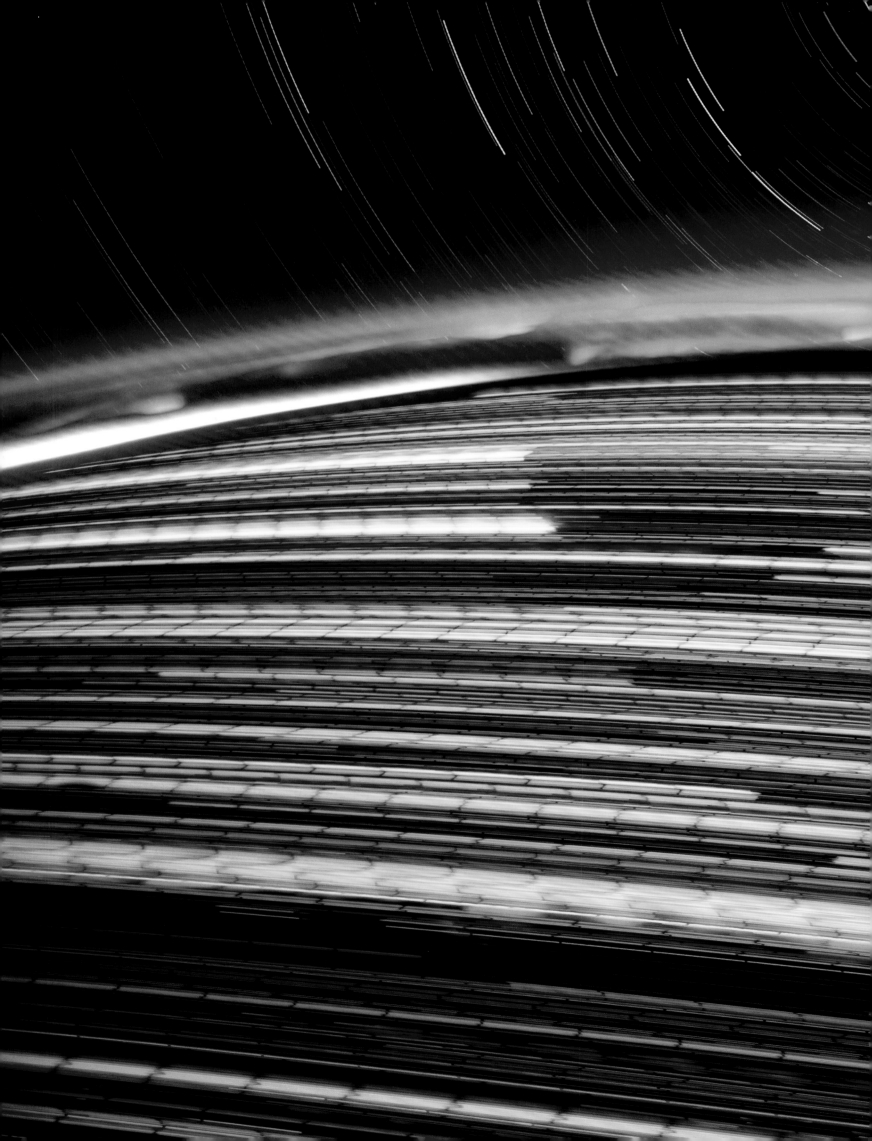

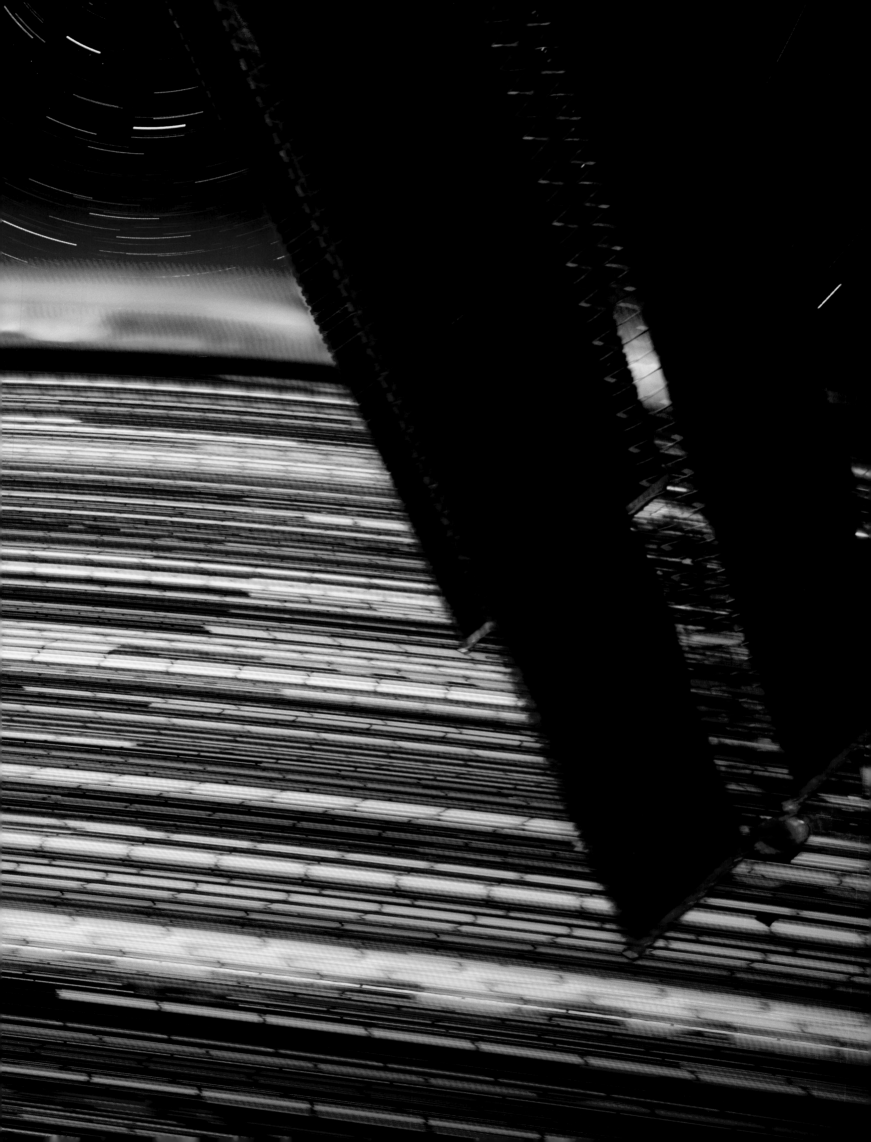

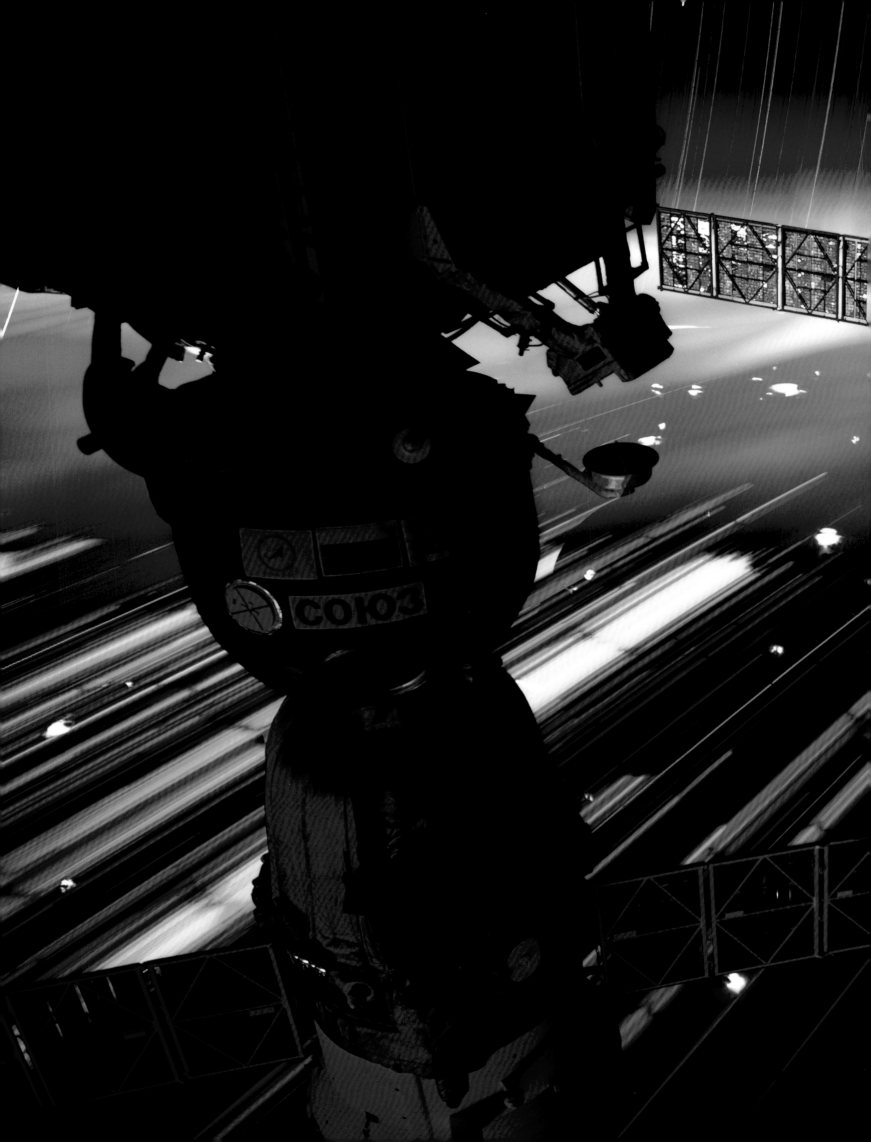

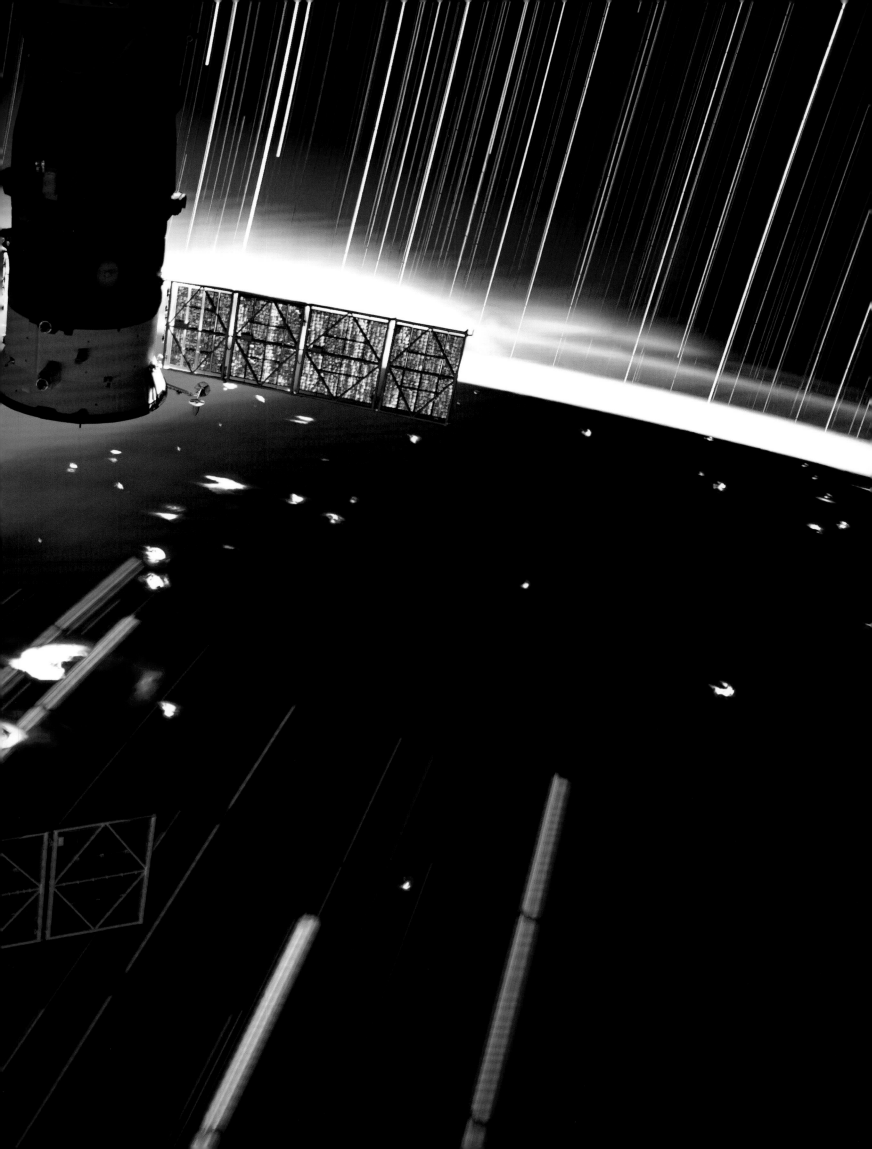

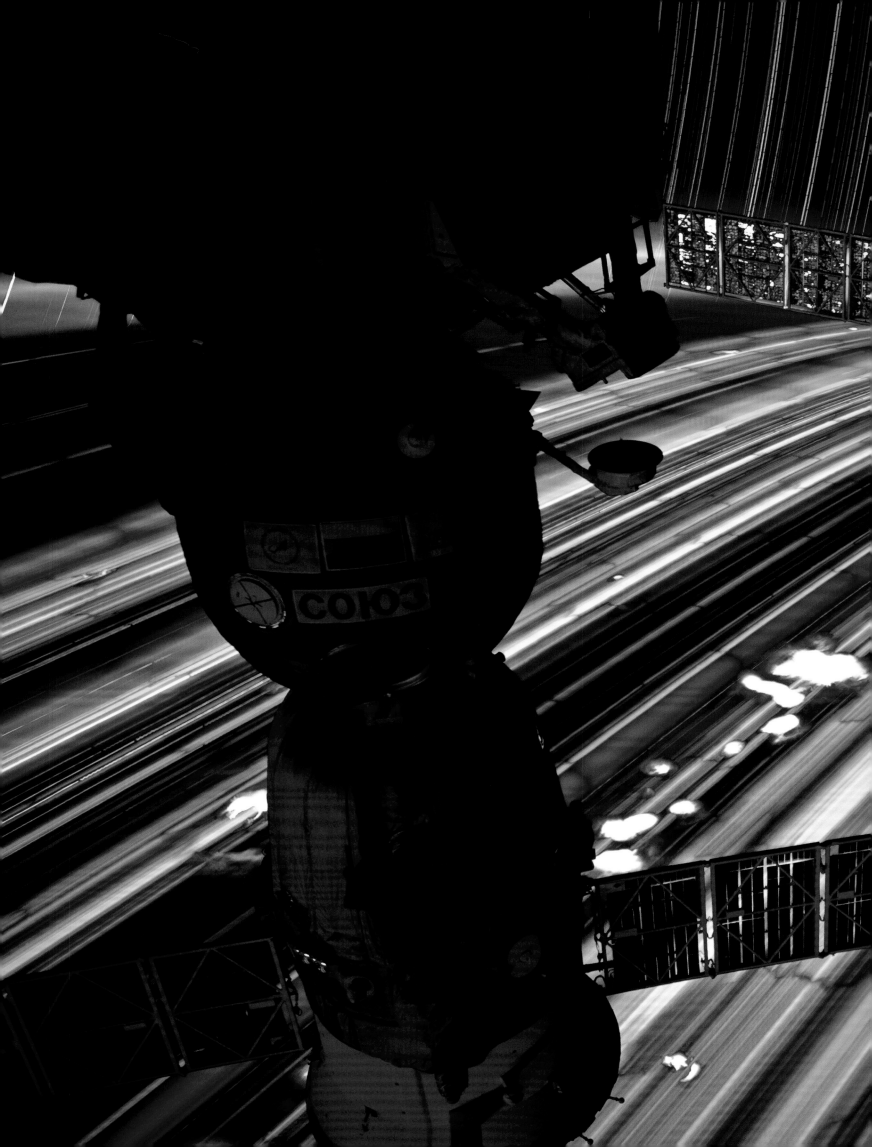

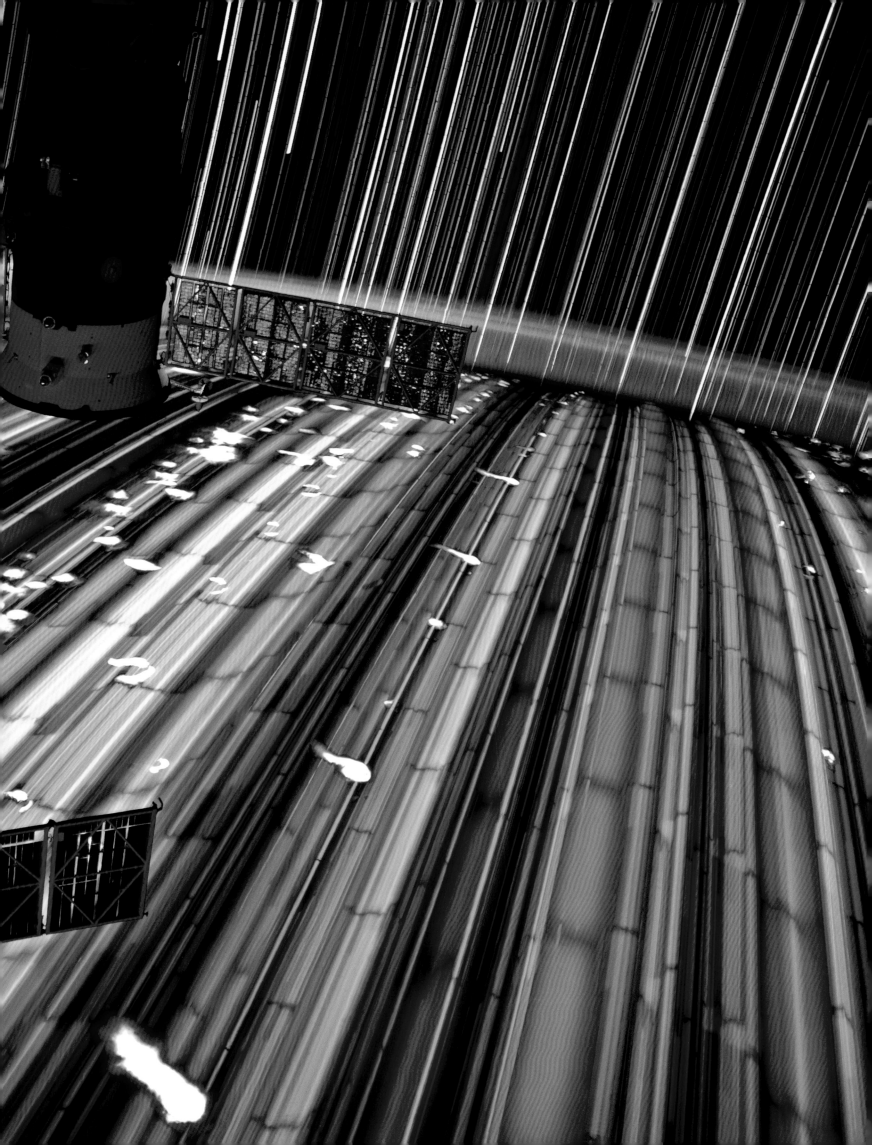

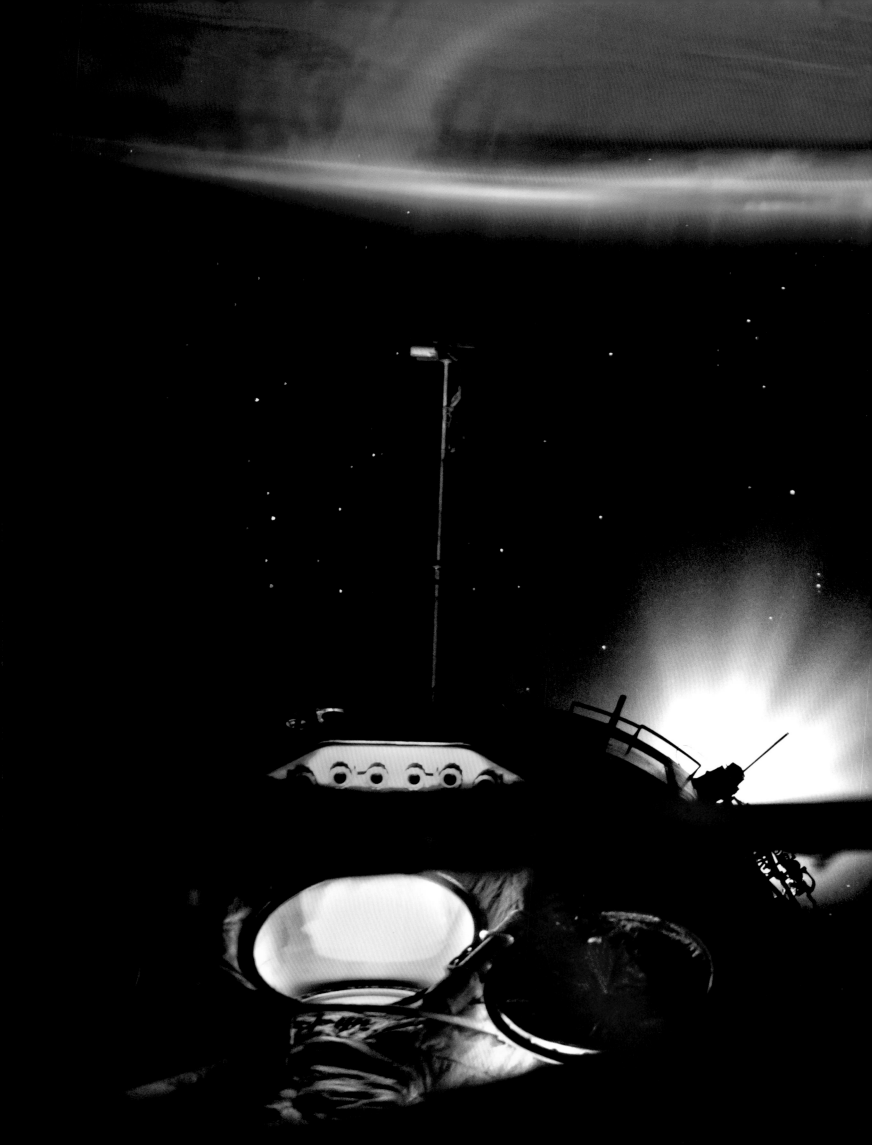

SHOOTING SPACE

Traveling into space guarantees a captivating story, but the richness of the experience is often overwhelmed by the dangerous and demanding reality of simply surviving. A good photograph should tell a story and be technically sound. That's not always easy in space.

The basic technical elements of photography are the same no matter the circumstances, or altitude. Exposure—the interplay among shutter speed, aperture (f-stop), and the sensitivity of the recording medium used (ISO)—and focus create an image. Composition adds the art. Something about a particular scene triggers the choice to make a photograph. Surrounded by a nearly infinite set of visual details, composing an image is as much about what to leave out as what to leave in. When the stars align, the result is worth a thousand words.

Taking good photographs inside or outside the International Space Station is a lot more difficult than it might at first appear. The range of brightness—from sunlit clouds brightly blanketing the Earth to the inky darkness of space—far exceeds what can be captured in a single frame. Auto-exposure algorithms, optimized for the buffered light found in our atmosphere, are fooled by the stark contrast of a brilliantly lit planet immersed in blackness. Viewpoints are determined by where space station engineers decided to put windows. Improving your composition by moving a few feet in one direction or another just isn't an option. Every window is quadruple-glazed, and even with anti-reflective coatings those eight surfaces can create nasty reflections that spoil your shot.

Orbital motion causes the Earth's surface to speed by at five miles per second. Manual tracking is required to avoid blurring, even at the fastest shutter speeds. The space station's interior resembles a long, poorly lit hallway cluttered with dangling cables, hoses, and wires. A standard flash makes your crewmates look like primordial, shiny-skinned lizards peering out of cave-like darkness. It is not uncommon for crewmates to float by inverted; facial-recognition software won't detect or focus on a face that's upside down. Technology finely tuned for one environment typically blows a few sour notes when transplanted to a radically new setting.

Earth's atmosphere is like a newborn's incubator, tenderly shielding humans on the planet's surface from the harshness of space radiation. When we're in space our bodies seem to be able to cope with exposure to this exo-atmospheric insult, but our cameras cannot. Cosmic rays—errant fragments of atoms moving at insane velocities—strike the sensors in digital cameras and leave multicolored streaks and destroy pixels. To me, streaks actually tell part of the story of space travel, so I leave them in place. Damaged pixels scream out and significantly degrade a photograph for anything but prosaic engineering utility. (I must note that while prosaic engineering utility may hinder artful rendition of human experience it does keep us alive when in space!)

Damage from cosmic rays is best corrected by taking "dark frames"— exposures made with the lens cap on, so that the extent of pixel damage is recorded without image information. These dark frames can be "subtracted" from photographs in post-processing, thus miraculously making most of the "hot" pixels simply disappear. If software filters are used to remove the damage instead, precious photographic detail is lost, and the photographs look like they were taken through a lens smeared with fingerprints.

(Previous spread) Rocket engine firing needed to lift space station to a higher orbit. Composite photo created from two images.

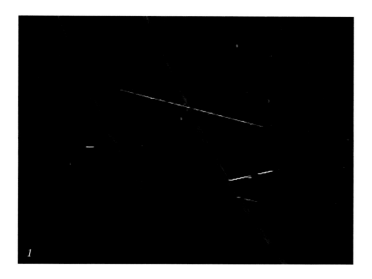

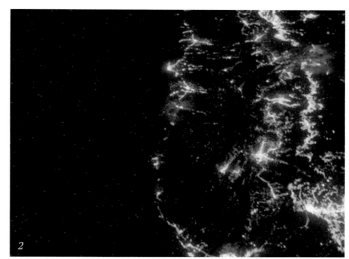

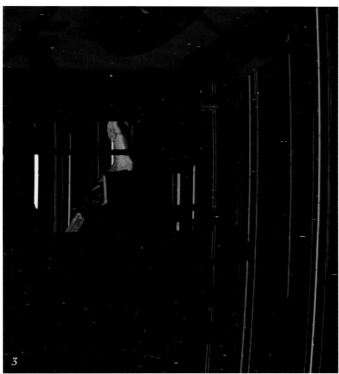

(1) *Magnified photograph showing multicolored cosmic ray streaks. These decorate space photography and, in their own special way, record part of the story of being there. I tend to leave these alone in my photographs and only remove cosmic ray-damaged hot pixels.*

(2) *Hot pixels appear in this magnified photograph as bright-colored speckles from more than a year's accumulation of cosmic ray damage. Significant camera damage builds up within two months on orbit and worsens over time. Cosmic ray damage*

distracts from a photograph's artfulness. If it's removed using image processing filters, significant detail is lost. We replace our camera bodies about once a year, and give the damaged ones a de-orbital cremation.

(3 - 4) *Magnified photographs show speckled hot pixels from cosmic ray damage in the raw image (left). During post-flight image processing the dark frame can be "subtracted" from the photograph (right), removing most of the cosmic ray damage.*

Astronauts' images of Earth can be many things: documentation of life in space, contributions to a scientific database, or, in their purest form, works of art. Taking photographs of natural phenomena over days, weeks, or months while spaceborne can advance our knowledge while enriching our sense of who we are as human beings.

Images captured by astronauts complement those from satellites. Once programmed, satellites can record massive amounts of imagery, typically with greater consistency and better resolution than is possible for an astronaut with a camera. But humans, inspired by direct experience, can explore insights that go beyond what can be preprogrammed. Driven by impulses that are not always exclusively scientific, or even rational, astronauts spontaneously collect novel imagery—photographs with the power to surprise and captivate.

During my last mission, in 2012, my crewmates and I took more than 500,000 photographs—pushing the total number taken from the International

A FINAL THOUGHT
BY DONALD R. PETTIT

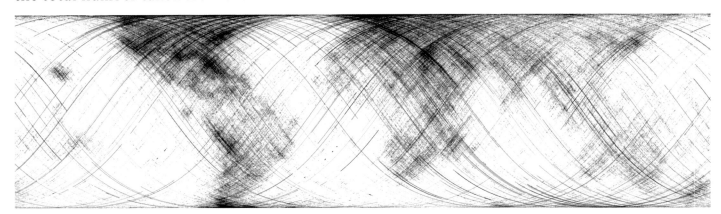

Space Station over a million. In 2013, just to see what might happen, Nathan Bergey, then a visiting scholar at Portland State University in Oregon, plotted the location of the space station at the moment each of those 1.1 million photographs was taken on a blank map of the Earth. A new vision of Earth's geography emerged. The continents appear in ghostly outlines, and places of striking beauty are thick with dots. Regions of constant cloud cover, and the feature-less reaches of the mid-ocean zones, rarely caught a photographer's attention, and are nearly devoid of images.

Parsed in this manner, nothing of the particular photographic subject remains, only the fact that a human being, driven by something intangible— curiosity, awe, aesthetic delight, perhaps even a moment of homesickness—chose to release a camera's shutter. In the record of those million choices, a powerful story is inscribed: the human experience of being spaceborne.

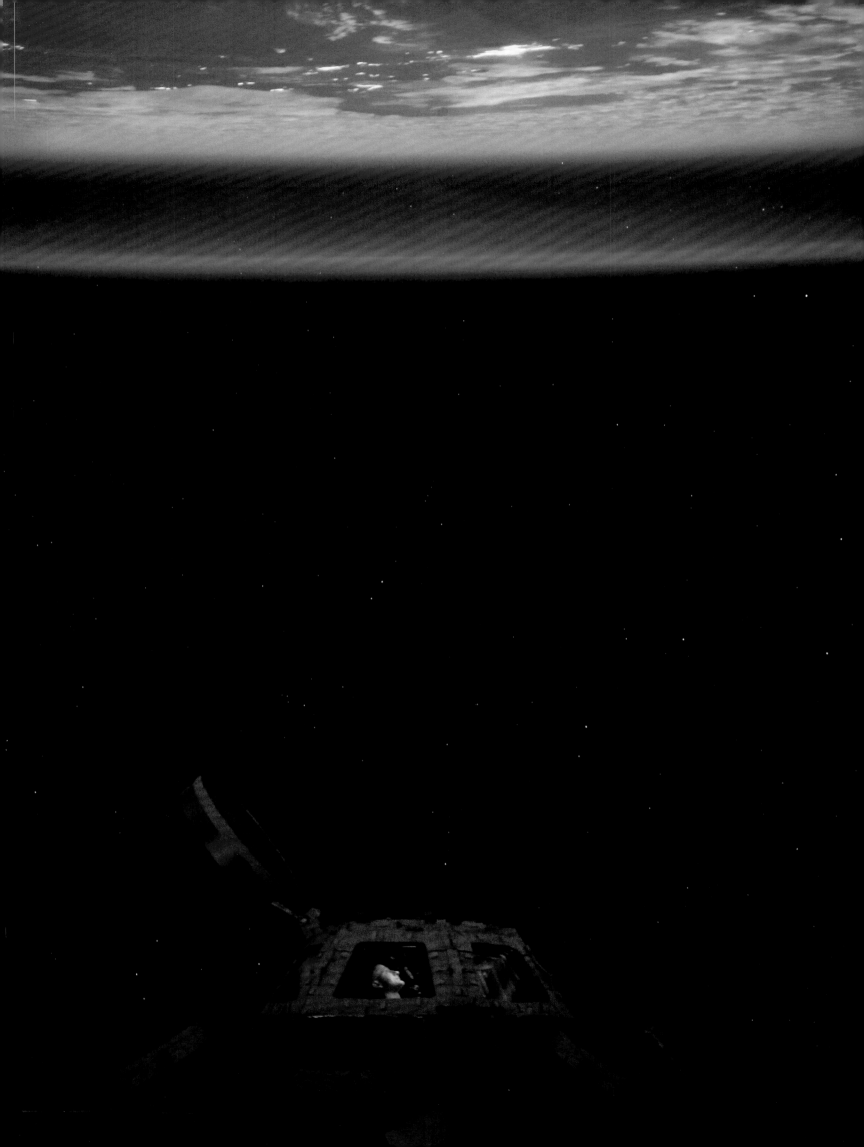

ACKNOWLEDGEMENTS

I want to acknowledge all my space station crewmates, who have been such an important part of this photographic journey: for Expedition 6 in 2002-2003, Ken Bowersox, Nicoli Budarin; for Expedition 30/31 in 2011-2012, Dan Burbank, Anton Shkaplerov, Anatoli Ivanishin, Andre Kuipers, Oleg Kononenko, Joe Acaba, Sergei Revin, and Gennady Padalka.

Though my space shuttle missions each lasted only a few weeks, my crewmates did much to teach me how to behave in space. I am grateful to my crewmates on STS-113, *Endeavor*, Jim Wetherbee, Paul Lockhart, John Herrington, Mike Lopez-Alegria, Peggy Whitson, Valery Korzun, and Sergei Treschev; and on STS-126, *Endeavor*, Chris Ferguson, Eric Boe, Steve Bowen, Heide Stefanyshyn-Piper, Sandy Magnus, Greg Chamitoff, and when docked to the International Space Station, Mike Fincke, space station commander.

There are many who supported my missions but remained on Earth. NASA photo trainers Paul Reichert, Steve Berenzweig, Katrina Willoughby, John Turner, and Olga Loukianova were of immense help as I learned about the photographic equipment on the space station. After photographs were taken they had to be downlinked and archived: I thank Maura White and Kimberly Cook for fighting to save my photographs during a time of restricted downlink when I was instructed by mission control to delete nearly half of them. And I have learned much from Warren Harold and Crystal Schroeder, quiet experts who fine-tune raw digital files into works of art for NASA. I have applied much of what they taught me in the creation of the photographs presented in this book.

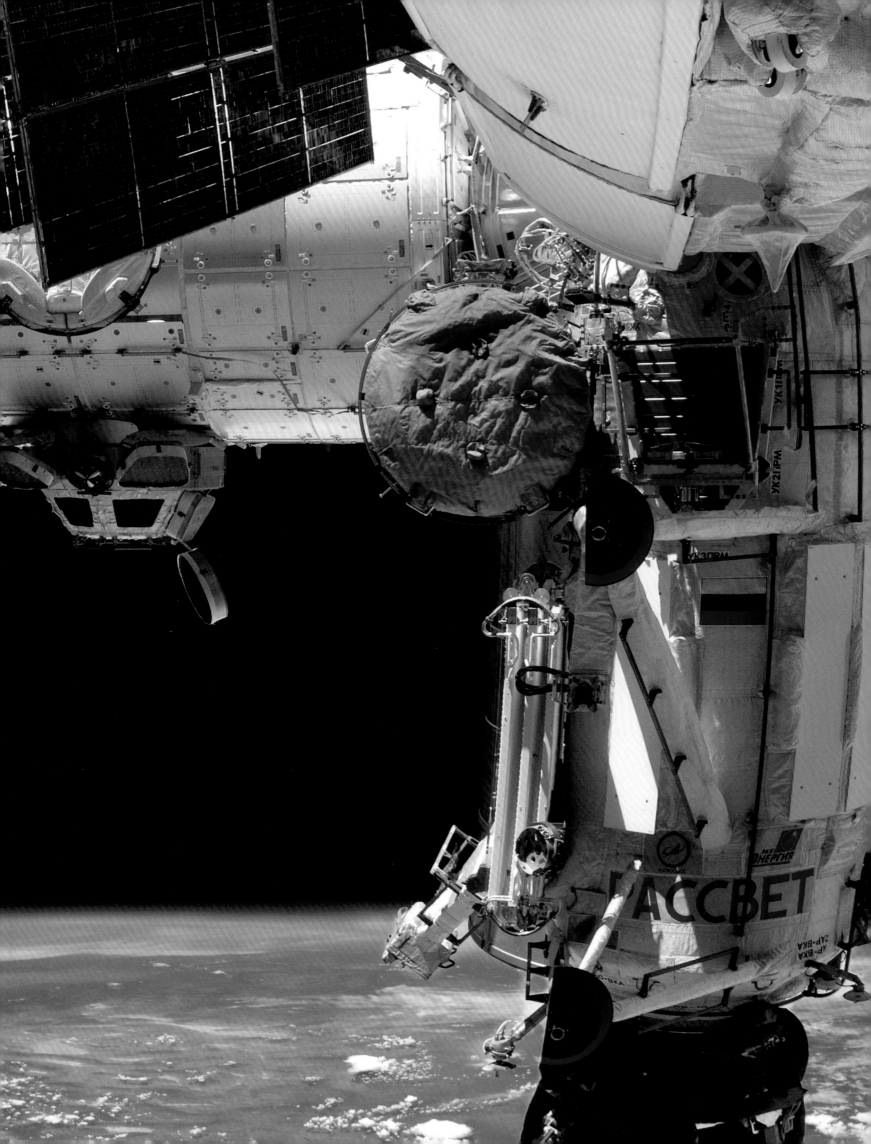

LAST DAY IN SPACE
BY DONALD R. PETTIT

Tomorrow we light our rocket
 we burn our engines and likewise burn a hole in the sky
 And fall to Earth
How does one spend your last day in space?
 looking at Earth
 a blue jewel surrounded by inky blackness
 occipital ecstasy
Unconstrained by your girth
 you fly with vestigial wings
The atmosphere on edge
 an iridescent blue with no earthly parallel
 electrifying diaphanous beauty
Guarded by Sirens of Space
 singing saccharin songs
 beckoning you to crash on the atmos-reef
 which tears you limb for limb
 and scorching what remains into cosmic croutons
 that sprinkle onto the garden salad of Earth
One last feast out the window
 a looking glass of wonderland
 offering both a portal to see your world
 and a translucent reflection to see yourself
Contemplation-
 what is your place in this world below
 how do you change it
 how does it change you
We are wedded to this planet
 until extinction we do part
 perhaps one planet is not enough
 least we become another fossil layer eroding from a cliff side
You study your charts
 we prepare our spaceship and our minds
 we make ready our descent into these seemingly gentile arms
The anticipation of hugging your wife
 your Boys with grins followed by pouting faces
 both happy to see you but not understanding why you left
How does one spend your last day in space
What would you do?